All These Liberations

Women Artists in the Eileen Harris Norton Collection

This book is dedicated to my mother, Rosalind Van Meter Harris, for inspiring my love of contemporary art, education, and for encouraging me to dream big.

All These Liberations

Women Artists in the Eileen Harris Norton Collection

Edited by Taylor Renee Aldridge

With contributions by Taylor Renee Aldridge, Sophia Belsheim, Susan Cahan, Chelsea Mikael Frazier, Thelma Golden, Genevieve Hyacinthe, Kellie Jones, Gelare Khoshgozaran, Kris Kuramitsu, Sarah Elizabeth Lewis, Steven Nelson, Legacy Russell, Lorna Simpson, and Lowery Stokes Sims

Distributed by Yale University Press,
New Haven and London

Contents

Artists Index

Mncane Nzuza

Toyin Ojih Odutola

Lorraine O'Grady

Ruby Osorio

Marta María Pérez Bravo

Adrian Piper

Calida Rawles

Faith Ringgold

Sandy Rodriguez

Alison Saar

Betye Saar

Lezley Saar

Analia Saban

Doris Salcedo

Amy Sherald

Lorna Simpson

Kianja Strobert

May Sun

Aya Takano

Alma Thomas

Mickalene Thomas

Fatimah Tuggar

Linda Vallejo

Ruth Waddy

Kara Walker

Carrie Mae Weems

Pat Ward Williams

Paula Wilson

Saya Woolfalk

Samira Yamin

Lynette Yiadom-Boakye

Brenna Youngblood

Foreword: Eileen Harris Norton & the Gift

Lorna Simpson

Sometimes when we find art, hear it, and fall in love with it,
sometimes art looks back at us, allowing us to experience it all as a gift.
—LORNA SIMPSON

Collecting art can have many connotations and motivations. For decades, Eileen Harris Norton has collected art—seeking work that resonates with her reflections of time, place, and her interior thoughts. Her collecting began first with her mother, then later in collaboration with her former husband, Peter Norton, and now, on her own. Her lens is essential. Not only is this a valuable insight for a collector, it can also define a collection and reveal a perspective, a lineage of artistic practice and institutional impact.

So often, collections are thought to need management from art advisers. That is a secondary truth and only a tiny part of the equation. From the start, Eileen has intellectually pursued collecting, having the intention and an interest at the boundaries of "exclusion" within art history and within the gallery world. She decided to develop close relationships with many curators and artists here in the United States and abroad. I remember conversations in the 1990s with Eileen about which artists she might find compelling, not for the sake of who or what was "new," but from the perspective of her experience and insights. As I understand it, her interests in collecting and philanthropy began with artists and curators. During the 1990s, who better to have many discussions with than Thelma Golden, then curator at the Whitney Museum of American Art in New York City.

I recall my dear friend, Robin Coste Lewis, Californian poet, lamenting that while she was evolving as an artist in the early 1980s, she was not aware of other Black creative people of her generation, from her childhood neighborhood, until many years later. And they were not aware of her. The issue wasn't that they did not exist but that their paths had simply not crossed. Eileen, too, waited years before her own direct connections to Black artmaking and art makers could develop.

A Black woman from the Watts neighborhood of Los Angeles, California, Eileen had a mother who often took her to visit museums, listen to music, and experience theater in that city. Later, she would collect contemporary work by artists of the African diaspora, female artists, and artists from Los Angeles. Her interactions with the art world in the 1990s revealed that she could not be talked into a purchase, and the complexity of her interests was not easily recognized. Many general conversations directed toward Eileen, by gallerists and art salesmen, might often only land on the term "Black artist," as if that were a complete description or statement, when she was attempting to talk about specific artists' practices. Her Californian, Black, and quietly observant presence and demeanor stood out.

Eileen's formal collecting practice began when she was a college student. A 1976 issue of the *Los Angeles Times* announced that prints by Samella Lewis and Ruth Waddy were on view at the Museum of African American Art in Los Angeles. Lewis and Waddy, who lived their lives as artists, scholars, and curators, were instrumental members of the Black Arts Movement in

California. Eileen's memorable encounter—described further in this catalog—with their work and with the artists themselves in a Black art institution would later define and inform her future collecting of, and relationships with, artists such as Adrian Piper, Glenn Ligon, Gary Simmons, Lorraine O'Grady, Mark Bradford, and many others. That moment would also acknowledge the importance and the richness of being in direct conversation with living artists. Significantly, this kind of conversation also needed to continue to be held in brick-and-mortar spaces in Black Los Angeles communities, and more broadly in US and international institutions. This early pivotal exchange, which foreshadowed her later focus on collecting work by women of color, would also later inform Eileen's philanthropy and the necessity to create, sustain, and democratize the reach of the rich experience of art.

At that time, Eileen was perceptive and skeptical of the many attempts to engage her about contemporary art in response to her activity as a collector. Eileen was somewhat of an anomaly, as one of the few Black women collectors, collecting at the rate that she was, at that time. Eileen was somewhat othered in comparison to her collecting peers—an experience that's all too familiar for women of color in the art world.

Beginning in the early 1990s, Peter and Eileen were not only supportive in collecting art, but they also awarded funding to curators to empower them to bring works into their museum collections, thereby creating a pathway to broaden the scope of inclusion to both museum collections and within the art historical canon. To name just two important exhibitions they supported: the Whitney Museum of American Art's groundbreaking *Black Male: Representations of Masculinity in Contemporary American Art*, curated by Thelma Golden in 1994, and the 1997 South African Biennale, curated by Okwui Enwezor with exhibitions held in Johannesburg and Cape Town.

Eileen and Peter's mission was to extend their financial support to curators whose efforts had an international scope of contemporary artists of the African diaspora and of Asian, Chicano, and Latin American descent. This support was pivotal for the field of contemporary art exhibitions during the early 1990s. Their efforts to create a diverse exchange of ideas within the curatorial field of art institutions were also in recognition that a diverse public would be able to experience this shift via exhibitions, and also reshape the mission of museum collections that would reflect broader perspectives and populations. For artists, their pioneering patronship created essential physical and intellectual spaces in which to have in-depth conversations with curators about practice and the evolution of ideas.

Since 2013, Eileen's vision and mission as a patron of the arts has continued and has led her to co-found, with Mark Bradford and Allan DiCastro, Art + Practice, a permanent exhibition space and nonprofit in Leimert Park, Los Angeles. A+P organizes exhibitions and public programs, collaborating with one foster-care service provider, an NGO supporting refugees around the world, and co-organizing traveling exhibitions with museum institutions for other communities to explore.

The gift—full circle.

All These Liberations: Women Artists in the Eileen Harris Norton Collection

Taylor Renee Aldridge

Lorraine O'Grady, *Sisters I–IV (Miscegenated Family Album Series)*, 1980–88.
Four Cibachrome diptychs (one pictured); each: 19¼ × 12⅞ in. Edition of 8
and 3 APs.

*Modernity can spread a bed of weaponry to what it calls the far reaches of the globe
but it cannot spread women's equality. It cannot stem the liquidity of capital, it cannot
even feed its own populations but female bodies are still trophy to tradition and culture.*

—DIONNE BRAND

*There are so many roots to the tree of anger
that sometimes the branches shatter
before they bear.
Sitting in Nedicks
the women rally before they march
discussing the problematic girls
they hire to make them free.
An almost white counterman passes
a waiting brother to serve them first
and the ladies neither notice nor reject
the slighter pleasures of their slavery.
But I who am bound by my mirror
as well as my bed
see causes in colour
as well as sex
and sit here wondering
which me will survive*
all these liberations.

—AUDRE LORDE

Epigraphs: Dionne Brand, *The Blue Clerk: Ars Poetica in 59 Versos* (Durham, NC: Duke University Press, 2018), 27; Audre Lorde, "Who Said It Was Simple," in *A Land Where Other People Live* (Detroit: Broadside Press, 1973). Copyright © 1973 by Audre Lorde. Reprinted with the permission of the Charlotte Sheedy Literary Agency.

All These Liberations gathers hundreds of modern and contemporary works by women artists from the collection of Eileen Harris Norton. The impetus for the book was *Collective Constellation: Selections from the Eileen Harris Norton Collection*, an exhibition that was transnational, intergenerational, and multi-ethnic in its focus, curated by Erin Christovale for Art + Practice in Los Angeles in 2020. Since then, we have experienced a global pandemic, international wars, continuing climate disaster, as well as civic uprisings sparked by state-sanctioned violence. We have had to reevaluate the preservation of our lives, our communities, and how we engage with one another. This book, written in the reality of such wakes and contemplations, is motivated by one specific inquiry: *In contemporary art, how may collectors support burgeoning living artists and the industry in which they function? In what ways can collectors be civically and socially minded in their collecting?* Eileen's collecting history offers a methodology on how one may approach such efforts in the so-called Art World. *All These Liberations* encourages thinking around the ways in which collectors may act as generative conspirators within the historically hegemonic contemporary art industry to create opportunities for radicality, intervention, and the liberation of marginalized voices from the periphery. In this essay, I work to illuminate some of the museological impacts that Eileen has instigated through clandestine collecting, donation, and philanthropic practice.

As we retroactively gaze at her often intuitive collecting modus operandi, it is most evident that the works in her collection explore themes and experiences that have anticipated the very world in which we are living today—a world that continues to question the validity of borderlands, our engagement with spiritual traditions and corporal existence, the threats of climate change, and the lack of autonomy women and other marginalized identities have over their own bodies due to ubiquitous and imposing capitalist, racist, cis-heterosexual, and patriarchal systems.[1]

These pervasive realities have been a compass for me as I have organized this book. The artists in the collection and, more specifically, this book have made work that continues to help us record the unbelievability of the world around us. The increased visibility within mainstream art institutions of historically oppressed groups—African American, women, Indigenous, and queer artists—is, in part, because of the intentional and intuitive collecting practices of Eileen and philanthropic efforts of the foundation she's led since the 1970s. Artists who have belonged to this collection, such as Mona Hatoum, Catherine Opie, Shirin Neshat, and Barbara Kruger, began incorporating taboo narratives surrounding HIV/AIDS, occupation in Palestine, silenced violences in civil wars, and queerness and gender nonconformity into their work. Eileen was drawn to works that were not apolitical and, in fact, acutely reflected the conditions that surround us. As the scholar Makeda Best has questioned: "What is the role of aesthetics and beauty in the face of catastrophe?"[2] The works in Eileen's collection allow viewers to contend with this query in ways that are rigorous, robust, and rhizomatic.

A Global Outlook Nurtured in Watts

Eileen's collection began in 1976, when she first purchased a print by the California-based organizer and arts advocate Ruth Waddy. During Black History Month, Eileen's mother, Rosalind Van Meter Harris, had seen an ad in the *Los Angeles Times* announcing a printmaking workshop by Waddy at the Museum of African American Art (MAAA), located in the now Baldwin Hills Crenshaw Mall. Known for writing themselves and others into art history, Waddy and Samella Lewis, a fellow pioneer of Black contemporary art scholarship and the founder of the MAAA, frequently offered accessible artmaking workshops in South Los Angeles.[3] Eileen and her mother met Waddy at the workshop and bought *The Exhorters* (1976).

1 While working on this book, *Roe v. Wade* was overturned by the US Supreme Court, ending the constitutional right to abortion that had been the law for decades. This reversal represented, for so many, the government's denial of people with a uterus control over their own bodies. And it also brings forth the possibility of other legislation informed by *Roe v. Wade* being overturned (such as same-sex marriage, the right to contraception, and the decriminalization of homosexuality).

2 Makeda Best, "Interval and Afterimage," in *Renate Aller: The Space Between Memory and Expectation* (Heidelberg: Kehrer Verlag, 2021), n.p.

3 Later that year, Waddy led a printmaking workshop inspired by a show at LACMA entitled *Two Centuries of Black American Art*. Curated by David C. Driskell, that landmark exhibition, the first encyclopedic show of Black artists practicing for more than two hundred years in this country, would reverberate throughout contemporary art history.

In the print, a group of male zealots appears to be preaching a political sermon, as a lone woman with a head covering looks on in quietude. The scene offers early insight into Eileen's collecting style, a method of influence that is expansive yet surreptitious.[4]

Eileen's parents had separated when she was young, and she lived with her mother. Rosalind worked as a clerk at Thrifty (now Rite Aid) Pharmacy. Eileen's father, Willie Frank Harris, lived a solitary life in Alaska, where he had moved to find freedom and autonomy in a nation still operating under Jim Crow laws. Alaska provided some escape, but this resulted in estrangement from his family. Eileen sought him out as a young adult and learned that he was then living in Bakersfield, California. Soon after, she and her mother went to visit him, only to be greeted by a neighbor who informed them that he had recently passed away. Although Eileen never had the opportunity to develop a relationship with her father, she had many other paternal figures during her upbringing.

4 Steven Nelson's essay in this volume succinctly establishes Waddy as not solely an arts and community advocate but also an ambassador, a Black American woman artist with a distinct political voice during the civil rights era. Instead of political protests and expressive militancy, Waddy has shared that she was more interested in covert activism that challenged old systems and created new ones; community organizing through art was her way of resolving inequality and injustice.

Eileen's childhood home was built by her maternal grandfather, Robert Van Meter, in the early 1920s, after he and his wife, Estella Greene Van Meter, migrated from Louisiana. Eileen grew up in Watts at 1673 East Imperial Highway with her grandfather, mother, and her two uncles—Robert Greene and Hubert Garth Van Meter. Another uncle, Donald James Van Meter, also lived in Los Angeles. Eileen remembers she and her mother, who was the second youngest of four children and the only girl, often rallying against the men of the house during playful debates. Nonetheless, the family of five often moved as a unit.

One of Harris Norton's most memorable experiences in the home was during the Watts Rebellion, which erupted in her neighborhood in 1965. The upheaval began after a white police officer stopped and arrested a Black driver. At the time, the atmosphere in Los Angeles, and many other American cities, was contentious between Black communities and majority white police forces that had great authority to impose punitive action whenever they chose. As many Black Americans continued to migrate from the American South to escape racial terror, they

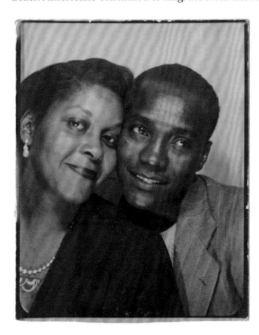

Eileen's parents, Rosalind Van Meter Harris and Willie Frank Harris, 1951.

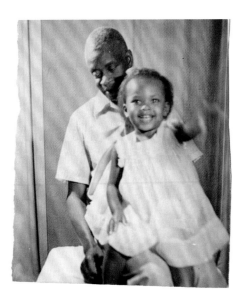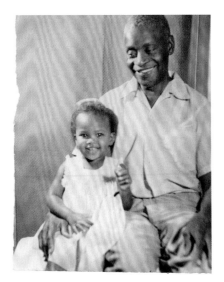

Eileen and her grandfather Robert Van Meter, October 10, 1954.

settled in Northern and Western American cities to the chagrin of many white Americans. In this anti-Black environment, racist whites enforced segregation, red-lined neighborhoods, and restricted access to work and necessary resources for Black Americans. Because of the ubiquity of systemic racism, the traffic stop that ignited the rebellion did not exist in a vacuum. Word spread that the arresting officers had beaten a pregnant Black woman, which immediately heightened tensions.[5] Afterward, many Black residents took to the streets to burn and loot businesses in the area, exhausting their frustrations with the oppression they had been living with for years. Eileen was a young girl when the fires raged not too far from her home, and she remembers being in constant fear during the multiday rebellion. Radicality and rebellion were all around her in her childhood, and she witnessed the development of the arts movements that the upheaval spawned.

The ruin that was left in the wake of the Watts Rebellion incited many Black Angelenos to document and express themselves during a watershed moment of Black resistance and rage in America's history. On the occasion of *Now Dig This!*, a groundbreaking exhibition by the art historian Kellie Jones that celebrated contributions by post-Watts Rebellion artists, the curator Naima J. Keith concluded: "The uprising in Los Angeles led artists to consider the transformative power of art, which was realized in the reworking, quite literally, of the physical ruins of South Los Angeles. As artists crafted works out of the charred remnants of their world, a form of assemblage art was born."[6]

Artists like Betye Saar, John T. Riddle, David Hammons, Senga Nengudi, John Outterbridge, and Noah Purifoy, the patron saint of Los Angeles assemblage, employed discarded and unconventional materials from their immediate surroundings to comment on and make record of the ingenuity that can be generated out of ruin. It is no surprise that Saar, one of the artists who took the Watts environment as one of her main subjects, would later become heavily collected by Eileen decades later. Deeply informed by the Rebellion, Saar adapted an upcycle

5 John McWhorter, "Burned, Baby, Burned," *Washington Post*, August 14, 2005, https://www .washingtonpost.com/wp-dyn /content/article/2005/08/13 /AR2005081300103.html.

6 Naima J. Keith, "Rebellion and Its Aftermath: Assemblage and Film in L.A. and London," in *Now Dig This! Art and Black Los Angeles, 1960–1980*, digital archive (Los Angeles: Hammer Museum, 2016), https://hammer.ucla.edu /now-dig-this/essays/rebellion -and-its-aftermath.

sensibility to repurpose materials that were discarded or destroyed. As an adolescent, Saar had borne witness to the making of the Watts Tower (1921-54), a public art installation made by the tile mason Simon Rodia, an Italian immigrant. Eileen also grew up close to that highly accessible artwork, which proved the value of living with and among art for all to appreciate. The seventeen interconnected sculptural towers, located a few blocks from Eileen's childhood home, are renowned for their scale and assemblage sensibility, as well as for the ways in which Rodia made his sculptural process visible and open to the Watts community.

One of the Saar works in Eileen's collection, *Last Dance* (1975), embodies that sensibility of assemblage, as well as the altar-like qualities evident in her turn toward the spiritual and ritual. In the wake of her great-aunt Hattie's passing, Saar constructed an homage to her elder, who was like a grandmother to the artist. In *Last Dance*, Saar included items that Hattie might have arranged in preparation for a party, such as hair ribbons, a silk flower, compact, and a fan.[7] The work is a black treasure box with a black lining, containing small trinkets and worn manila-colored papers that appear to be letters.[8] Saar's metaphysical connection between multigenerational elders embodies the familial connections present in Eileen's childhood home in Watts.

Eileen's uncles, Robert and Hubert, had served in the US Army. They enjoyed traveling and often vacationed from Los Angeles to visit other countries. They, too, were appreciators of all kinds of arts. Robert attended UCLA and wrote fiction in his spare time, and Hubert, like Eileen, was a photographer and highly skilled culinary artist. Through her uncles, she met Alvin Ailey at the Shrine Auditorium, before he would leave for Harlem and found his eponymous dance company. They attended art openings and traveled often, exposing a young Eileen to a multitude of cultures. During her summer break in college, Eileen and her family took a trip coordinated by an uncle, touring various countries in Europe

7 Kellie Jones, *South of Pico* (Durham, NC: Duke University Press, 2017), 123.

8 *Last Dance* was presented in her solo show *MATRIX*, at the Wadsworth Atheneum Museum of Art, in Hartford, Connecticut, in 1976. In the accompanying brochure, Saar writes: "Sometimes I feel like a medium, like the connection between the material and the message. My current work is involved with nostalgic journeys, with secrets, and with mystical powers."

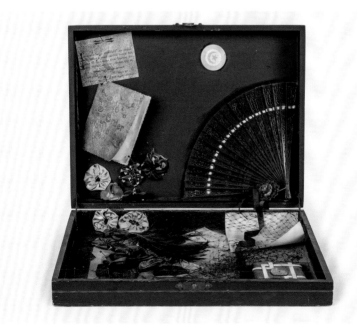

Betye Saar, *Last Dance*, 1975. Multi-media construction; dimensions variable.

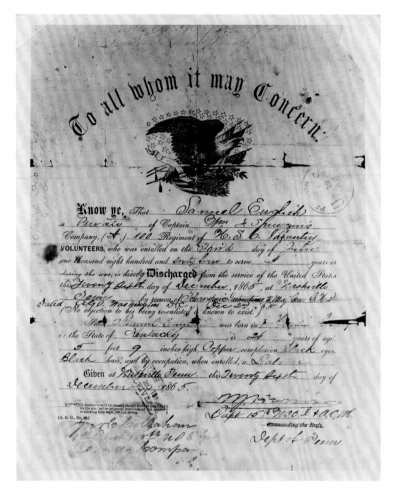

Civil War discharge papers of Samuel English, Eileen's great-great-grandfather.

and Eastern Africa. Through the efforts of her mother and other family members, Eileen was surrounded by international culture and the arts.

Rosalind appeared uninhibited and interested in the world around her. Her curiosity continued to pique after the premiere in 1977 of *Roots*, one of the first cinematic endeavors that captured the true violences of American slavery in a syndicated platform. After viewing the limited television series, Rosalind wanted to know more about her own genealogy. Through extensive research, she discovered her great-great-grandfather, Samuel English, who had served in the Union Army during the Civil War and been enslaved, bound to two plantations in the South.

That same year, 1977, Eileen graduated from the University of Southern California with a master's degree in bilingual education. In the years prior, she had been working within the Los Angeles Unified School District. The school's student body was primarily Black, but war and unrest in Central America had led to a large influx of Latino students, which increased demand for English as a Second Language (ESL) teachers. This exposure to the material effects of war and asylum-seeking youth would be a great influence on her philanthropy and, specifically, the founding of Art + Practice in 2014, focusing on children affected by social

upheaval. Additionally, these experiences indirectly informed her draw to works that gave insight into the terrors of war and exile, such as *Atrabiliarios* (1993) by Doris Salcedo, which features worn shoes by those, mostly women, who disappeared during the Colombian conflict in the second half of the twentieth century.[9]

In *Art On My Mind: Visual Politics*, bell hooks writes, "The politics of seeing —how we perceive the visual, how we write about it and talk about it—I understand that perspective from which we approach art is overdetermined by location."[10] Eileen's upbringing in Watts during the civil rights era and Black Arts Movement, in a multigenerational home, along with her exposure to multiple countries during her youth, shaped and sharpened her consciousness of transnationalism and the interconnectedness of cultures. Thinking globally, while being rooted in her very specific Black and West locale, is intrinsic to the way she shows up in all areas of her life. These experiences directly inform the artwork she is drawn to and likewise the philanthropic efforts to which she is committed.

Los Angeles's Budding Contemporary Art Ecosystem

When Eileen began the collection, the world was serendipitously opening up to allow more avenues for connection, production, and exchange through globalization, which influenced an international art world to become more cosmopolitan, intertwined, and ultimately more accessible for both artists and their patrons.

While Eileen had been buying art before she met Peter Norton, now her former husband, in 1981, the couple began collecting together, shortly after he achieved success as a software developer. In the 1980s, Peter purchased his first IBM computer and began developing software to recover lost files. At the time, Eileen was working as an ESL instructor in Los Angeles. As the art historian Susan Cahan, a former manager of the collection, has remarked: "Eileen began to question her future as a teacher. Proposition 13 had passed a couple years earlier, propelling the already strained L.A. school system into financial crisis. The war in El Salvador poured thousands of kids from Central America into L.A. classrooms. As an ESL and bilingual educator, Eileen felt disheartened and frustrated by the system's inability to meet the students' needs."[11]

Soon after, Eileen quit teaching and as co-founder of Peter Norton Computing Inc., she began working with Peter to scale the business. With the proliferation of professional and personal computers at this time, the business began to take off. The Nortons sold their software company for millions of dollars and undertook major philanthropic endeavors through a family foundation. Simultaneously, they became students of contemporary art.

Los Angeles entered the mainstream art world in the twentieth century, starting with a small base of collectors, many of whom focused on everything but modern and contemporary art.[12] Through the strong development of Los Angeles County Museum of Art's (LACMA) Contemporary Department and Contemporary Art Council (CAC), the eventual Broad Contemporary Museum at LACMA, and in the late 1970s, the founding of the city's first museum exclusively dedicated to contemporary art—Museum of Contemporary Art (MOCA)—a vibrant ecosystem of contemporary artmaking was cemented and sustained. At the CAC, Eileen, along with Peter, experienced a deep

9 In the aftermath of the assassination in 1948 of the liberal leader Jorge Eliécer Gaitán Ayala and the suppression of communists, a conflict began between liberalists and right-wing Colombians. Paramilitary and guerrilla groups used this method of disappearance to instill fear in civilians and maintain control during the conflict.

10 bell hooks, *Art on My Mind: Visual Politics* (New York: New Press, 1995), 2.

11 Susan Cahan, "Eileen Norton: Portrait of a Collector and Philanthropist," *Art Wire* 14, no. 1 (1998): 7-8.

12 Lynn Zelevansky has written an extensive account of LA arts development for a retrospective of LACMA, in which she writes: "Despite a tradition of democratic, utopian radicalism, for much of the last century, Los Angeles was a culturally and politically conservative city. L.A. was founded by rugged individualists—cowboys, adventurers, oil and property speculators—and populated over the first half of the twentieth century by large migrations of Middle Americans, many of whom had been farmers rather than urbanites. . . . For a long time the resulting community was not predominantly progressive, cosmopolitan or hungry for the latest developments in the visual arts." See Zelevansky, "Ars Longa, Vita Brevis: Contemporary Art at LACMA, 1913-2007," in *The Broad Contemporary Art Museum at the Los Angeles County Museum of Art* (Los Angeles: Los Angeles County Museum of Art, 2008), 91.

All These Liberations: Women Artists in the Eileen Harris Norton Collection

incubation of arts education and insight into how to best support artists. The CAC was known for its Young Talent Award grant, which began in the 1960s, providing local artists with $1,200 to encourage them to remain and maintain a studio in Los Angeles instead of moving to New York City. This retention enabled more living and emerging artists to settle in Los Angeles and contribute to its burgeoning arts community. Eileen and Peter lived in Venice, where many artists had their studios. During the late 1980s and early 1990s, they began to visit them and purchase art.

The first work they collected was by the young abstractionist Carla Pagliaro. Later, Eileen and Peter focused on works of art by emerging artists that cost less than $10,000. She thought it would be best to support living artists, and as curator Paul Schimmel put it, they were "specialists in the area of emerging artists with strong political and social content."[13]

Despite the guiding principles they outlined for their collection, Eileen's collecting practices have always been deeply intuitive, a result of her own interest and discernment. She has often enjoyed walking into galleries and buying work with no prior knowledge of the artist, unconcerned with their market value or potential. Peter Norton once shared: "[Eileen] will not tell you this herself, but the cold hard fact is, that I'm known in the art community, but she is the one with the taste."[14]

Eileen's collecting methods and patron practices reflect her own sensible, aesthetic eye and are congruent with the many sociopolitical currents that have evolved throughout the world in recent decades, often mirroring an avant-garde impulse. As Robert Storr, a recipient of the Norton Family Foundation curator grant, has said of the Nortons' collecting in the early 1990s: "I wouldn't necessarily call (the art in their collection) cutting edge . . . sometimes it's just out on the edge . . . period."[15] Being on the precipice of emerging art, and keen enough to follow her instincts, Eileen was able to anticipate and collect works of unprecedented nuance that have gone on to become canonical in the discourse of contemporary art.

In a more subtle provocation, Renée Green, one of the most compelling contemporary artists of our time, delicately captures the violent traditions tied to colonial French textile design in *Mise-en-scène II: Commemorative Toile* (1992-94), included in Eileen's collection. The French eighteenth-century Baroque fabric called *toile* was made possible by the exploitation and pillaging of Asian and African resources. To make the exploits more explicit, Green offered her own take on toile, imbuing the design with scenes of enslaved Africans, alongside vignettes of bucolic France and uprisings in French colonies.

In a similar impulse of provocation, but altogether different in form and content, is *R.S.V.P.* (1976-77) by Senga Nengudi, who was practicing as a performance artist and sculptor in the wake of the Watts Rebellion in Los Angeles. *R.S.V.P.* is an ongoing series of soft sculptures made from malleable materials like pantyhose, calfskin, and sand. Just Above Midtown (JAM)—a New York City gallery founded by Linda Goode Bryant—presented the 1976 exhibition in which *R.S.V.P.* debuted. Remarking on the show and its stirring appeal, Bryant recalls: "For eighteen days, questions and answers were spoken out loud in the gallery, prompting spontaneous conversations and discussions between individuals and groups, friends and strangers. . . . Senga asked us to respond and we did."[16] Nengudi's work was concerned with confrontation and served as an invitation to think collaboratively about the uncommon and found materials the artist used to remark on imminent decline tied to certain bodies. Nengudi allowed us to question, *How can matters of relation inform, name, and alter such realities where we currently exist?*[17] This same index of questioning and investigation of dynamics, between people, which is tied

13 Bettijane Levine, "The 'Model Millionaires': The Nortons Rode the Computer Revolution to a State of Financial Bliss. Then They Decided It was Time to Play—With Their Kids, Art, and Charities," *Los Angeles Times*, June 12, 1994, https://www.latimes.com/archives/la-xpm-1994-06-12-ls-3441-story.html.

14 Cahan, "Eileen Norton," 7–8.

15 Levine, "'Model Millionaires.'"

16 Linda Goode Bryant, "Senga Nengudi: Répondez S'il Vous Plaît," in *Senga Nengudi* (Munich: Hirmer, 2019), 183.

18

Renée Green, *Mise-en-scène II: Commemorative Toile*, 1992–94. Chair covered
with beige toile fabric with pigment on cotton wrap sateen; 29 × 29 × 23 in.

Senga Nengudi, *R.S.V.P.*, 1976–77. Nylon mesh, rubber, and sand; 36 × 20 in.

to the efforts of postmodernism to activate and play with modes of relation, can extend to describe the ways Eileen, sometimes collectively with Peter, created *happenings* among institutions, artists, and audiences to create an opportunity for dialogue and discourse via their support of the avant-garde.

In addition to these bold acquisitions, the Nortons were quite influential to what were then controversial art presentations but are now seen as landmarks in the history of exhibition making. The Nortons were largely instrumental in traveling *Black Male: Representations of Masculinity in Contemporary American Art* (1994–95), an exhibition at the Whitney Museum curated by Thelma Golden, to the Hammer Museum, underwriting exhibition costs and providing additional support for programming.[18] The latter allowed Golden's curatorial mission—to subvert, challenge, and transform negative stereotypes about Black men—to prevail through a series of lectures and pointed dialogues. As Golden declares in her interview with Eileen in this volume, "[*Black Male*] wouldn't have happened without [Eileen]."

On the Verge: Culture Wars and Women Artists as Critics

It's important to discuss the environment that was incubating during the late 1980s and early 1990s as the Nortons' collecting and philanthropy work began to grow. In the wake of postmodern discourse, critiques about exclusivity and sustaining the status quo emerged about an art world that continued to marginalize subjects of non-white male identities. Even in its critiques of modernism's discourse of othering, postmodern discourse was still not sufficient in creating space for traditionally marginalized groups to participate in a dialogue with the larger art world about the complexities of various identities and intersecting oppressions. The response to postmodernism's failure is particularly documented through the zeitgeist of *multiculturalism*. As the scholar Nettrice Gaskins has noted: "Multiculturalism offered a distinct culture war fought over issues of exclusion and identity politics. The conservative climate in the United States government during the 1980s and 1990s set the stage for a series of battles concerning the position of underrepresented minorities in the arts. In the 1980s, emerging artists of color were trying to define a new aesthetics of representation."[19]

The Eileen Harris Norton Collection captures the shifting zeitgeists of this time as it relates to multiculturalism, growing economic markets, and the metabolism of cultural exchange throughout the world—a robust catalog of global views. Eileen has collected some of the most canonical work by women who were providing social commentary on racialized, gendered, and sexual subjectivity against the backdrop of globalization, the process in which organizations and businesses have developed and operated on an international scale since the end of the Cold War, among other economical changes.

This global account is best captured in the works by artist Fatimah Tuggar. In her photomontage *Working Woman* (1997), Tuggar digitally assembles images of a grinning, rural Nigerian woman engaging with modern technologies, like the desktop computer. Since the 1990s, Tuggar has constructed such photomontages to call attention to the growing digital divide between certain countries as the hyper-development of technology and virtual communication continue to peak.

17 In a recent interview, Nengudi extended on this phenomena of relation among object, artist, and audience to produce a series of provocations: "In a literal sense, the sculpture is a dance partner. I'm intrigued with being enveloped by or having a relationship with sculpture. . . . I find it very sensual, very creative, this interaction. I'm very interested in how things relate to each other and when someone views my work I think about the fact that there's this threesome that happens: I interact with you, and then this third thing happens—in human relationships that could result in a child." Natalie Hergurt, "Repondez s'il vous plait: An Interview with Senga Nengudi," *Mutual Art*, September 28, 2016, https://www.mutualart.com /Article/Repondez-sil-vous-plait --An-Interview-wi/71B964571 BB7D4AF.

18 Lynell George, "The 'Black Male' Debate: Controversy Over the Whitney Show Has Arrived Ahead of Its L.A. Outing—Alternative Exhibitions are Planned," *Los Angeles Times*, February 22, 1995, https://www.latimes.com/archives /la-xpm-1995-02-22-ca-34639 -story.html.

19 Nettrice Gaskins, "Polyculturalist Visions, New Frameworks of Representation: Multiculturalism and the American Culture Wars," *Art 21*, January 17, 2017, http:// magazine.art21.org/2017/01/17 /polyculturalist-visions-new -frameworks-of-representation -multiculturalism-and-the -american-culture-wars /#.YvFo53bMLIU.

As the scholar Nicole R. Fleetwood has eloquently described, Tuggar "employs contemporary technology to comment on the history of technological development and the fantasies and nationalist imperatives invested in these movements."[20] Tuggar's work is still relevant years later as we experience the proliferation of Artificial Intelligence (AI) in technology. While AI is contextualized as a tool that can make the world better for all, many scholars have noted how this advanced technology can further the chasm between privileged groups and those who have been historically discriminated against.[21]

Eileen embodies what it means to enable the growth of an artist while growing as a collector alongside them. This is primarily exemplified through her support of the artist Lorna Simpson, since encountering the budding artist's work during her MFA show *Gestures/Reenactments* at the University of California, San Diego, in 1989. Since that time, Eileen has collected and infused dozens of works by Simpson in her collection and in the collections of museums throughout the United States. Simpson herself provides testament to this in the foreword of this catalog.

One of the Simpson works in the collection, *You're Fine* (1988), anticipates and responds to a range of speculative experiences around the Black femme body. An African American female lies horizontally in a photographic rendering of four panels. The figure's back is to the viewer as she reposes in a crisp white gown. One arm disappears in front of her body, while the other rests over her head, revealing soft, deep-brown skin that extends through her legs. The words "YOU'RE FINE" are installed above the image, while "YOU'RE HIRED" settles below. To the left is a column of more phrases connoting a medical experience: "physical exam," "blood test," "heart," and more. As Kellie Jones has written, "*You're Fine* not only denotes the figure's health,

20 Nicole R. Fleetwood, "Visible Seams: Gender, Race, Technology, and the Media Art of Fatimah Tuggar," *Signs* 30, no. 1 (2004): 1429–54, https://doi.org/10.1086/421888.

21 Olga Akselrod, "How Artificial Intelligence Can Deepen Racial and Economic Inequities," ACLU, July 13, 2021, https://www.aclu.org/news/privacy-technology/how-artificial-intelligence-can-deepen-racial-and-economic-inequities.

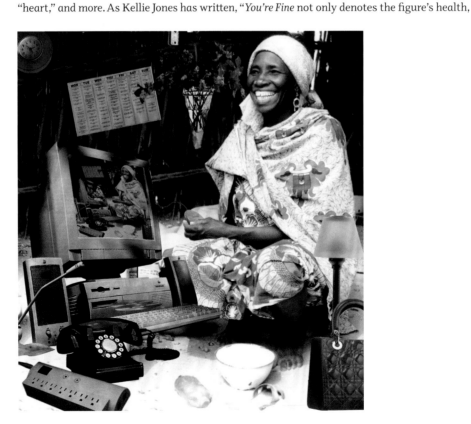

Fatimah Tuggar, *Working Woman*, 1997. Computer montage (inkjet on vinyl print); 60 × 48 in.

but in vernacular parlance, comments on her attractiveness."[22] Additionally, the reality of labor is introduced through the text below. Placing a Black woman's subjectivity within multiple fields of (subjugated) relation—perceptions of beauty, Western medical establishment, ways women are expected to labor, and unsolicited romantic advancements from men—is rife with antagonism and harsh conditions. Particularly within Western medicine, studies confirm that Black women are the most disregarded by doctors and care for their bodies is often delayed or nonexistent. Symptoms go ignored and are often disbelieved. The work codifies this long legacy of mistreatment of Black women and their bodies within the postcolonial medical project, from Saartjie Baartman to Henrietta Lacks to Shamony Makeba Gibson.[23]

How the subject is viewed and contextualized is an ongoing interest of Eileen's. This is evident in her selection of artworks that show the ways in which women's bodies are organized, named, categorized, possessed, oppressed, and suppressed through the Western colonial systems and ways of looking, and how such subjectivities are subjugated in the traditions of white and hegemonic institutions. For instance, in *When and Where I Enter, The British Museum*, a 2007 work by photographer Carrie Mae Weems, the artist helps us consider corporal implications in the presence of colonial histories and the architectures that celebrate them. In the image, Weems is both author and subject. She stands stoically in front of the British Museum, as she embodies the many barriers that non-white individuals are often confronted with before entering institutions that honor imperial conquests. Weems situates herself in the frame, right of center, adorned in all black, in front of the historical museum like a sentinel, or a statuesque haint who is sent to haunt the museum for its colonial exploits. Founded in 1753, the museum is known for its collection of Benin bronzes, looted by the British Army in 1897 from the coast of Nigeria.[24] As the archaeologist and anthropologist Dan Hicks has historicized, "The museum is not just a device for slowing down time, but also a weapon in its own right."[25] Through the use of photographic portraiture, Weems reifies and materializes the various intersectional oppressions that are endured through a Black femme embodiment within historic museum collections.

Returning to this notion of the museological, Eileen's work as a philanthropist, along with the Peter Norton Family Foundation, supported interventions within colonial museum status quo by granting funds to innovative curators to purchase unconventional works for their museum collections. The endeavor was simply named "Curator Grants," and under the auspices of the Peter Norton Family Foundation, grants of $50,000 were issued to dozens of curators at museums from 1989 to 2000. With such support, the Metropolitan Museum of Art, with the curatorial advice of then curator grant awardee Lowery Stokes Sims, expanded the museum's Lorna Simpson holdings with the purchase of *Parts* (1998) and *9 Props* (1995). In the roundtable discussion in this volume, Kellie Jones (who was also a grant recipient in 1992) and Stokes Sims remarked about the value of such grants and the impact they not only had for museum collections, but on the careers of living artists as well as their own. This generosity often allowed young curators to be empowered in their respective institutions in ways they might not have been otherwise. This often fostered acquisitions of burgeoning contemporary artists who had not been on the radar of traditional museums, and ultimately allowed their work to be acquired through the direction of these curators.

In another route toward supporting emerging artists directly, the Peter Norton Family Foundation became renowned for its annual Christmas art edition project, in which it commissioned

22 Kellie Jones, *EyeMinded: Living and Writing Contemporary Art* (Durham, NC: Duke University Press, 2022), 91.

23 The 2022 documentary *Aftershock* premiered as I was writing this essay. The film succinctly argues that the US maternal health system is particularly neglectful to Black women. See Beandra July, "'Aftershock' Review: A Moving Ode to the Black Family," *New York Times*, July 19, 2022, https://www.nytimes.com/2022/07/19/movies/aftershock-review.html.

24 Alex Marshall, "This Art Was Looted 123 Years Ago. Will It Ever Be Returned?" *New York Times*, January 23, 2020, updated October 29, 2021, https://www.nytimes.com/2020/01/23/arts/design/benin-bronzes.html.

25 Dan Hicks, *The Brutish Museums: The Benin Bronzes, Colonial Violence, and Cultural Restitution* (London: Pluto Press, 2021), 6.

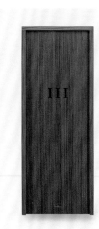

Lorna Simpson, *III (Three Wishbones in a Wood Box)*, 1994. Bronze, rubber, ceramic, and felt; 5 × 18 × 8 in. Edition: Peter Norton Family Christmas Project.

an artist to make editions of an artwork to be sent to their network of friends, family, and colleagues. In 1994, they commissioned Simpson, who made *III* (1994), a redwood box with the Roman numeral III engraved on top. Inside are three small wishbones of rubber, ceramic, and bronze, encased in a thick piece of felt. And all made in an edition of five thousand. The Norton Family Christmas cards were legendary in offering up an innovative way to draw meaningful connections between artists, art, and their publics. Over the course of several years, artists such as Kara Walker, May Sun, and Pae White were asked to create commissioned works specifically for the project. The cards represent a relic for the ways in which Eileen and Peter's collection practice was embedded into their daily lives, through their relationships with artists and the way the art lived among them and their children, Diana and Michael.

One of the children's favorite pieces was Liza Lou's full-scale, papier-mâché, immersive *Kitchen* (1991-96), an installation housed in the basement of their home. The work captures tensions in materiality, providing illusions of the *real* and the *ready-made* that might be imbued with a range of concepts that extend beyond what it represents—a product of imagination, trickery, and reverence. The presence of Lou's installation emboldens the power of encountering conceptual art in the everyday. Lou's installation celebrated lineages of labor in the domestic domain that were often relegated to women. In the very making of *Kitchen*, which took more than five years, Lou monumentalized the work of domestic labor, which is often minimized, invisibilized, and underappreciated. When I consider Eileen's collecting practice in relation to domesticity, artwork often feels intrinsic to the ways she *makes home*. Eileen *lives* with her artworks, not merely among them. In her Santa Monica home, Tanya Aguiñiga's *Felt Chairs* (2012) are unpreciously settled in a bedroom, Alison Saar's *Congolene Resistance* (2020) greets visitors in the hallway, and Kara Walker's prints gaze over the dining-room table over intimate meals.

Collecting as Communion

In *Untitled*, a diptych by Lorna Simpson (1997), a group of influential scholars, curators, and museum leaders—including (from left) Connie Wolf, Susan Cahan, Mary Jane Jacob, Andrea Miller-Keller, Nancy Spector, Lynn Zelevansky, Susanne Ghez, Kellie Jones, Amada Cruz,

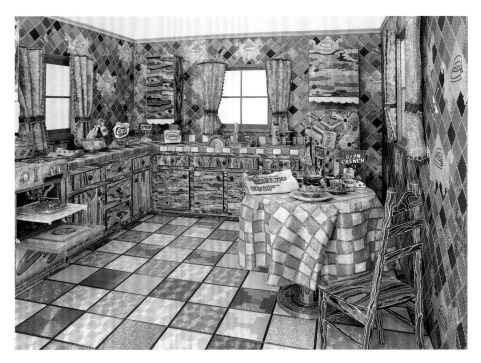

Liza Lou, *Kitchen*, 1991–96. Beads, plaster, wood, and found objects; 96 × 132 × 168 in.
Whitney Museum of American Art, New York, gift of Peter Norton, 2008.339a-x.

Thelma Golden, Sheryl Conkleton, and John Hanhardt—stand around Eileen Harris Norton and Peter Norton. One view portrays the front of members in the group, while the other image (in classic Simpson style), shows them with their backs toward the viewer—a playful refusal. The markings of these images capture a pivotal moment in contemporary art history, when many of the subjects in these photos, who are now art world leaders, were establishing their careers. And many of these individuals either had already or would go on to organize exhibitions and publish scholarship that pushed an art world forward beyond traditional confines of the hegemonic status quo. The Nortons had facilitated a trip with these curators to the Second Johannesburg Biennale in 1997, curated by the late Okwui Enwezor. For a contemporary curator like myself—who has benefited from and studied the rigorous work of the curators featured in the image—the energy within and outside the frame is palpable with play, wonder, whimsy, rigor, and intellect. Joy emanates from the document.

By 1997, Nelson Mandela had been carrying out the unthinkable for three years, serving as president of South Africa, a country that had kept him imprisoned for decades under Apartheid. Enwezor's work as a scholar and curator was fiercely defined by his desire to create a contemporary arts discourse in the wake of African independence from colonial empires—Enwezor had liberated the actual form of the biennale to *not* include pavilions but rather an amalgam of presentations and ideas. Insurgency, freedom, counter-hegemonies are what emboldened this era. And thus, Eileen's collecting was shaped by this environment, one that was so keen to amplify the margins. In turn, she supported young arts leaders who were contributing bold and thought-provoking scholarship that has ultimately anticipated the arts ecosystem of today, one that is more reflective of the actual world. Eileen has continued to instigate communion around visual art through Art + Practice, co-founded with artist Mark Bradford and activist

Allan DiCastro. A+P supports the local needs of transition-age foster youth and children experiencing displacement worldwide through its collaborations with nonprofit social service providers. A+P, situated in the historically Black Leimert Park neighborhood of South LA, also provides Angelenos with free access to contemporary art.

Inspired by Eileen's philanthropy and her conceptual art interests—that concern family, environment and access to education—four main themes have guided my organization of this volume.[26] The first is borderlands, exile, and the makings of home. Artists like Doris Salcedo, Mona Hatoum, and Shirin Neshat help us contend with how we might define refuge and the precarities that can persist around it. Gelare Khoshgozaran expounds upon "the language of home," writing of the tensions between distant dialogue among generations bifurcated by exile and borderlands, and offering an analysis of Mona Hatoum's work in the Eileen Harris Norton Collection that gestures to and from intimate and interior objects. Extending on these notions of exile and nation-states are artists whose subject matters are intentionally obscured in public spheres and whose experiences inform a sociopolitical consciousness. These themes are indelibly present in the work of Ana Mendieta, Belkis Ayón, Marta María Pérez Bravo, and Aimée García. I think about the ways in which certain artists speak back and intertwine with one another in scope and concepts. For instance, the Cuban artist García and LA-based Samira Yamin both critique state-led propaganda exhausted through media outlets to perpetuate imperialism and oppression.

26 Eileen's work as a philanthropist continues to grow in the initiatives offered through the Eileen Harris Norton Foundation. The primary focus of the foundation is to support families and youth, environmental justice, and education initiatives, with an emphasis on the arts. Eileen Harris Norton Foundation, https://ehnfound.org.

A second theme that continued to emerge in my review of the collection was that of rememory, somatic and spiritual, as notably rendered in works by Ayón, Lezley Saar, and Pat Ward Williams, whose work on the cover of this volume, *Loa* (1986-94), invokes a history of African ancestral spiritual traditions. Likewise, the art historian Genevieve Hyacinthe brilliantly employs Adrian Piper's *Food for the Spirit* (1971) to remark on philosophy and the psycho-spiritual. As she writes in her essay, "Women of color are creating artforms across media emanating the free spirit of transcendental beingness"—a statement true of the transnational collection of work by women artists in Eileen's holdings.

A third factor that was pervasive in my thinking around this book is the material reality of environmental ruin. As we descend deeper into global warming and the effects that globalization has had on the landscape, I consider the prophetic and monumental works of Maya Lin, Julie Mehretu, and Wangechi Mutu. I sought to engage a scholar who is writing into ecological discourse, the absence of and disregard for marginalized people who have not been considered in the institutional disciplines related to fauna and flora (Indigenous, women, Black). Chelsea Frazier is doing this courageous work and has specifically used the work of Wangechi Mutu to further her efforts in naming a Black feminist ecological discourse.

Fourth, and finally, I want to contend with the complexities of gender at this moment, given that this volume is celebrating creative contributions by women artists. I questioned how I could go about editing a book centered on women artists to look back on offerings such as Linda Nochlin's germane 1971 essay "Why Have There Been No Great Women Artists?" and Connie Butler's groundbreaking exhibition *WACK! Art and the Feminist Revolution*; Patricia Hill-Collins's scholarship on intersecting oppressions experienced by women of color; bell hooks's *Art on My Mind*; and Audre Lorde's lucid poesis, while also orienting toward a horizon at the present and on the cusp of futurity to look through a lens of nonbinary Black feminism. It was this declaration by the writers Johanna Burton and Tourmaline that guided my thinking around this

question of gender with regard to this book: "In nonbinary thinking, conclusions themselves are a moot point, though this hardly means reverting to relativism."[27]

To this end, I hope *All These Liberations* feels fleshy, agile, and porous, to leave room for nondefinitive reflections, especially with regard to identities and how we might define ourselves. To follow Eileen's collecting style, the book features essays by some of the most innovative thinkers of contemporary art. Both Sarah Elizabeth Lewis and Legacy Russell speak to femme gender in historical and future ways, respectively. Lewis offers a look back on the 1920 suffrage movement, which coincided with Christovale's 2020 exhibition of Eileen's collection at A+P. In the essay, Lewis charts the erasure and impact of Black suffragists to the movement, and how that history could be used as a device for viewing Eileen's collection. Likewise, Russell examines art works as they relate to self-making in a nation that has perpetually undermined the humanity and humanness of Black women. In "Variations in Womxnhood," Russell reveals how "Black women—and, in radical intersection and exchange, women of color more broadly, in a cooperative struggle for new freedoms—experiment, discover, and territorialize through the delineation of a 'remodeled' self-image," and how self-imaging for femme subjects may (at its best) continue to be amorphous and ever-changing.

27 Reina Gossett, Eric A. Stanley, and Johanna Burton, *Trap Door: Trans Cultural Production and the Politics of Visibility* (Cambridge, MA: MIT Press, 2022), introduction.

Also in this volume, the art historian Steven Nelson offers a closer glimpse into the first work of Ruth Waddy that Eileen purchased, *The Exhorters* (1976), and the life of the under-celebrated artist, advocate, and world-builder. Nelson writes about Waddy as an influential interlocutor in California, Chicago, the United States writ large, and even as a diplomat in Russia, in an effort to create, sustain, and represent Black creative ecosystems throughout the world. The interviews in this book include a dialogue between Eileen and Thelma Golden, director of the Studio Museum in Harlem, and a roundtable discussion between myself, Susan Cahan, Kris Kuramitsu, Kellie Jones, and Lowery Stokes Sims. Both ground readers in the recent history of the art world and the museological shifts that Eileen contributed to over time.

In the epigraph to this essay, I reference a poem by Audre Lorde that observes the hierarchies of liberation. And how women of color, namely Black women, are relied upon to aid in the freedom-making of others who hold more privilege. The poem captures an overarching theme of women artists in Eileen's collection who insist on a specific sovereignty, despite this reality. The interwoven web of femme difference and its complex beauty is embodied and represented in the works by women artists in the Eileen Harris Norton Collection. They exemplify the many ways art can be a compass in expressing taboos, offering up urgent critique, and documenting histories that are often marginalized or erased. Eileen's collection is an expansive record of women's work that truly reflects a global collective consciousness around femme conditions in the contemporary.

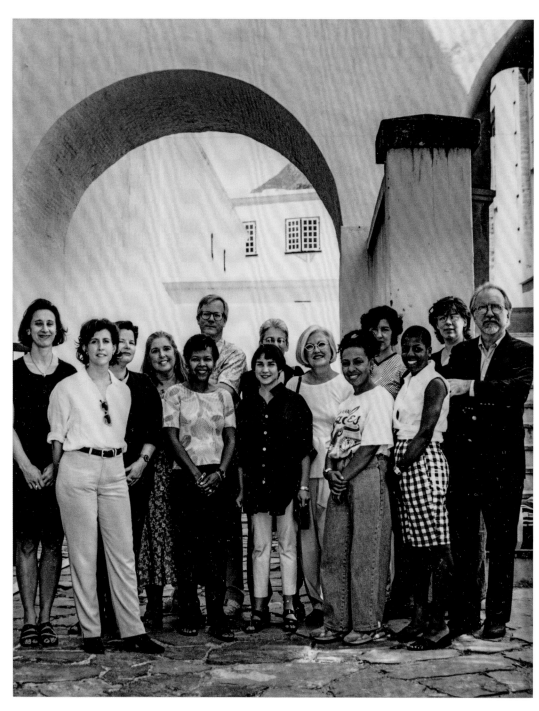

Lorna Simpson, *Untitled (Curator trip to Johannesburg Biennial)*, 1997. Two
gelatin silver prints in double-sided frame; 11¾ × 9½ in.

Eileen Harris Norton's Collective Constellation: Art and Rights at the Centennial of Women's Suffrage

Sarah Elizabeth Lewis

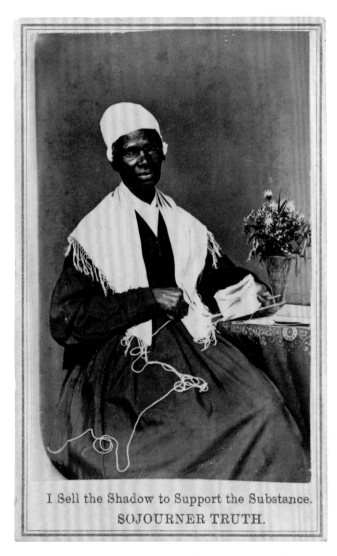

Sojourner Truth, "I Sell the Shadow to Support the Substance," 1864. Albumen silver print from glass negative; image: 3⅜ × 2⅛ in. Metropolitan Museum of Art, New York, Purchase, Alfred Stieglitz Society Gifts, 2013.54.

The landmark exhibition that inspired this book, *Collective Constellation: Selections from the Eileen Harris Norton Collection* at Art + Practice (2020) curated by Erin Christovale, was timed to coincide with the centenary of women's suffrage. It was a project of both commemoration and reorientation with a rare organizational configuration. As Eileen Harris Norton noted, "All the works included in the exhibition are by women of color from different backgrounds, the curator is a Black woman, and me, the collector, is a Black woman. In the museum world, institutions don't typically entertain an arrangement like this."[1]

Harris Norton's comment on the exhibition underscores a central feature of the legacy of Black suffragists—looking became shared, and often contested, work. Even after the passage of the Nineteenth Amendment, women of color were denied the right to vote. Full enfranchisement for Black Americans would come nearly fifty years later, with the passage of the Voting Rights Act of 1965 and a new campaign for suffrage led by Black women. As the historian Rosalyn Terborg-Penn notes: "Within a few years, white supremacy was victorious throughout the South. Unlike Black men, who had been disenfranchised within twenty years after the ratification of the Fifteenth Amendment, Black women had lost the vote in less than a decade."[2] What has been less understood in the midst of this history is how the belated suffrage for Black women and women of color made artistic practices tools for advocacy, self-authorship, and societal assertion.

Can suffrage become a lens to examine the practices of women artists of African descent? Discussions around women's suffrage and the arts tend to focus on the role of artistic practices in service of the movement. One example is *Votes for Women: A Portrait of Persistence* at the Smithsonian National Portrait Gallery (2019-20). This was not only the first major exhibition in the United States to address the role played by visual and material culture—from flags and posters to banners and printed ephemera—and, specifically, portraiture, in the fight for women's rights. *Votes for Women* was also an acknowledgment of the ongoing work required to honor this history's nuance and complexity.

1 Interview with Eileen Harris Norton, *Frieze*, February 17, 2020, https://www.frieze.com/article/women-artists-ive-met-over-years-and-collected-are-so-extraordinary-they-should-be.

2 Brent Staples, "How the Suffrage Movement Betrayed Black Women," *New York Times*, July 28, 2018, https://www.nytimes.com/2018/07/28/opinion/sunday/suffrage-movement-racism-black-women.html; and Rosalyn Terborg-Penn, *African American Women in the Struggle for the Vote, 1850-1920* (Bloomington: Indiana University Press, 1998), 156. Also see Martha Jones, *Vanguard: How Black Women Broke Barriers, Won the Vote, and Insisted on Equality for All* (New York: Basic Books, 2020).

At a time when the work of leading Black suffragists was often unwelcome, Black women crafted and mobilized images that became critical documents for insisting on racial equity and agency. The women's suffrage movement coincided with the use of images to support narratives about who counts and who belongs in society. In the mid-nineteenth century, the use, circulation, and creation of images determined intimacies, aspirations, and social boundaries. By the turn of the twentieth century, photographs were decidedly civic forms of currency. Sojourner Truth's sophisticated use of the medium to control and disseminate her own image is a well-known example of how women have used photography as a political weapon. Yet a broad, understudied history of photographic agency by generations of Black suffragists uncovers invaluable documents that attest to their thwarted and central roles in the collective history of women's rights.[3]

As the right to vote was contested for Black women even after the Nineteenth Amendment, the advocacy of rights and equality was inextricably connected to the power of the arts, particularly photography. With precious little scholarship about many women of color in the suffrage movement, the few images of Black suffragists provide invaluable conduits to the past. Leaders such as Nannie Helen Burroughs, Ida B. Wells-Barnett, Sarah Parker Redmond, and Mary Church Terrell knew, as did Frederick Douglass—a supporter of women's rights who understood the power of photography—that representational democracy is secured not only by laws and norms, but also by narratives fashioned by the power of regard and visual representation itself.[4]

In this context, it is hard to overstate the significance that the first work to have entered Harris Norton's collection was by artist and arts advocate Ruth Waddy. Waddy was also the first artist Harris Norton had ever seen in person. They met in 1976 during Black History Month, as Waddy sat making woodblock prints at the Museum of African American Art in Los Angeles. Waddy's quiet command had an impact, as did the fact that no one was paying attention to her. Harris Norton's mother encouraged her to speak to the artist and buy a few prints. Waddy's principles inspired her, providing a model that is key to understanding the weight, scope, criticality, and intentionality behind her collection of women artists of color.

What permeates Harris Norton's collection is a commitment to what animated Waddy's work as an artist and arts advocate: the understanding of how art shapes the critical imagination and impacts social movements and civic society.[5] Waddy was an activist, organizer, editor, and artist during her postwar career in California, creating the earliest professional associations for Black artists and volumes on African American art.[6] One round-trip bus ticket spawned visits to dozens of states, where Waddy gathered works for her publication *Prints by American Negro Artists* (1965).[7] With Samella Lewis, also represented in Harris Norton's collection, Waddy co-edited the two-volume series *Black Artists on Art* (1969 and 1971). These volumes exemplify the dual labor that challenges the work to support art from within the African diaspora—one is often simultaneously researching and writing while crafting the archive itself. Waddy modeled these two developments in the history of art by artists of African descent: honoring how art becomes an expression of the right to craft a life, as well as embarking on the crucial work of documenting, collecting, and historicizing this act by Black collectors and institutions.

3 See Sarah Elizabeth Lewis, "For Black Suffragists, the Lens Was a Mighty Sword," *New York Times*, August 12, 2020, https://www .nytimes.com/2020/08/12/arts /19th-amendment-black-womens -suffrage-photos.html.

4 Lewis, "For Black Suffragists."

5 Waddy defines her work as focused, ultimately, on the "civic and social." See Ruth G. Waddy, "African American Artists of Los Angeles: Ruth G. Waddy," interview by Karen Anne Mason on July 27, 1991, in San Francisco (Los Angeles: Oral History Program, University of California, Los Angeles, 1993), 53. Also see Andrea Gyorody, "Ruth Waddy," in *Now Dig This! Art in Black Los Angeles, 1960–1980*, digital archive (Los Angeles: Hammer Museum, 2016), https://hammer.ucla.edu /now-dig-this/artists/ruth-waddy.

6 Samella Lewis, "Ruth Waddy, a California Signature," *The International Review of African American Art* 9, no. 4 (Summer 1991): 50–52, 56–61; and Samella S. Lewis and Ruth G. Waddy, *Black Artists on Art*, vol. 1 (Los Angeles: Contemporary Crafts Publishers, 1969).

7 This book of prints was inspired by the volume edited by Margaret T. Burroughs, who founded the DuSable Museum of African American History in Chicago. In 1980, Waddy donated these prints to the DuSable Museum. See Lewis, "Ruth Waddy, a California Signature," 56, 57.

Kianja Strobert, Installation view of *Marathon (II)*, *Big Blue*, and *Hurtle*, 2012.
Colored sand, mixed media on paper, concrete, acrylic, brass hook, and twine;
dimensions variable.

What are equivalents in the arts to voting? They are exemplified in the very acts that Waddy and Harris Norton have made the work of their lives: writing, collecting, organizing, and exhibiting. They considered how Black artists and artists of color have been represented, counted, and assessed in the art world and for the arena of history.

Waddy's ambitions, she revealed in hindsight, were decidedly political, inspired by a desire to be part of the long history of suffrage as she went about organizing Black artists and collecting their work. Waddy was born in 1909, just before the Harlem Renaissance debates about the role of art as a form of propaganda to push back against stereotypes. When leaders including Alain Locke, W. E. B. Du Bois, and Langston Hughes engaged in critical questions about how art would or should contribute to American civic society, they inaugurated and elucidated the political inflection of any practice of exhibiting, collecting, and displaying art made by those of African descent. Waddy's work extended this inquiry. "The artists thought I was an artist, because they couldn't conceive of a person, just a lay person, being that interested," she explained in an interview at the end of her long life. "Of course, I didn't tell them that my ultimate aim was civic and social. I didn't mention that to them."[8]

8 Waddy interview, transcript, 53.

I first came to understand the relationship between the arts and women's rights alongside Kianja Strobert, an artist whose work is in Harris Norton's collection. We took art classes in the same room at an all-girls school with a legacy that had not been the education of many young Black women like ourselves. In hindsight, most of what I learned came from my study of the arts in rooms where Strobert insisted upon the validity of her imagination, her vision, her sense of what should be possible on the page, in the round, and through the objects at her disposal.

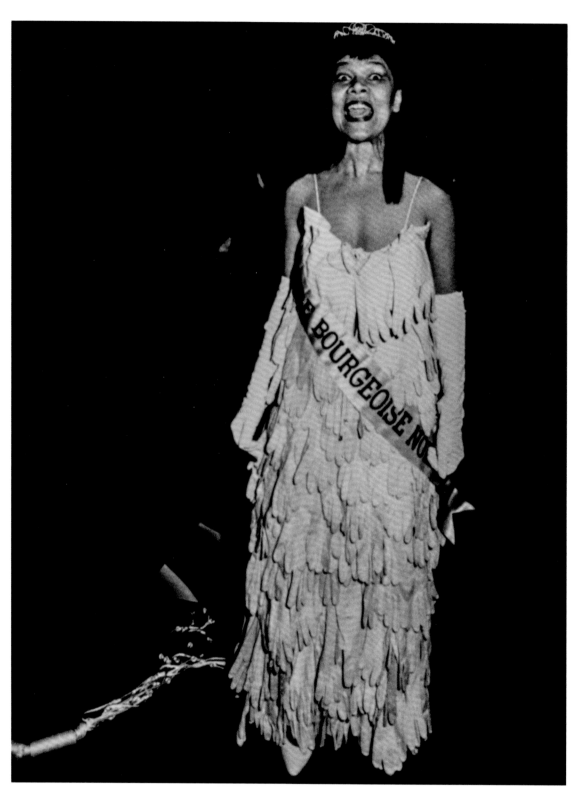

Lorraine O'Grady, *Mlle Bourgeoise Noire Goes to the New Museum*, 1981.
Cibachrome; 40 × 30 in.

In art class, the rest of us created works. She created worlds. Strobert's 2012 pieces in Harris Norton's collection, *Marathon (II)*, *Big Blue*, and *Hurtle*, were shown as an installation in a corner of the *Collective Constellation* exhibition. There, blue sand in a triangular shape was placed diagonally across from a rock painting with black at one corner, bound with twine to a wall. This was surmounted by an expressionist painting of a swirl of blues, reds, and white hatches of color centralizing one black, outlined eye. There was no identifying mark to this facial form. Instead, it seemed to fashion an environment for itself out of the color field around it, suggesting a Beauford Delaney-esque merger of figure, environment, and emotive tone registered in hue, value, and chromatic scale. Together, the works offer a world lived in and crafted, both constrained and utterly unbound.

Harris Norton began collecting works by artists such as Lorraine O'Grady, Carrie Mae Weems, and Alison, Lezley, and Betye Saar, among many others, well before their entrance not only into museums but other private collections, as Thelma Golden mentions in the interview in this volume. O'Grady had a "strong sense that the art world she aspired to was only beginning to come into formation," as the critic Aruna d'Souza has argued the artist believed.[9] It took decades for the art world to embrace and develop the audience that O'Grady hoped would exist. During that time, O'Grady used the trappings of gendered societal traditions in order to disrupt them. In her work *Mlle Bourgeoise Noire Goes to the New Museum* (1981), there are two sets of black and white photographs depicting her performance at the downtown museum opening following one she had staged at Just Above Midtown (JAM) the previous year. O'Grady arrived dressed in a glittering tiara, white elbow-length gloves, and a spaghetti-strap dress made from white gloves, draped in a sash proclaiming this persona "Mlle Bourgeoise Noire" (Miss Black Middle Class). Her fanciful costume belies the courageous and bold urging that she bellowed at the end of her performance. She recited her poem that begins with the admonishment "WAIT / Wait in your alternate / alternate spaces spitted on fish hooks of hope / be polite wait to be discovered ... stay in your place," and ended with the guerrilla cry, "THAT'S ENOUGH don't you know sleeping beauty needs / more than a kiss to awake / now is the time for an INVASION."[10]

Artists in Harris Norton's collection engage in a form of world-making, anticipating the future that would be ready for them, what Saidiya Hartman might consider "another arrangement of the possible."[11] Her collection is anticipatory. It represents the work of artists who invented a world that would be ready for them. It is a compendium of how aesthetics are deployed to foresee embodied rights. The artistic practices heralded within these pages marshal aesthetics to usher the unknown, unheralded, and unseen into being. Yet the term collecting is too narrow to describe what Harris Norton has done for the art world and beyond. With a focus on African American, Southern Californian, and women artists in a global context, she is an advocate for a new, capacious narration. The Eileen Harris Norton Collection is an accessible archive of a should-be history of the arts.

9 Aruna d'Souza in Lorraine O'Grady, *Writing in Space, 1973–2019* (Durham, NC: Duke University Press, 2020), xxiii.

10 Lorraine O'Grady's poem for this New Museum performance followed her first one at Just Above Midtown/Downtown on June 5, 1980. The poems read at the events differ. See O'Grady, *Writing in Space*, 8–10, 291f4.

11 Saidiya Hartman, *Wayward Lives, Beautiful Experiments: Intimate Histories of Riotous Black Girls, Troublesome Women, and Queer Radicals* (New York: W. W. Norton, 2019), 302.

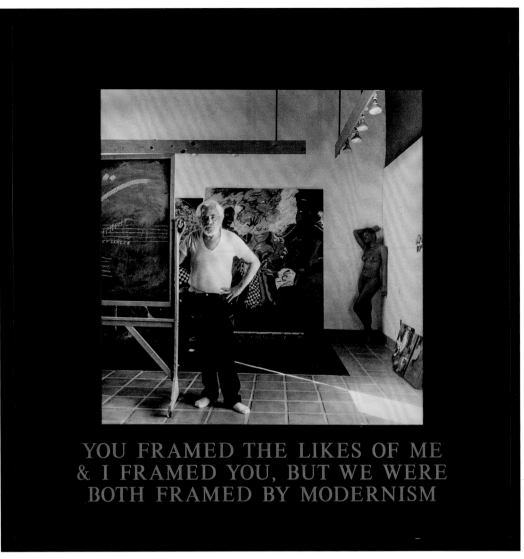

Carrie Mae Weems, *Framed by Modernism (Seduced By One Another, Yet Bound by Certain Social Conventions; You Framed The Likes of Me & I Framed You, But We Were Both Framed By Modernism; & Even Though We Knew Better, We Continued That Time Honored Tradition of The Artist & His Model)*, 1997. Three silver prints with text etched in glass; each: 31¼ × 31¼ in. Edition 1/5.

KNEW BETTER
TIME HONORED
TIST & HIS MODEL

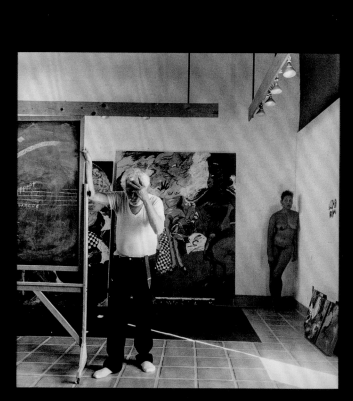

SEDUCED BY ONE ANOTHER,
YET BOUND BY CERTAIN
SOCIAL CONVENTIONS

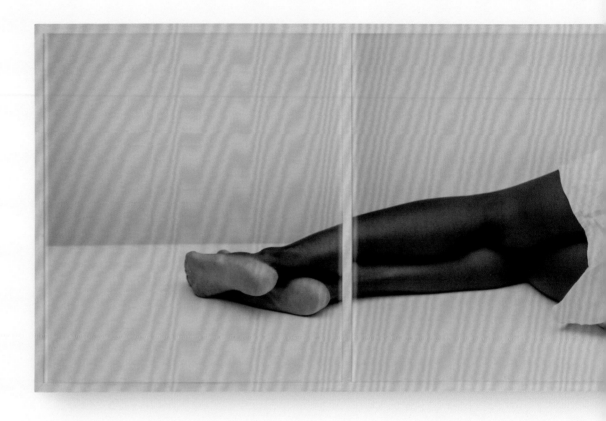

PHYSICAL EXAM

BLOOD TEST

HEART

REFLEXES

CHEST X-RAY

ABDOMEN

ELECTROCARDIOGRAM

URINE

LUNG CAPACITY

EYES

EARS

HEIGHT

WEIGHT

Lorna Simpson, *You're Fine*, 1988. Four dye diffusion color Polaroid prints,
fifteen engraved plastic plaques, ceramic letters; overall: 39 × 108⅛ × 1⅝ in.

FINE

SECRETARIAL POSITION

HIRED

Ruth Waddy's Social Subjects

Steven Nelson

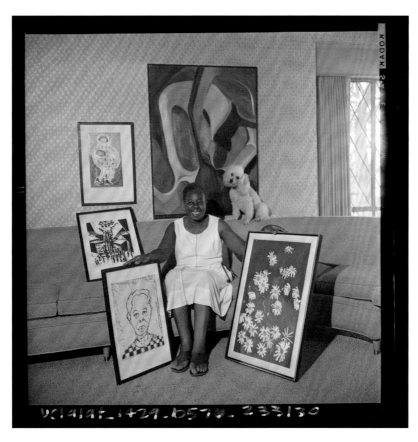

Artist Ruth G. Waddy with some of her work, Los Angeles, California, 1966.

In 1966, Ruth G. Waddy (1909-2003) did a photoshoot with *Los Angeles Times* photojournalist John Malmin. Seated on her living room sofa, she posed with some of her works and her dog, Cliquot. The resulting photograph accompanied *Times* reporter Art Seidenbaum's story of Waddy's trip to the Soviet Union planned for July of that year. He marveled at her selection by Margaret Burroughs to take the journey.[1]

Waddy and Seidenbaum already knew each another. A couple of years earlier, she had taken him on a tour of Los Angeles's Black art scene, showing him that his 1963 comment—that not many African Americans were working in the visual arts in the city—was wrong.[2] Though Seidenbaum greatly admired Waddy in her role as a community organizer and as an unexpected diplomat, he made little of her artwork.[3] However, Malmin saw things differently. Not casting out Waddy's role as a mover and shaker in the field of Black art in Los Angeles, the photojournalist depicts her as a woman who has comfortably— and happily—assumed the role of artist.

1 Art Seidenbaum, "One Woman's Mission to Moscow," *Los Angeles Times*, July 9, 1966, B1.

2 Art Seidenbaum, "A Rising Color in Artist Spectrum," *Los Angeles Times*, July 1, 1964, C1.

3 Seidenbaum, "A Rising Color," C1.

4 Paul Von Blum, "Ulysses Jenkins: A Griot for the Electronic Age," *The Journal of Pan African Studies* 3, no. 2 (September 2009): 144.

Despite a body of work that stretches from the early 1960s into at least the 1980s, it is fair to say that Waddy is best known for her tireless advocacy for African American art and artists in Los Angeles and beyond. From founding the organization Art West Associated in 1962 and serving as its first president, to traveling through the United States by bus in 1964 to collect prints from African American artists for her 1965 book *Prints by American Negro Artists*, to her collaboration with artist and art historian Samella Lewis that resulted in the groundbreaking volumes *Black Artists on Art* in 1969 and 1971, Waddy was instrumental in bringing together African American artists, increasing their visibility, and expanding opportunities for them. She was considered a driving force on the scene, leading scholar Paul Von Blum to call her "the matriarch of African American art in Los Angeles."[4] Malmin's photograph invites an examination of Waddy's oeuvre, a mix of abstract and representational images that reveals her complex views of Black experience, politics, and diasporic history, as well as her concern with the deterioration of African American communities at the hands of a capitalist system build on a foundation of white supremacy. "I was 53 years old when I entered the art world,"

Waddy told an interviewer in 1983.[5] This turn was in the midst of her work with African American artists through Art West Associated. She knew little about artmaking at the time. Indeed, her intent was to raise awareness and appreciation of Los Angeles's many Black artists. She claimed that they embarrassed her into becoming an artist, leading her to enroll in the Famous Artist Schools' correspondence course. By the following year, Waddy was painting and showing her work in local exhibitions, including the 1963 Los Angeles All-City Outdoor Art Festival held in Barnsdall Park. In early 1964, she received honorable mention in the first annual Negro History Calendar Art Competition for her oil portraits of African American entertainer Bert Williams and African American jockey Jimmy Winkfield. If Waddy had been a reluctant artist at the beginning, one would never have known it based on the fervor with which she worked and exhibited.

In addition to her correspondence courses and exposure to Los Angeles-based artists, Waddy's work on *Prints by American Negro Artists* provided an extraordinary opportunity to learn about printmaking. Traveling around the country by bus, she visited more than fifty artists' studios, amassing an impressive collection of prints for the publication. No doubt the dozens of woodcuts, linocuts, serigraphs, etchings, metal prints, lithographs, and monoprints she accumulated served as models for study and experimentation. Waddy further supplemented the things she learned in artists' studios and her correspondence courses with offerings at Los Angeles City College and Otis Art Institute. She also gained exposure to the Tamarind Lithography Workshop. Founded by artist June Wayne in Hollywood in 1960, the workshop revived stone and metal-plate printing, spurring a renaissance in the graphic arts in the United States. Waddy also familiarized herself with the work and pedagogy of Corita Kent, whose 1960s serigraphs connected spirituality to politics and consumer culture through a pop sensibility. In addition to learning the nuts and bolts of artmaking in different mediums, Waddy saw the gamut of aesthetic possibilities available to her.

The political and social setting that led to Waddy's advocacy and organizing also served as inspiration for her visual practices. Whether abstract or representational, whether portrait or still life, whether direct commentary on the political and social situations in front of her or indirect meditation, Waddy's oeuvre took its cues from the state of Black life in the United States.[6] In 1969, she wrote of her work, "Occasionally I find a subject to paint or print that is color, whimsey, joy, not happiness. I feel that happiness is a cultivated, social condition [that] may forego joy that is visited upon the simple (uncompounded, without subtlety) minded. However, more often than not, my subjects are social evoking, I hope, an emotional reaction from the viewer."[7] At times, her social subjects meditate upon the position of African Americans in a dramatically shifting society that was leaving many of them in the dust; at others, they revel in bucolic moments of quotidian life.

For Waddy, the capacity of art to evoke emotion gives it social currency in a similar fashion to the effects of religion. Both, in her mind, are spiritual in nature. Like religion, art, in her words, "inspires one. It lends you courage. It makes a pleasant atmosphere. . . . It makes you think."[8] In Waddy's framework, the social work of art, the thinking that it induces, provides a vehicle not only for a pleasant atmosphere and positive emotions, but also for fundamental societal transformation. Waddy's definition was far-reaching, encompassing the full range of her work. There were the pleasant moments brought forth by her paintings of daisies and pastoral scenes as well as her portraits of famous African Americans. There were the pleasant feelings produced by her linocuts depicting pomegranates in a bowl or the artist herself.

5 "Ruth Waddy: Late-Blooming, Talented Artist," *Los Angeles Sentinel*, April 14, 1983, 11.

6 Samella S. Lewis and Ruth G. Waddy, *Black Artists on Art*, 2 vols. (Los Angeles: Contemporary Crafts Publishers, 1969-71), 2: viii.

7 Lewis and Waddy, *Black Artists on Art*, 1:116.

8 Ruth G. Waddy, "African American Artists of Los Angeles: Ruth G. Waddy," interview by Karen Anne Mason on July 27, 1991, in San Francisco (Los Angeles: Oral History Program, University of California, Los Angeles, 1993), 53.

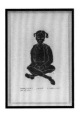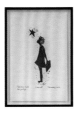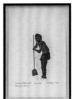

Ruth Waddy, *The Children*, 1973. Six reproductions of linocut prints; each: 20¼ × 14¼ in.

Waddy's images of children, a primary focus in her oeuvre, elicit the full range of emotive responses she sought to arouse. In 1973, Waddy produced a series of seven linocuts called *The Children*. Based on the nursery rhyme "Monday's Child," the artist paired each of the seven girls depicted with a day of the week. She also created a sampler that features the seven children together (see page 136). The rhyme reads:

> *Monday's child is fair of face*
> *Tuesday's child is full of grace*
> *Wednesday's child is full of woe*
> *Thursday's child has far to go,*
> *Friday's child is loving and giving,*
> *Saturday's child must work for a living,*
> *And the child that is born on the Sabbath day*
> *Is bonny and blithe, and good and gay.*

First printed in the 1830s, this nursery rhyme was aimed at helping children remember the days of the week while also identifying a child's character based on their day of birth. Over the years, the rhyme has been reproduced with illustrations of children countless times; by the 1970s, however, it appears that few, if any, of these samplers, handkerchiefs, posters, or other objects featured Black children. In Waddy's hands, the rhyme becomes part of African American folklore, recasting the popular text as an intrinsic part of Black life. She also introduced a humorous twist: Wednesday's child is full of woe because her umbrella won't open.

In addition to being a favorite subject—whether graduating from kindergarten, fishing, bathing, or simply being—children fulfill vital functions in Waddy's practice. She calls them "the hope of mankind," for they are open to learning and to change. She also admires their ability to speak plainly and openly.[9] In these ways, children can work as provocations to thought and transcendence.

9 Waddy, "African American Artists of Los Angeles," 103.

As was the case with many of the artists of the Black Arts Movement, Waddy saw Africa as an important piece of African American history. In an untitled linocut from 1968, for example, she incorporates a Fanti Akua'ba fertility doll into a tableau that is less about the continent itself than it is about the construction of a diasporic history capable of uplifting Black Americans. Waddy also considered African liberation struggles in connection to the political state of African Americans. *The Key* (1969), with its armed soldiers, connects African independence to struggles at home. Though Waddy did not ascribe to the romantic ideals of Africa-as-Motherland held closely by the Black Arts Movement and the AfriCOBRA artists, the continent stands as the fulcrum on which she imagined an African American past and its relevance in the present.

Ruth Waddy, *Self-Portrait*, 1966. Linocut print; 23 × 19¾ in.

Ruth Waddy, *Untitled #1*, Series B, 1968. Linocut; 21 × 25 in.
Edition 4/12. Museum of Nebraska Art, Purchase made possible
by Marilyn F. Belschner Arts Endowment Fund, Accession No:
2019.18.01.

Although Waddy foregrounds the connection of the artwork with the viewer and the emotional and psychological work she wishes her content to do, it is line and color as well as printing and paper that serve as the vehicles to forward her goals. As she honed her skills, she developed an interest in the play of volume. In linocuts *Matter of Opinion* (c. 1965), included in *Prints by American Negro Artists*, and *Self-Portrait* (1966), Waddy surprisingly juxtaposes flatness with modeling. A group of columns crisscrossed by a giant X rises from a bright orange background in *Matter of Opinion*. Though the viewer first experiences the energy produced by the juxtaposition of the color and the off-white paper, upon closer examination, they become witness to the artist's formal experimentation. Waddy rendered some of the columns—as well as the X—as flat shapes, cleanly gouging the linoleum with a reasonably wide gouge. Two columns, in contrast, have volume. Each represents a different opinion, and each clashes with another. *Matter of Opinion* is less about the unreliability of speech than it is about the unreliability of the messenger.

Self-Portrait engages in a similar play between flatness and volume. Waddy renders her head and its features in a straightforward fashion. She gives her hair, face, neck, and body volume. These contrast sharply with her patterned, albeit flat, blouse, which according to the artist gives a foundation to the work.[10] However, the blouse exceeds the contours of the artist's body, which suggests that while Waddy was interested in the materiality of her body and how she could form it through the linocut, she was also interested in the form of the linocut itself.

Matter of Opinion, with its concern with the disconnection of speech from fact, resonates with *The Exhorters*, a linocut Waddy first produced in 1969. In this scene, the artist depicts a group of men, arms raised, all speaking at once. The lone woman in the work, perhaps a stand-in for Waddy herself, is silent. In this version, she overprinted the black figures with red and pink inks, giving the scene further dramatic effect. In a 1991 interview, Waddy said of the linocut, "This was during the civil rights days. Everybody was telling everybody else they should do this and they should do that. They should be thus and so. And everyone—each one had a different concept of what should be done."[11] Made in the midst of the rise of Black Nationalism and the Black Arts Movement, *The Exhorters* registers as ambivalence and critique. Here, the pitched arguments about liberation, freedom, and equal rights devolve into noise.

10 Waddy, "African American Artists of Los Angeles," 106.

11 Waddy, "African American Artists of Los Angeles," 105.

12 Manning Marable, *How Capitalism Underdeveloped Black America: Problems in Race, Political Economy, and Society* (1983; Chicago: Haymarket Books, 2015), 94.

Whether bursting forth from Black Nationalists or emanating from mainstream media, Waddy was long concerned with the deleterious effects of misinformation and propaganda, explicitly exploring them in the linocut *Our Children* (1982). Here a child set in front of a television is subject to the ideological brainwashing resulting from a barrage of what we today call "alternative facts." Works such as *Our Children* call to mind the historian Manning Marable's contention that Americans of all colors are subject to the false notion of the United States as a bastion of justice and equal opportunity.[12]

In 1968 and 1969, Waddy produced several versions of the linocut *The Fence*. Printed on newspaper job listings, stock tables, and the like, the black fence and the rubble from which it rises blocks any easy reading of the text below. *Matter of Opinion*'s abstraction seems to be a rehearsal for *The Fence*, in which posts become representational, rising out of what could be construed as a Black community reduced to rubble. Indeed, in blocking access to the newsprint, *The Fence* exists as an allegory of the centuries-long underdevelopment of Black communities under American capitalism. Waddy's print points to the rhetoric of free enterprise and free markets as ideological farce, existing as a visual analogue of Marable's assertion that African

Americans "have been on the other side of one of the most remarkable and rapid accumulations of capital seen anywhere in human history."[13]

In the 1960s and 1970s, in tandem with the civil rights movement and Black Nationalism as well as the steep decline for many African American communities, crime rates exploded and the prison population expanded significantly. By the early 1980s, homicide was the leading cause of death for African Americans between the ages of twenty-five and thirty-four, and the rates of incarceration for Black men began to skyrocket. Waddy's linocut *What Would You Do* (1982) is a meditation on these devastating conditions. Collaging the question "What would you do" in black letters next to the image, Waddy includes the following next to the image of a young black man:

> Just out of jail
> No Job
> No Prospects
> No Education
> No Food
> 1.00 in pocket

Is he addressing us, or is Waddy describing him? The artist has left that for us to decide. In a fashion reminiscent of Adrian Piper's conceptual works, Waddy through direct address implicates the viewer, leaving them uncomfortable and, like the figure in the print, without escape.

To make matters worse, the economic recession of the early 1980s disproportionately affected Brown and Black Americans. In 1982, the Black unemployment rate had shot up to 18.9%, more than twice that of whites.[14] In addition to *Our Children* and *What Would You Do*, Waddy's linocut *Emergency Call* (1982) attends to the devastating conditions of Black communities at that moment. Depicting a small girl who must climb onto a garbage pail to reach a pay phone, the work visualizes Waddy's belief that, unlike adults, children—specifically African American children—have the ingenuity and creativity to solve even the most serious problems.[15] To return to the sampler, no matter what day a child was born on, not blinded by despair, except perhaps in the case of a nonfunctioning umbrella, these innocents represent hope and in Waddy's oeuvre have the potential to transform the world.

It seems that sometime in the 1970s, Waddy turned her attention fully to linocuts, perhaps because of their accessibility. In her essay in *Prints by American Negro Artists*, she stressed that one of the most important things about prints was their availability "to the public for their homes and private collections at modest prices." Given her concern with art's accessibility, making work that could be within reach to those without great financial resources falls squarely in line with her ideas on art's social function. In short: Waddy wanted art to be both conceptually and economically attainable by the broadest possible publics. Such accessibility and affordability led to a young Eileen Harris Norton making two of Waddy's prints her first art purchase in 1976.

Waddy's body of work was dedicated to the evocation of an emotional response capable of bringing together feeling, spirituality, happiness, and clarion calls for social change. Her oeuvre was civic and it was social. If she had a Black aesthetic, it was a capacious one. It could include the abstract and the representational. It could accommodate the joy of children and the pain wrought by racism. It could encompass daisies and deterioration. Waddy's work stands at the intersection of the personal, the spiritual, and the political, insisting on their presence and resting confident in their ability to change Black worlds for the better.

13 Marable, *How Capitalism Underdeveloped Black America*, 1–2.

14 "Unemployment rates by race and ethnicity," US Bureau of Labor Statistics, accessed February 2, 2021, https://www.bls.gov/opub /ted/2011/ted_20111005_data.htm.

15 Waddy, "African American Artists of Los Angeles," 109.

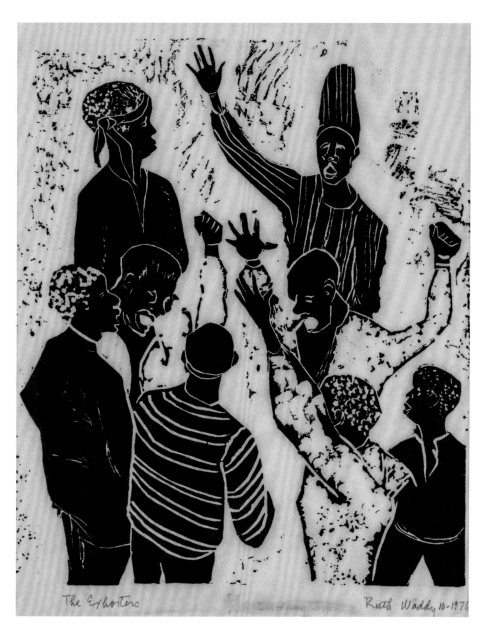

Ruth Waddy, *The Exhorters*, 1976. Linocut print; 21⅛ × 17¼ × 1 in. Edition 8/25.

Ruth Waddy, *The Fence*, 1969. Linocut on newspaper; 16½ × 14 in.

Ruth Waddy, *Emergency Call*, 1982. Linocut print; 25¾ × 15¼ × ¾ in. Edition 5/6.

Ruth Waddy, *What Would You Do*, 1982. Linocut and collaged lettering on Japanese paper under glass; 22 × 18 in.

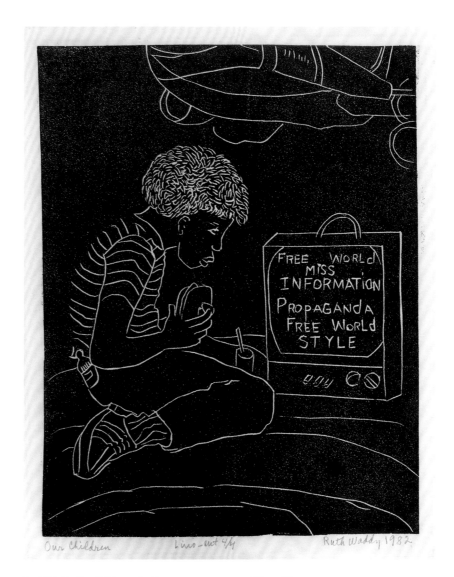

Ruth Waddy, *Our Children*, 1982. Linocut on woven paper; 18¾ × 15¼ in.
Edition 4/4. Museum of Nebraska Art, Museum Purchase made possible by
Marilyn F. Belschner Arts Endowment Fund, Accession No: 2023.06.09.

Shirin Neshat, *Rapture Series*, 1999. Gelatin silver print.

Interview with Thelma Golden

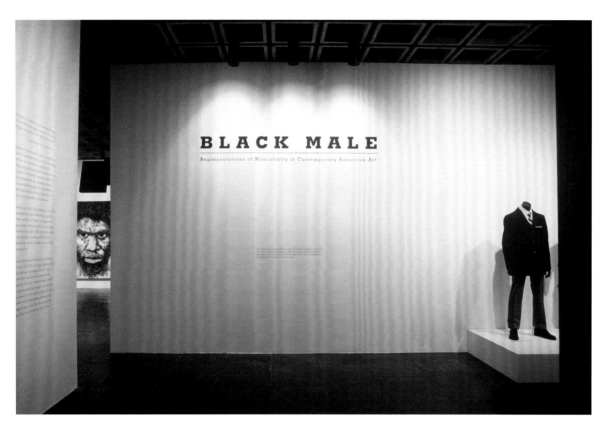

Installation view of title wall in *Black Male: Representations of Masculinity in Contemporary American Art*, at the Whitney Museum of American Art, New York, November 10, 1994–March 5, 1995. Pictured, from left: Robert Arneson, *Special Assistant to the President*, 1989, and Fred Wilson, *Guarded View*, 1991.

Thelma Golden (T.G.): When I first saw your collection on view in *Collective Constellation: Selections from the Eileen Harris Norton Collection* (2020) at Art + Practice—a space that you helped make possible—your impact on the art world became clear. Many people saw that exhibition, and for some it was their first experience at an art space or a museum, which is something at the heart of what you, Allan [DiCastro], and Mark [Bradford] envisioned for Art + Practice. This idea is also in the DNA of the Studio Museum in Harlem, where we think about the importance of having art and art experiences in our city for all. I think this sets the tone for what I'd like to discuss with you today.

You grew up in LA—I'm curious about your first museum experience.

Eileen Harris Norton (E.H.N.): My mother and I often drove to Exposition Park to visit the Los Angeles Museum of History, Science and Art [today the Natural History Museum of Los Angeles County] to see the rose garden—that's all there was, then. And we went to the mission museums when we would take trips and travel through California. Our visits focused on historical art and culture—I came to contemporary art later.

T.G.: Acquiring a work by Ruth Waddy marked the beginning of your collecting. What made you want to own and live with that work of art?

E.H.N.: My mom or I saw an ad in the *Los Angeles Times*. It was Black History Month, and there were going to be artists showing their work at the Museum of African American Art— Samella Lewis and Ruth Waddy—so we went. Waddy was there demonstrating how she made her woodblock prints. We'd never met a living artist. Of course, I had seen art—like Picassos and Monets and all the French Impressionists—but to see a Black woman artist in LA sitting there. . . . We were standing back, but my mom goes, "We've got to go talk to the lady," so we went up and said hello. My mom said, "You've got to buy something." My mom worked at Thrifty and was a working person, and then here was this woman who was older than my mom sitting there making art. We were wowed.

T.G.: Ruth Waddy was an artist and a printmaker who also worked as a curator and an art historian, like so many artists of that moment. The Black artists of her generation could not wait for other people to curate or write about their work, so they did that for themselves and others. Your meeting her seems profound because, as you say, you and your mother saw her as a Black woman artist, and she saw you as Black women appreciating her. This seems to predict one of the ways you are so significant as a collector: your relationship not just to artworks, but to artists. The idea that artists are people with lives and stories and histories. You not only bought the work but you made a commitment to steward it—so many people were introduced to Ruth Waddy's work in your exhibition. Was that the beginning of wanting to understand artists' work through knowing the artist themselves?

E.H.N.: Yes, because that experience has always stayed with me. It stayed with me when I was living in Venice with my former husband Peter Norton around all these artists. I always enjoyed going to the artists' studios more so than to galleries or museums.

T.G.: We met in 1992, before the 1993 Whitney Biennial. You collect many artists who were in that biennial. And then in 1994, I curated the exhibition *Black Male: Representations of Masculinity in Contemporary American Art*—that was the beginning of my career.[1] The exhibition would not have happened without you.

It won't surprise you, but that exhibition, the catalog, and many images of it are resurfacing at this moment. I'm constantly getting tagged [on social media] as people look for art that has continued to talk about the terror acted upon Black men at the hand of the State, but also in culture. Much of that exhibition happened because during the studio visit process, Daniel Joseph Martinez took us in his truck to South LA and I saw many of the places where the uprisings had occurred. In the '93 Biennial, we included the video of the police beating Rodney King, which in many ways predicted this moment of self-created, citizen-created evidence. It was Daniel who took me down to South LA and gave me this understanding, and that is what made me want to curate an exhibition called *Black Male* that asked, "How do we engage?"

Likewise, in those days, your collecting was engaged and focused yet you also supported artists and discovered them before museums bought their work. You met Lorna Simpson and Glenn Ligon in the 1990s, and when I look at the works you have of Lorna's, for example, all her classic 1980s and early 1990s work, you were collecting her as a private collector before anyone else was.

E.H.N.: Yes, and Gary Simmons. In the early 1990s, people would look at us and ask, "Who are you collecting?" And we said, "Lorna Simpson, David Hammons, Daniel Joseph Martinez." They were all like, "What? Who?"

T.G.: Looking back, many of these artists who you just named, and so many more in your collection—Lorraine O'Grady; Carrie Mae Weems; Alison, Lezley, and Betye Saar—are all in museums. But when you started acquiring their work, many were sadly not well known. Your collecting opened up a lot of opportunities for them. For those of us curators interested in their work, not only did The Foundation collect the works, but it gifted many works of art to institutions, and also gave pioneering grants to curators for acquisitions. I acquired the Fred Wilson sculpture *Guarded View* (1991) at the Whitney Museum, after it was presented in *Black Male*, with the curatorial grant I received from you and Peter.

1 The 1993 Whitney Biennial, curated by Thelma Golden, John Handhardt, Lisa Phillips, and Elisabeth Sussman, is considered groundbreaking for its focus on multimedia work that tackled major social and political themes of the day. Controversial at the time, the exhibition is credited, in the words of one contemporary critic, with "breaking the biennial mold and demonstrating that this mainstay of the contemporary art scene can be radically changed." See Roberta Smith, "At the Whitney, a Biennial with a Social Conscience," *New York Times*, March 4, 1993. The following year, Golden curated *Black Male: Representations of Masculinity in Contemporary American Art* (Whitney Museum of American Art, New York, November 10, 1994-March 5, 1995), which broke further ground for its treatment of a subject so often excluded from museums.

E.H.N.: And how many times have I seen that referenced in articles and books?

T.G.: Exactly. The multiplying effect of your collecting was important, but I also think that at the time that you were investing in acquiring artists of color, the art world was beginning to open up to becoming more multicultural. Many curators and art historians were trained between art history and ethnic studies, and many institutions were beginning to embrace the idea of a multicultural United States. As a Black woman and a collector who was so intentional in supporting artists of color, women artists, California artists, local artists, you validated all of those ways of thinking, being, and curating. You've continued to collect emerging artists. What's it like now for you to encounter a new artist's work?

E.H.N.: I am very excited about some of the newest artists in the collection—Amy Sherald, Sadie Barnette, and Sandy Rodriguez. I like supporting artists at the beginning of their careers and watching them grow.

T.G.: In this trajectory, you've collected artists of color, women artists, Black artists, Latinx artists. This particular catalog of women artists that we're discussing follows an exhibition of your collection, co-organized by A+P and the Hammer Museum. Why now?

E.H.N.: Since the founding of A+P, Allan and Mark have always said, "One day, Eileen, we're going to do a show from your collection." The year 2020 seemed like the right moment, and we thought it would be best to talk to the Hammer, since they were the first institutional partner A+P worked with to launch its exhibitions program in 2014. I spoke with Connie Butler, and she said, "Erin Christovale could do it." Erin and I had lunch and I thought, "Wow, she's fabulous, energetic." I adore her. So, that's how it came up. It's the year of the woman; we'll focus on exhibiting women of color in my collection. Erin created the artist exhibition list. I was amazed. She's included some of my favorites in the show.

T.G.: The selections Erin made in *Collective Constellation* are, importantly, intergenerational. She presents artists like Lorraine O'Grady and Betye Saar in relation to artists from multiple generations. She presents Lynette Yiadom-Boakye along with other international artists. In a way, it's a microcosm of your collecting interests in a cohesive, cogent manner. The exhibition—and I'm going to go so far as to say your collection as a whole—proposes that there are shared ideas in all the works. These are all artists with very strong visual voices. In a cross-generational, cross-media dialogue, these artists are saying a lot to each other in their works and in their lives. The viewer sees precedents and antecedents even in the way the works are installed. I feel your commitment to artists whose works speak to us right now and also to our future.

E.H.N.: I love that. People are asking me, "Oh, Eileen, your collection, how did you do that?" I've been collecting a long time. That's the thing. And these artists are all still working.

T.G.: I thought it was beautiful how many of these conversations existed in the exhibition. As I looked again at the catalog of works in your collection, and had the chance to think again, for example, about Lynette's figuration in relation to Samella Lewis's, and also the connections between Lynette's work and Lorraine O'Grady's, who is a conceptual artist, with this idea of the figure as it populates ideas and identity. I was also thinking that this is what inspired you about Saya Woolfalk's work.

E.H.N.: Now that I think about it, there's a similar feel to them—there's texture, there's color, there's layer, there's the figure. It's got it all. I've always liked her work.

T.G.: Another artist that you collect in-depth is Carrie Mae Weems.

E.H.N.: The first pieces we saw of hers were the plates. We saw her photos too. She did two series—the man eating the watermelon and the woman eating the chicken. I like that reference to Black people. It's blunt. It's a stereotype, but to me, how she references those stereotypes is funny. The other series, which is so powerful at this moment we're in, where she's talking about Black history—Medgar Evers and Martin Luther King Jr. What she was talking about twenty years ago—it's here, right now. I can still look at it and say, "Ah, Carrie Mae, you knew."

T.G.: So much of Carrie's work is informed by the genius of her visual eye as a photographer and image maker, and her commitment to her practice as a visual historian. She's documenting the ways we understand culture through stereotypes and archetypes. Was there ever a point when it was important for you to buy works that have images of Black people?

E.H.N.: Absolutely. We wanted to collect works by people of color and have paintings of people of color.

T.G.: Something that Carrie also engages with—where there's such a dialogue between her work and Lorna's work—is a self-defined sense of beauty and notion of Blackness. You also committed early on to Kara Walker. One of Kara's first New York exhibitions was at the Drawing Center.[2] It was a jewel of show, which featured the twenty-five-foot narrative installation *Gone: An Historical Romance of a Civil War as It Occurred b'tween the Dusky Thighs of One Young Negress and Her Heart* (1994), which preceded several works by Kara Walker in your collection, such as *The Means to an End . . . A Shadow Drama in Five Acts* (1995), and *Slavery! Slavery!* (1997).

E.H.N.: Which are fantastic! Those pieces are phenomenal. Like you said, when Kara came on the scene, *she came on the scene*, because the work was so in your face. Again, referencing our history, my history, because my great-grandparents were slaves. The scenes are quite raw, showing anger and hate and just the pain of it all. Nobody was doing what Kara did.

T.G.: She was courageous to confront the visualization of a history that we know was born out of physical, sexual, psychological, and political violence, and the power dynamics that violence shows. You have such an amazing selection of Kara's works. There's the block print, called *African/American* (1998). Kara is such a virtuoso, whether it's in painting, drawing, or cutouts. Now, let's talk about Alma Thomas. This is a relatively recent acquisition.

E.H.N.: It began with that photograph of the Obamas' dining room in the White House. I didn't know Alma Thomas. And then I was talking to Dr. [Leon] Banks about her work and learned that she was his junior high art teacher.[3]

T.G.: Alma Thomas was born in 1891 and was the first fine arts graduate of Howard University in 1924. She taught at Shaw Junior High, where Dr. Banks would have been her student. When she retired at sixty-four, she set up her studio in her kitchen, and that's when she started painting and investing in her art practice. She was the first Black woman to have a show at the Whitney, in 1972; and the first Black woman to have a show at the Corcoran, in 1974.

E.H.N.: I saw that painting and was wowed. And then I knew you were on the committee helping the White House acquire the art.[4] I love my paintings *Untitled* (1968) and *Azaleas in Spring* (1968).

T.G.: I'm glad you own those works because she really is a pioneering artist. I came to know her work through an exhibition at the Studio Museum in 1983 that produced a small brochure

2 *Selections Fall 1994: Installations by Jeff Beall, Brad Brown, Larry Krone, and Kara Walker*, The Drawing Center, New York, September 10-October 22, 1994.

3 Leon Banks, PhD, is a longtime art collector and patron who began to collect in the 1950s, and by the 1960s and 1970s had focused his efforts on acquiring works by Black artists, eventually gifting many of them to public art institutions. Along with other figures such as actor Sidney Poitier, who collected both emerging and established Black artists, Banks has served as a model for subsequent generations of Black collectors.

4 *Alma Thomas: Moving Heaven & Earth, Paintings and Works on Paper, 1958-1978*, Michael Rosenfeld Gallery, New York, March 20-May 16, 2015.

I found as a curatorial intern there in the 1980s. I always loved the work. When I began my career at the Whitney as its first Black curator, I knew of the history of her exhibition there in 1972. There are beautiful photos of the exhibition in the Whitney's archive. I happened to know she was widely collected by Black collectors of Banks's generation—though not by the mainstream art world. I was privileged to see some of her greatest works in the homes of these collections.

E.H.N.: They all had her work.

T.G.: Lorna Simpson is another artist whom you've collected, basically from the beginning of her career to the present. Her work *You're Fine* (1988) is prescient in its attention to the issue of sexual harassment, which remains a conversation of today. The work comes from when she was working in Polaroid film. Also in your collection is *Time Piece* (1990)—both works center on Black women's bodies. Lorna's approach to centering Black women has inspired a whole generation of artists. Her early work was seminal for its use of photo and text. *The Park* (1995) is one of her works that takes on narrative, and all of this work begins to predict her move into video. You also have *Double Portrait* (2013), which is a screenprint, but its form forecasts her later collages, which came before her current painting practice. Looking at this group of works in your collection helps us to see and understand Lorna's genius. The arc of her career has taken her across media, and in each moment she created important, significant work.

E.H.N.: Yes, she has.

T.G.: I wanted to talk about Doris Salcedo and May Sun. May's *Reconfiguring the Urban Landscape* (1992) is in your collection. This inclusion evidences, again, the range of artists in your collection.

E.H.N.: May was doing a lot of public art. In those early years, we were looking at LA artists, women, and women of color. I've known her a long time and see her sometimes at A+P's events.

T.G.: It's a great example of these long relationships you have with artists and the multicultural LA art community that has existed over the decades.

E.H.N.: Yes, and Doris Salcedo. Those works were acquired during a period when we were looking at Latinx artists. We had a whole Latinx collection that was quite extensive. When we first saw Doris's work, it was just riveting. Yet it's work that's also painful to look at. Doris, and also Kara, too, make work that engages this kind of power. It seems like women artists are always dealing with the pain of their lives.

T.G.: There's a way your collection traces a conceptual practice of women artists whose works deal with complicated, painful issues. They're also lyrical and striking. So, there is this amazing collision. Doris's work in your collection also has a conversation with all three Saars—Betye, Alison, and Lezley.

E.H.N.: Betye, Alison, and Lezley are all talking about life, women, being Black. Betye is the queen. I mean, she is in her nineties and she is still making important work.

T.G.: You've known Betye for as long as you've collected. When we talk about this landscape your collection involves—women artists, Black artists, LA artists—Betye is central to all these ideas.

E.H.N.: We would go see Betye's work in the 1980s, and Betye would be there, and then later Alison was there, as well as Lezley. We got to know the whole family. Going to see their work, talking with them, seeing their shows.

T.G.: You and Betye both have strong LA roots. You know how much she talks about the Watts Towers and their creator Simon Rodia, and how seeing the towers being built shaped her

formation as an artist. You often talk about being a born-and-bred Angeleno. Seeing the city and understanding it from a cultural place seems to be a connection.

E.H.N.: I grew up not far from Watts. My mom and her brothers saw Rodia building the towers when they were going to school. It was part of the landscape. We lived in Watts for a long time.

T.G.: What is so important about Betye, Alison, and Lezley is the way their ideas of ritual and spirit and memory reside within the work—you feel you can touch these ideas and abstractions. You have that beautiful work of Betye's, *Souvenir of Friendship* (1977).

E.H.N.: I think that was one of the first works I acquired by Betye—she gave that to me.

T.G.: Betye's works are all so full, as are Alison's and Lezley's, which takes me to another pioneering woman artist of Betye's generation, Faith Ringgold. At this moment, when we're talking about freedom fighters, your quilt is called *Wanted: Douglass, Tubman, and Truth* (1997), obviously referring to Frederick Douglass, Harriet Tubman, and Sojourner Truth.

E.H.N.: Yes. When I first acquired that work I didn't really know about Faith. I love her work, and there was an article about her in the *New York Times* not too long ago showing early work. I only knew her through the quilts. I didn't know about these incredibly important paintings from the early 1970s—the paintings that were from the era of protest movements, of which Faith was a part.

T.G.: The quilts were about reclaiming a history that still isn't fully recorded. The story quilts bring the narrative of history into physical form, which is beautiful.

E.H.N.: I love that quilt, what it represents. She's an amazing artist and is still working.

T.G.: When the Museum of Modern Art in New York reopened with its expanded galleries in 2019, they put her painting *Die* (1967) near Picasso's *Les Demoiselles d'Avignon* (1907). It was a provocative and powerful statement about the potential rewriting of art history.

Another pioneering figure in your collection is Adrian Piper. *Self-Portrait Exaggerating My Negroid Features* (1981) is a masterpiece. I'm glad you lent it to the Adrian Piper retrospective.[5]

E.H.N.: The show was amazing. I'd known of Adrian, but I had no idea about the work that she has been making in recent years. She is amazing.

5 *Adrian Piper: A Synthesis of Intuitions, 1965-2016*, Museum of Modern Art, New York, March 31-July 22, 2018; and *Adrian Piper: Concepts and Intuitions, 1965-2016*, Hammer Museum, Los Angeles, October 7, 2018-January 6, 2019.

T.G.: She has worked consistently since the late 1960s, and her work has been deeply conceptual, it's been rigorous, it's been thorough in its examination of ideas. It contains a multitude of visual languages. You have a work of Adrian Piper's in your collection that is very significant to me. It is one of those works I hold in my heart, and it's from the *Food for the Spirit* photographs, Nos. 1, 6, and 12 (1971). You've got number twelve, which came later in the series. It seems to me that in this period of your collection, mature women artists and their visions spoke to you.

E.H.N.: We had been collecting younger artists for a while, then we started again broadening the vision of the collection. Like with Doris Salcedo, Faith Ringgold, Adrian Piper, Lorraine O'Grady. At that time, nobody on the West Coast really knew these Black women artists, and they had careers and were working, so it made sense for our collection—to broaden it, give it some depth.

T.G.: This focus also defined a way to think about women artists: not from the limiting perspective of gender, but from an approach to gender that offered a way to collect artists

Chandra McCormick, *Ascension*, 2005. Photograph; 24 × 31 in.

who represented so many possibilities. Another example of this would be the group of works in your collection by Shirin Neshat, from the 1990s, when she was exploring this idea of her homeland, Iran, and more broadly gender and identity in the Middle East.

E.H.N.: She is such a fabulous artist. She was barely known at the time I started collecting her artworks. Now, at the time of this interview, The Broad has produced a show entitled *Shirin Neshat: I Will Greet the Sun Again* (2020), capturing the whole arc of her career. We bought her work when she wasn't known, but one sees the work and goes, "Whoa, look at what this woman is doing." Betye and Lorna and all these women are talking about their experiences, gender, and place in the world. Shirin does the same thing from the perspective of her culture.

T.G.: I would like to ask you about Chandra McCormick. You have long held an interest in conceptual photography in your collection, and the acquisition of Chandra's work brings your collection into a relationship with a wider photographic history.

E.H.N.: I've known Chandra McCormick and her husband, Keith Calhoun, since 2008. They're so themselves. I like when an artist is an artist. They are artists and documentarians living in New Orleans all these years, taking photos of their world. I love the work.

T.G.: Their photographs in your collection were in *Prospect.3*.[6] Like so many artworks in your collection, these works deal with Black history and Black culture, and these particular photographs document Hurricane Katrina. Chandra and Keith are artists, as you say, who were not just documenting but also living in New Orleans through that moment. These works indicate, in a way, the trauma of that time. They're citizen artists, because they're artists and also civic leaders.

I would love to hear your thoughts on Maya Lin's *Phases of the Moon* (1998).

6 *Prospect.3: Notes for Now*, curated by Franklin Sirmans, now director of the Pérez Art Museum Miami, was the third iteration of the Prospect New Orleans triennial exhibition, on view October 25, 2014–January 25, 2015 at various sites across New Orleans.

Emily Kame Kngwarreye, *Wild Yam and Emu Food*, 1990. Synthetic polymer
paint on canvas; 59⅞ × 47¹¹⁄₁₆ in.

E.H.N.: Maya's brilliant. Her work is more architectural. It's more environment-based, and *Phases of the Moon* is a beautiful piece. But her work, again, has a visceral feel to it. You can't touch it, but you want to touch it. Even her landscape prints are textural. She's of a different mold than the others. She's a brilliant artist.

T.G.: Genevieve Gaignard's work is a newer addition to your collection.

E.H.N.: Yes. I recently acquired a photograph of Genevieve's, *Miss Daisy* (2020), with the artist dressed in a blond wig, trench coat, and floral dress and carrying two green handbags. Her work captures her in costume, placing her in these imagined scenes. A lot of people don't know she's Black, so they might think, "Oh, here's a nice domestic scene." But its reading is different because she's Black and playing with these notions of race and identity. She is so engaging and just draws you into the work.

T.G.: She takes a complex history, the history of passing, of colorism, of interracial engagement, and embodies it by using herself in the tradition of many artists—someone like Lorraine O'Grady or Adrian Piper, but also artists like Cindy Sherman.

Your collection includes so many different artistic languages. The last work I'm going to ask you about is by Emily Kame Kngwarreye (1910-1996), the Indigenous artist from the Utopia community in Australia.

E.H.N.: At Gagosian [in Beverly Hills] there was this knockout show of Indigenous Australian artists. Kngwarreye's work really stood out to me—*Wild Yam and Emu Food* (1990). Like you said, Emily was from the Utopia Aboriginal community. She lived in the desert and often ate the wild yams and emu birds native to her home. Her painting spoke to her experience, her life. It wasn't a picture of the bird or the food; it's an abstract painting. It's beautifully layered, textured, and she used dirt and sand in the paint. There's a whole process of how she made her paints.

T.G.: Your collection creates a way to understand all of these artists' different voices, their individual experiences, and artistic significance, and how powerful they are when seen collectively. You supported women artists at such early points in their careers, or when their careers needed to be lifted up. We see the evidence of that now. People now understand that their collections cannot be representative in any way when they don't collect artists of color, and certainly when they don't collect women of color, who are too often excluded. I think your collection tells such a wonderful intergenerational story.

I've told you this many times, but you've opened up space for not just the artists, but for those of us who are committed to making space for artists institutionally, writing about them and championing them—you pioneered and created so much opportunity for all of us in this way. I am grateful.

E.H.N.: Thank you.

Faith Ringgold, *Wanted: Douglass, Tubman, and Truth*, 1997. Acrylic on canvas, painted and pieced; 77 × 82¼ in.

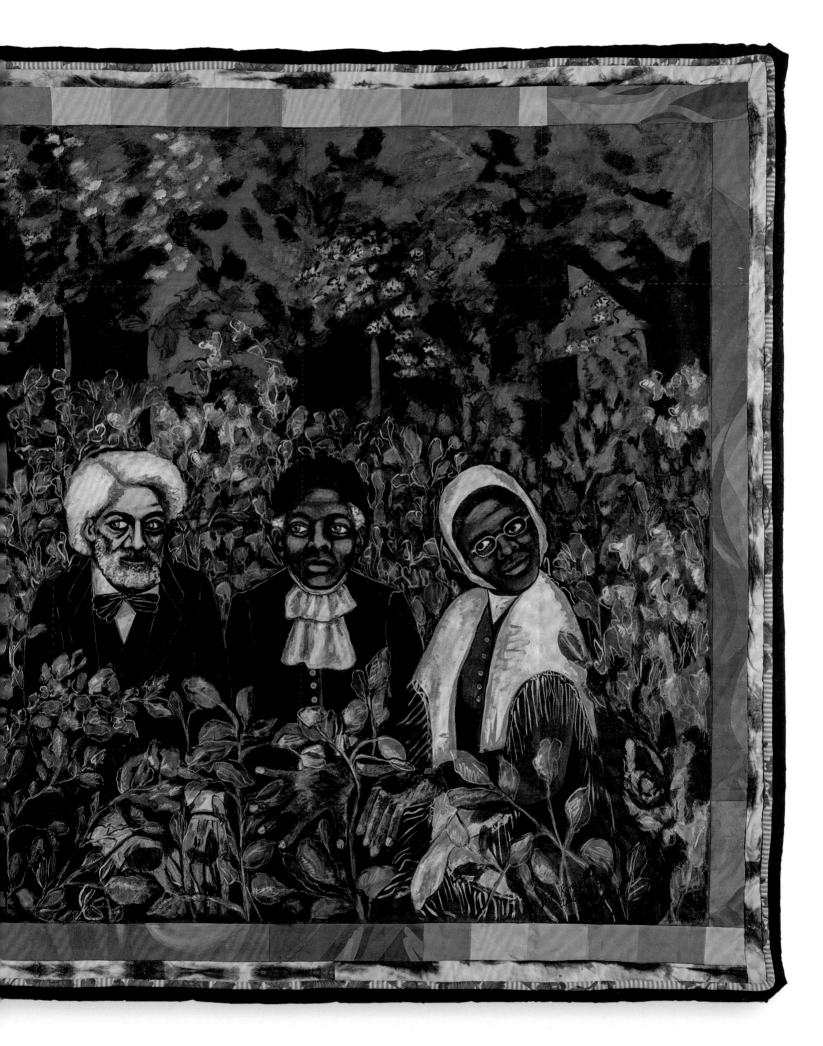

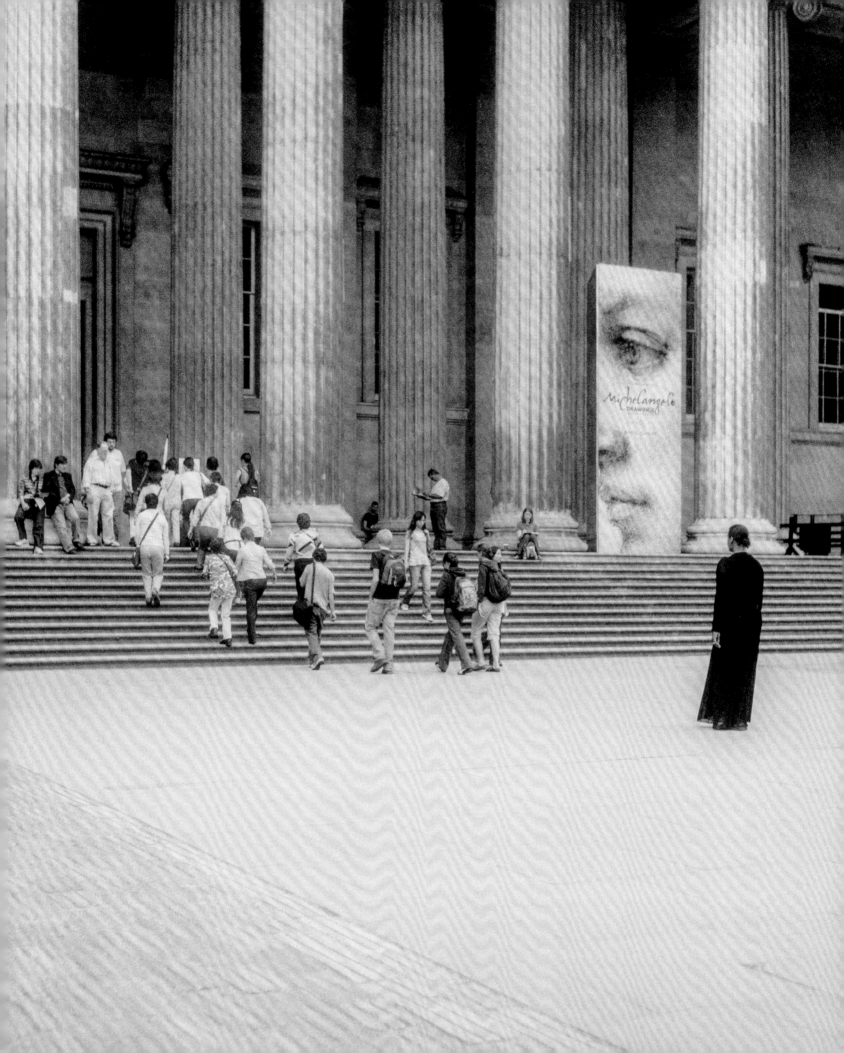

Carrie Mae Weems, *When and Where I Enter, The British Museum*, 2007. Digital print on Somerset Enhanced Velvet paper; 30 × 20 in.

Pictured: Tanya Aguiñiga, *Felt Chairs*, 2012, and Lorna Simpson, *Double Portrait (Visual Arts Lincoln Center/Vera List Art Project 2013)*, 2013.

The Edge of the World is Not the End: On Black Feminine Beingness

Genevieve Hyacinthe

Adrian Piper, *Food for the Spirit,* 1971 (photographic reprints 1997). Fourteen gelatin silver prints; each: 14½ × 15 in. Edition of 3. Detail: photograph #6 of 14.

Adrian Piper, *Food for the Spirit,* 1971 (photographic reprints 1997). Fourteen gelatin silver prints; each: 14½ × 15 in. Edition of 3. Detail: photograph #12 of 14.

I am a human being, and what befalls human beings can also happen to me.
—IMMANUEL KANT

Go to the edge. When you get there dig your heels in. step back. kneel down. lean your lungs over the ledge and scream. stomach into the void and retch. hands holding rocks. throw them. empty out. breathe. stay there. your head as low down as possible. until all you can hear is the sound of your breathing. ragged and loud. this is how you know that the edge of the world is not the end. do you know it? when you know it, turn around.
—ALEXIS PAULINE GUMBS

Immanuel Kant and Alexis Pauline Gumbs write about the unknown of human beingness with an air of hesitancy. Included in his *Observations on the Feeling of the Beautiful and Sublime* (1764), Kant's lamentation was originally published in the form of a condolence letter addressed to the mother of Johann Friedrich von Funk, one of his philosophy students at the University of Königsberg in the eighteenth century, who, at the age of either twenty-one or twenty-two, unexpectedly passed away.[1] Kant expresses empathy for the trajectory of human life, where irrespective of what path our free will takes, we have only melancholy within our hearts due to death's incontrovertible void.[2] With a message that there is more than this known world for us to experience, and that we have the capacity to meet it through raw and dedicated self-awareness, Gumbs's words in her *DUB: Finding Ceremony*, while contemplative, are directive. I interpret her voice as one of spiritual guidance. Her poetics have an air of ritual action and encourage us to align with the awesomeness of human beingness, including the sublimity and transcendence with which we resonate. The activation of this self-conscious awareness is a feat attainable through acknowledging that which Kant does not: namely, the divine within. In this reception-based musing, I examine a selection of works from the Eileen Harris Norton Collection by Alma Thomas, Adrian Piper, and Xiomara De Oliver in relation to Black feminine beingness and sublimity. I situate Piper's *Food for the Spirit* (1971) as a point of departure for this speculative consideration.

Epigraphs: Immanuel Kant, "Thoughts on the Occasion of Mr. Johann Friedrich von Funk's Untimely Death," in *Observations on the Feeling of the Beautiful and Sublime and Other Writings*, ed. Patrick Frierson and Paul Guyer (New York: Cambridge University Press, 2011), 4; and Alexis Pauline Gumbs, "Losing It All," *DUB: Finding Ceremony* (Durham, NC: Duke University Press, 2020), 121.

1 Steve Naragon, "1760: Funk," *Chronological List of Kant's Writings*, last modified June 16, 2021, https://users.manchester .edu/facstaff/ssnaragon/Kant /Helps/WritingsData.htm.

2 Kant, "Thoughts," 4.

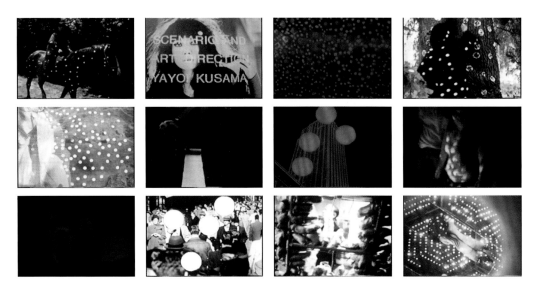

Yayoi Kusama, Film stills from *Kusama's Self-Obliteration*, 1967.

Funk in the Mirror

We might imagine that in *Food for the Spirit* Piper thought she was teetering on the brink of metaphorical life and death, or entropic depletion, without the hope of transcendent ongoingness, as she carried out her ritual project alone in her New York City apartment. Enacted "over several weeks," Piper fasted while practicing yoga; reading Kant aloud, often into a recording device; writing notes on the pages of his *Critique of Pure Reason*; and taking a set of fourteen black and white photos of herself in a mirror with a Brownie camera as she appeared in various states of dress and undress.[3] As the art historian John Bowles recounts, the process became overwhelming, stirring within her "an exhilaratingly visceral 'fear of losing . . .' [herself] in transcendent study and meditation, which she countered with 'the reality check' in the mirror."[4]

There is an abundance of critical analysis surrounding this ritual performance, much of it developed out of Piper's writing on the work, which points us to Kant's *Critique of Pure Reason*. Like Bowles, many discuss this particular text as the foundation for Piper's action.[5] I simply wonder if that specific treatise is the only one Piper sees in the smudged mirror reflection during those long days of fasting and meditation, and how we might expand our reading of the work if it is not.

Like von Funk at the University of Königsberg in about 1760, Piper was also about twenty-two years old when we encountered her at the City University of New York as a student of Kantian philosophy, performing her *Food for the Spirit* meditation in July 1971. The cause of von Funk's death was exhaustion, which we might view as the wearing out of the mind, body, and spirit.[6] We see the same happening to Piper, by her own design, in the intense *Food for the Spirit* context, where she is fasting and meditating, and beyond her control, some twenty years later, during her time as a tenured professor of philosophy. We read about the latter in the chronology she maps out on her Adrian Piper Research Archive Foundation

3 Jan Avgikos, "Adrian Piper: Thomas Erben Gallery," *Artforum* 5, no. 1 (May 1998): 147.

4 John Bowles, *Adrian Piper: Race, Gender, and Embodiment* (Durham, NC: Duke University Press, 2011), 205.

5 For example, David Platzker, "Adrian Piper Unities," in *Adrian Piper: A Synthesis of Intuitions*, ed. Christophe Cherix, Cornelia Butler, and David Platzker (New York: Museum of Modern Art, 2018), 30–49; and Kobena Mercer, "Contrapositional Becomings: Adrian Piper Performs Questions of Identity," in *Adrian Piper: A Reader*, ed. Emily Hall and Sarah Resnick (New York: Museum of Modern Art, 2018), 102–31.

6 Naragon, "1760: Funk."

Berlin page.[7] She describes these academic moments using terms resonant with von Funk's demise, referring to them with the repetitive vibe of PTSD, as experiences of "exhaustion" and "collapse," regularly occurring during or at the end of semesters of intense teaching (1990–97) until she can shift her perspective with yoga. Unique among her entries, where exhaustion and collapse are perpetual, in 1997 there is an aberration where, she writes, she "intensifies yoga practice to three-plus hours daily, becomes vegan. Doesn't collapse from physical exhaustion at the end of spring semester."[8] In short, I view von Funk's exhaustion-induced demise as a not uncommon affliction of humanity, and it is one that strikes Piper in her *Food for the Spirit* reflection and throughout her professional academic life. This exhaustion is transmuted by yoga asanas, meditation, and philosophy into transcendence and continuity through the cultivation of an awareness of connection with the divine, enlivening all things, including the self.[9]

The philosopher Tu Wei-ming distills Kant's *Critique of Pure Reason*, writing, "We can attain only to knowledge of appearances and never to knowledge of things in themselves."[10] Reflecting on Tu's statement leads me to feel in part that *Critique of Pure Reason* is too limiting a frame for Piper's project: In *Food for the Spirit*, Piper is engaging with the process of knowing by pondering her reflection, which might be viewed as an evocation of Kant's "knowing" through surface or appearances. Yet there is also clearly a process of discipline and repetition at work that brings the Asian spiritual practices of Hindu Yoga and Buddhism to mind. Patañjali, the Hindu mystic and philosopher who authored *The Yoga Sutras* (200 BCE–200 CE), for instance, writes that *samādhi*—an elevated consciousness, equanimity of self with life and death—is grace cultivated through a disciplined practice of devotional repetition.[11] This devotional repetition conjures the yoga asanas, journaling, and fasting as Piper simultaneously carries out along with her encounters with her reflection during the *Food for the Spirit* action. Moving closer to the teachings of Patañjali and adding a contentious complement, if not counter, to Kant, Tu asserts that "Chinese thinkers" arrive at the essence of human-ness through a process of intellectual intuition that functions as not only "a cognitive knowing"—an amalgamation of the conscious observation that Kant points to and an unconscious sensibility or intrinsic knowing that he reserves for the divine only—but that is "also a creative act."

For Tu, the individual nurtures this deep knowing through repetition, which fosters connection with the divine within the self. As Tu submits, "Intellectual intuition is thus the self-disclosure of the original mind of humanity, which is universal, infinite, and creative. For ontologically it is the same as the mind of heaven."[12] And lastly, linking these ideas with those of Heidegger, Tu suggests we come to this "creative inheritance" through the process of repetitive action that is never the same, because through the re-doing, differences emerge that necessitate creative negotiation. Heidegger states, "We do not repeat a beginning by reducing it to something past and now known, which need merely be imitated; no, the beginning must be begun again, more radically, with all the strangeness, darkness, insecurity that attend a true beginning."[13] Piper's work, like that of Alma Thomas and Xiomara De Oliver, also working in their respective ways in the nexus of the Black Abstraction tradition in women's performance and painting, entangles with this phenomenological sense of repetition and beingness.

7 Adrian Piper, "Adrian Piper Personal Chronology," Adrian Piper Research Archive Foundation Berlin, http://www.adrianpiper.com/personal_chrono.shtml.

8 Piper, "Personal Chronology." The full sequence reads: "1991: Collapses twice from physical exhaustion, ends spring semester on medical leave; 1992 . . . Collapses from physical exhaustion at end of spring and fall semesters; 1993 . . . Collapses from physical exhaustion at the end of the spring and fall semesters; 1994 . . . collapses from physical exhaustion at end of spring and fall semesters. Mother dies from emphysema; 1995 . . . collapses from physical exhaustion, ends spring semester on medical leave . . . at the end of fall semester. Starts studying Iyengar yoga with Arthur Kilmurray . . . 1997 . . . Intensifies yoga practice to three-plus hours daily, becomes vegan. Doesn't collapse from physical exhaustion at the end of spring semester."

9 Due to Piper's interest in Kant as a student and subsequent expertise as a scholar, she was likely aware of the von Funk text, because it is the first chapter in *Observations on the Feeling of the Beautiful and Sublime*.

10 Tu Wei-ming, "The 'Problematik' of Kant and the Issue of Transcendence: A Reflection on 'Sinological Torque,'" *Philosophy East and West* 28, no. 2 (1978): 217.

11 Pradeep Gokhale, "Interplay of Sāṅkhya and Buddhist Ideas in the Yoga of Patañjali (with Special Reference to Yogasūtra and Yogabhāṣya)," *Sambhāṣaṇ* 2, nos. 1–2 (January–March, 2021; April–June 2021): 48.

12 Tu, "'Problematik,'" 217.

13 Quoted in Tu, "'Problematik,'" 220.

Considering this in relation to *Food for the Spirit*, one can see Piper is engaging in creative ritual, beginning again and again while grappling with that strangeness and dark insecurity meeting her in the mirror, as the "I" that "consider(s) [her] capacity for self-discipline infinite."[14] Additionally, we might also reflect upon the art critic Elvan Zabunyan's assertion, "Piper exhibits this same 'self-control' [as the epic archer, Arjuna, in the *Bhagavad Gita*] in the act of creation."[15] We see in those fourteen photographs her struggle to see herself and thus affirm her existence in the smudged opacity of her reflection: the dusky-colored young woman fades into the twilight, never complete darkness, which to me is a glimmer of her acquiescence not to Kant's doubt but rather to divinity's transcendence over finality.[16]

Exercising Piper's call for audience catalysis—whereby through empathic, intersubjective engagement between the artist and her beholders she sparks change, bigger than solely art institutional concerns, in the people who encounter her work as part of the formation of its meaning—I conjecture that divinity's ubiquity within human beingness is a lesson she learned in part from von Funk.[17] Aware of the potential dissonances inherent to making such a claim, I speculate that "Funk" is a phenomenon that existed in the *Food for the Spirit* mirror with Piper as a trace of a fellow Kant student, Johann Friedrich von Funk, and also concerning the Black sonic world of the era, brimming with early Funk rhythms in formation. During the time she created *Food for the Spirit,* she was also integrating proto-Funk influences into her work, as in her *Aretha Franklin Catalysis* action (1971-72),[18] in which she incorporated the diva innovator's *Respect* as part of her performance art experimentations that "focused on the relationship between the art and viewer in a new, more immediate way."[19]

Some years later, Piper would create *Funk Lessons*, a collaborative performance she led several times at various institutions between 1982 and 1984, introducing people to the philosophy and practice of Funk music through

Alma Thomas, *Azaleas in Spring*, 1968. Acrylic on canvas; 20 × 24 in.

14 Elvan Zabunyan, "Body and Soul," in Hall and Resnick, *Adrian Piper: A Reader*, 230.

15 Zabunyan, "Body and Soul," 222.

16 Soon after completing the series, Piper did not originally situate the photographs in the order they were taken. Instead, she organized them from the lightest and most legible to the darkest and most obscure. See Bowles, *Adrian Piper*, 217.

17 Gerlinde Van Puymbroeck, "Adrian Piper's Aesthetic Agency: Photography as Catalysis for Resisting Neo-Liberal Competitive Paradigms," *Philosophy of Photography* 10, no. 1 (2019): 49.

18 Lucy Ives, "Trust Survey 2018," *Art in America*, December 1, 2018, https://www.artnews.com/art-in-america/features/trust-survey-2018-63582/. I refer to Franklin's *Respect* (1967) as "proto-Funk," because it is more reflective of the Rhythm and Blues style that will influence Funk's development. Franklin's *Rock Steady* (1972), with its gritty, driving bass, is more representative of the Funk style. For more on Aretha Franklin as an influence on Piper, see Adrian Piper, "Passages: Aretha Franklin (1942-2018)," *Artforum*, August 17, 2018, https://www.artforum.com/passages/adrian-piper-on-aretha-franklin-76251.

19 For Piper's inclusion of Franklin's *Respect*, see Ives, "Trust Survey 2018"; for the mention of intensified immediacy in Piper's *Catalysis* works (1970-73), see Jillian Steinhauer, "Outside the Comfort Zone: Adrian Piper's Art Plays with Identity and Confronts Defensiveness," *The New Republic*, May 30, 2018, https://newrepublic.com/article/148298/outside-comfort-zone-adrian-piper.

lectures and dance immersion. The work highlights an ongoing valence within Piper's oeuvre, which is the notion that, to evoke one of the central tenets of Funk artistry, we are, as George Clinton might say, "On the one, everybody on the one."[20] As Rickey Vincent puts it, in some US Black sonic and visual experiences, an "African" timing remains, in which individual pulses have moments of convergence within a space of collective timing, even if only for a moment: "A locked, happening rhythm brings everybody together grooving as one."[21] A central characteristic of Funk music, Piper writes, is the "desire for self-transcendence: to 'become one' with the music, one's lover, other people, the universe."[22] Later in her career, Piper's *Funk Lessons* would shape-shift into Shiva as Nataraja's cosmic dance of "mastery over the cosmic cycle and . . . promise to enlighten the faithful,"[23] occurring "at the center of the universe" and within the heart and soul of all beings. In her "participatory performance"[24] *Shiva Dances with the Art Institute of Chicago* (2004), the community members converge with her to "Get down and party. Together."[25]

Miss Alma's Pulsing and Eternal Spacetime: "I've Been Here for at Least Three or Four Generations."[26]

Food for the Spirit emerges out of the energies surrounding and immediately preceding it in the mid-to-late 1960s. Women of color are creating artforms across media, emanating the free spirit of transcendental beingness, as in Alice Coltrane's free jazz albums like *Universal Consciousness* (1971). Like Yayoi Kusama, for instance, whose self-obliteration actions and mirror pieces dissolved the boundaries among herself as "artist," the participants, and the site into a rapturous yet disquieting unity, Piper creates a cluster of paintings in which we behold her body as a liminal presence glowing and fading in and out of a field of prismatic vibrancy never fully realized or stilled, *LSD Self-Portrait from the Inside Out* (1966) among them.[27] Although we might imagine that this inability to strike a fixed sense of self might stir existential apprehension, the vibrant orange and red colors that interplay with bold black contour lines to form both Piper and her sky of diamonds feel more magical than foreboding. Piper's corporeal and psychic expansion resonates with paintings of the era by Alma Thomas, who similarly transgresses the contours of material experience and in so doing reveals the cosmic flow of all things.

As Thomas's fellow Abstract Expressionist painter Barnett Newman states, "All artists, whether primitive or sophisticated, have been involved in the handling of chaos,"[28] and we see this virtuosity in Thomas's painting *Air View of Spring Nursery* (1966). In that work, Thomas transforms the seen into the unseen, as a bed of flowers manifests as the pulses of color filling the picture plane with a rhythmic horizontality that adds grace to the grid undergirding it. Collapsing linear time and unmooring fixed perspectives are actions in accordance with the temporality of the Black Atlantic, and this idea is carried out in Thomas's work.[29] As Thomas puts it, she exhibits "the courage to fling open new skies" by painting flora from the all-seeing perspective of divinity, where the atoms that comprise petals and leaves appear simultaneously as the stardust of all matter.[30]

20 Rickey Vincent, *Funk: The Music, the People, and the Rhythm of the One* (New York: St. Martin's Griffin, 1996), 37.

21 Vincent, *Funk*, 37.

22 Adrian Piper, "Notes on Funk I–IV," in *Out of Order, Out of Sight*, vol. 1, *Selected Writings in Meta-Art 1968-1992* (Cambridge, MA: MIT Press, 1996), 214.

23 Padma Kaimal, "Shiva Nataraja: Shifting Meanings of an Icon," *Art Bulletin* 81, no. 3 (1999): 394.

24 See caption for Piper's *Shiva Dances with the Art Institute of Chicago* (2004), in Cherix, Butler, and Platzker, *Adrian Piper: A Synthesis of Intuitions*, 275.

25 Piper, "Notes on Funk," 195. This is a directive Piper used in her *Funk Lessons* series, which serves as the base structure for her collective dance experience in attunement with Shiva Nataraja. For more, see Adrian Piper, "Shiva Dances with the Art Institute of Chicago (October 2004; 01:43:18)," Adrian Piper Research Archive Foundation Berlin, http://www.adrianpiper.com/vs/video_sd.shtml.

26 Alma Thomas statement in Kellie Jones, "To the Max: Energy and Experimentation," in *Energy/Experimentation: Black Artists and Abstraction 1964-1980*, ed. Jones (New York: Studio Museum of Harlem, 2005), 29.

27 This cluster of amazing paintings includes *Negative Self-Portrait* (1966), *LSD Self-Portrait from the Inside Out* (1966), *LSD Void* (1966), *LSD Self-Portrait with Tamiko* (1966), and the *Alice in Wonderland* paintings of 1966. They are reproduced in *Adrian Piper: A Synthesis of Intuitions*.

28 Barnett Newman, "The Plasmic Image," in *Barnett Newman: Selected Writings and Interviews*, ed. John P. O'Neill (New York: Alfred A. Knopf, 1990), 139.

29 Michelle M. Wright, *Physics of Blackness: Beyond the Middle Passage Epistemology* (Minneapolis: University of Minnesota Press, 2015), 145.

30 Ann Gibson, "Putting Alma Thomas in Place: Modernist Painting, Color Theory, and Civil Rights," in *Alma W. Thomas: A Retrospective of the Paintings* (Rohnert Park, CA: Pomegranate, 1998), 38.

This elegant liminality manifests in the two Thomas paintings in Eileen's collection: *Azaleas in Spring* and *Untitled*, both created in 1968. In *Untitled*, *Spring Nursery*'s polychronic pulses are reconfigured into a disk, with its uneven, percolating edges and impactful, central positioning within the white picture plane eliciting the whirls of Shiva Nataraja's "centrifugal vectors" of reincarnation and the eternal hope radiating out of her painting *Study for Resurrection* (1966) alike.[31] Reflecting her own version of "'self-control' in the act of creation,"[32] Thomas again transforms her signature pulses, this time in *Azaleas in Spring*, as teeming touches of loose color, perhaps as the ethereal distillate of divine formation. Where Piper cultivated her ability to turn within to harvest her self-awareness to varying degrees with philosophy, Funk, meditation, and yoga, Kellie Jones suggests that Thomas's command in this area came into this world with her. The speech and hearing challenges that the artist experienced as a child may have driven her "toward an inner creative life,"[33] not unlike the mysteries of suffering endured by saints for their enlightenment and our own.

Black Feminine Calm at the Edge and in the Midst

In Xiomara De Oliver's paintings in Eileen's collection, Black feminine beingness stands at the edge of the world and navigates the ultimate truism of our liminal status as human beings, what the writer Simon Morley describes in our everyday life as an anxious state shaped by the oft-experienced liminal moments that "stretch our minds towards infinity . . . a constant of human consciousness," and at the time "when we lie at the margin between life and death . . . [as Luce Irigaray suggests] 'the envelope which separates and divides us, fades away.'"[34]

De Oliver's liminality is sensual with verdant tones and enchanted poses that bring the beholder a feeling of pleasure inflected by a mist of doubt emanated by the placelessness of her formless landscapes created through blurs and layers of paint bereft of locational cues. Paintings *#33*, *#35*, and *#37* (2005) from her *Parlor B-Girl* series show a lone, brown-complected, femme figure with a flourish of thick white hair, wearing an angel-toned white gown in the center of a richly opaque picture plane that, in accordance with the name of the series, implies private moments and spaces. In each painting, the B-Girl is in motion, floating in the middle of a black field, unencumbered by gravity. They take on different poses evocative of Vogue Femme ballroom choreographies, though it is unclear if the "B" De Oliver uses for the title is referencing that specific art form or the popular term "B-Girls," as in breakdancing girls from hip-hop culture, which derives from Funk and disco sensibilities, or her "Bombshell Girls," as in the painting *Allegory of Some Bombshell Girls—only in flamingo grass* of the same year. At the edge, De Oliver's figures dance through the fear, or, over the edge, they dance beyond it.

The Parlor B-Girls all look similar but not the same. Their faces have perhaps a sisterly resemblance rather than a twin affect; their white dresses are cut slightly differently; the poses—while all possessive of the low positioning and tensile grace of Vogue Femme—vary.[35] Thus, in their particularized way, they bring the intersections of minimalism and second-wave feminism performed by Piper in the mirror to mind and also what I am musing as the disquieting negotiation of her universal self alone in her New York City loft.[36] Each B-Girl

31 Kaimal, "Shiva Nataraja," 413; see Ross Gay, "Study for Resurrection," in *Alma W. Thomas: Everything Is Beautiful*, ed. Seth Feman and Jonathan Frederick Walz (New Haven: Yale University Press, 2021), 6.

32 Zabunyan, "Body and Soul," 222.

33 Jones, "To the Max," 29.

34 Simon Morley, "The Brain Is Wider Than the Sky," in *Chaos & Awe: Painting for the 21st Century*, ed. Mark W. Scala (Cambridge, MA: MIT Press, 2018), 33 and 34.

35 I use the descriptor *Vogue Femme* with the words of the ballroom-culture archivist Noelle Deleon in mind. She recently mentioned the overlaps of Vogue Femme and other ballroom-culture moves with yoga asanas, among other influences. Camille Lawrence, in Conversation with Noelle Deleon, "Honoring the Black Femme in Ballroom," Hemispheric Institute, New York University, June 22, 2022 (virtual).

36 Fred Moten, "Resistance of the Object: Adrian Piper's Theatricality," in *The Break: The Aesthetics of the Black Radical Tradition* (Minneapolis: University of Minnesota Press, 2003), 241.

Pictured: Alma Thomas, *Untitled*, 1968. Acrylic and graphite on canvas; 35¾ × 37⅝ in.

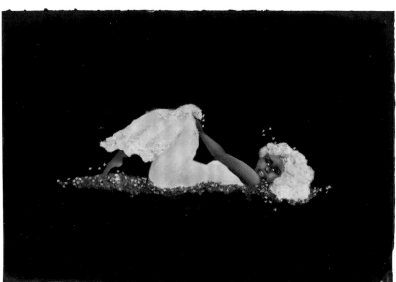

Clockwise: Xiomara De Oliver, *Parlor B-Girl #35*, 2005. Oil stick on paper; 20¼ × 15 in.

Xiomara De Oliver, *Parlor B-Girl #37*, 2005. Oil stick on paper; 22½ × 15 in.

Xiomara De Oliver, *Parlor B-Girl #33*, 2005. Oil stick on paper; 14 × 20¼ in.

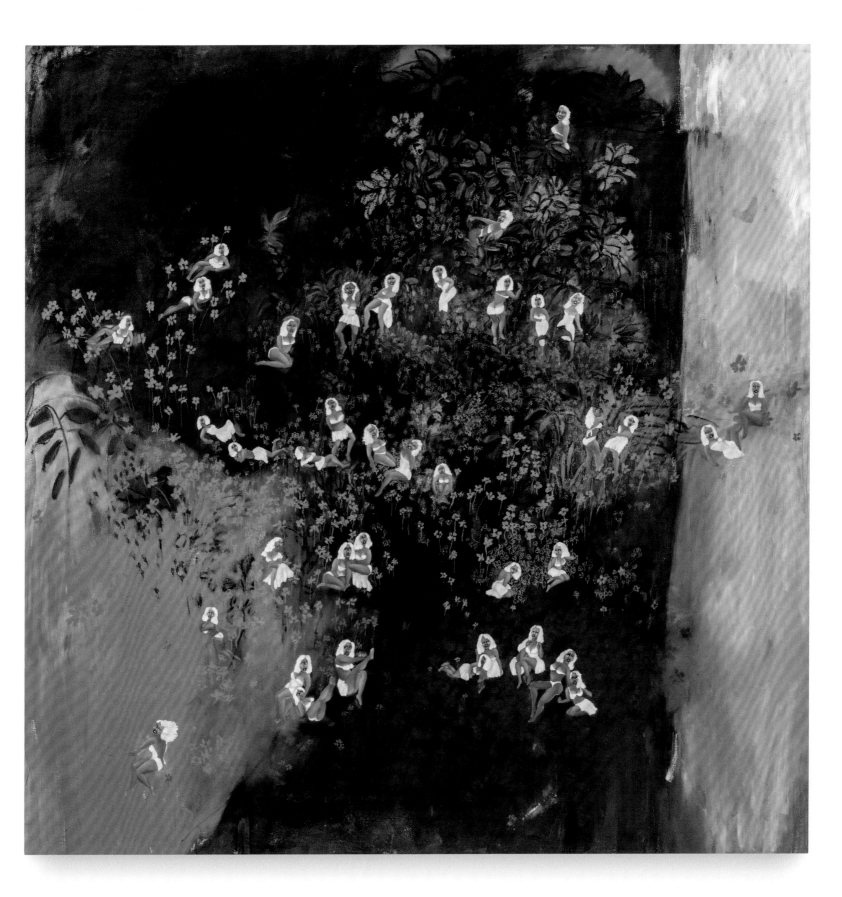

Xiomara De Oliver, *Allegory of Some Bombshell Girls—only in flamingo grass,*
2005. Oil stick, acrylic, and crayon on canvas; 80 × 80 in.

Alma Thomas, *Air View of Spring Nursery*, 1966. Acrylic on canvas; 48 × 48 in. The Columbus Museum, Museum purchase and gift of the National Association of Negro Business Women, and the Artist, G.1979.53.

seems to have the same circumstance: one by one, they appear in the parlor, intrepidly, not unlike those Bombshell Girls we see dancing and posing with free abandon in De Oliver's large painting *Allegory of Some Bombshell Girls—only in flamingo grass*. Like the Parlor B-Girls, the Bombshell Girls' appearance in white evokes the angelic, and their individuality is implied to some extent by the variegated styles of their outfits. At the same time, their brown skin and textured, white, shoulder-length hair visually unify them, perhaps due to De Oliver's practice of basing the women of her paintings "on her own likeness," a dynamic we might conjure as her boundlessness.[37] They/she dance(s) and pose(s) in the styles of Vogue Femme, breakdancing, go-go, and twerking while intermingling with delicately rendered flora, amid enchanting flows of greens, pinks, and yellows. Evocative of Matisse's *Luxe, Calme et Volupté* (1904), the revelry exuded by the Black women in the blooming field brings what can be viewed as the hope intrinsic to one's recognition of the human divinity existing within one's differentiated life and one's universal transcendence—*what befalls human beings*—in various states of precarity and confidence.[38] *This is how you know that the edge of the world is not the end.*[39]

37 Michelle Jacques, "Xiomara De Oliver," *Frequency*, ed. Samir S. Patel (New York: The Studio Museum in Harlem, 2005), 66.

38 Kant, "Thoughts," 4; Morley, "Brain Is Wider Than the Sky," 34–35.

39 Gumbs, "Losing It All," 121.

Alma Thomas, *Untitled (Study for Resurrection)*, 1966. Acrylic on paper; 24 × 24 in. Collection of Nancy and David Barbour, Alexandria, VA.

Adrian Piper, *Funk Lessons*, 1983–84. Group performance, University of California at Berkeley, 1983. Video documentation by Sam Samore; 00:14:58. Detail: video still at 00:00:41. Collection of the Adrian Piper Research Archive Foundation Berlin.

Adrian Piper, *Food For the Spirit*, 1971 (photographic reprints 1997). Fourteen gelatin silver prints; each: 14½ × 15 in. Edition of 3. Detail: photograph #1 of 14.

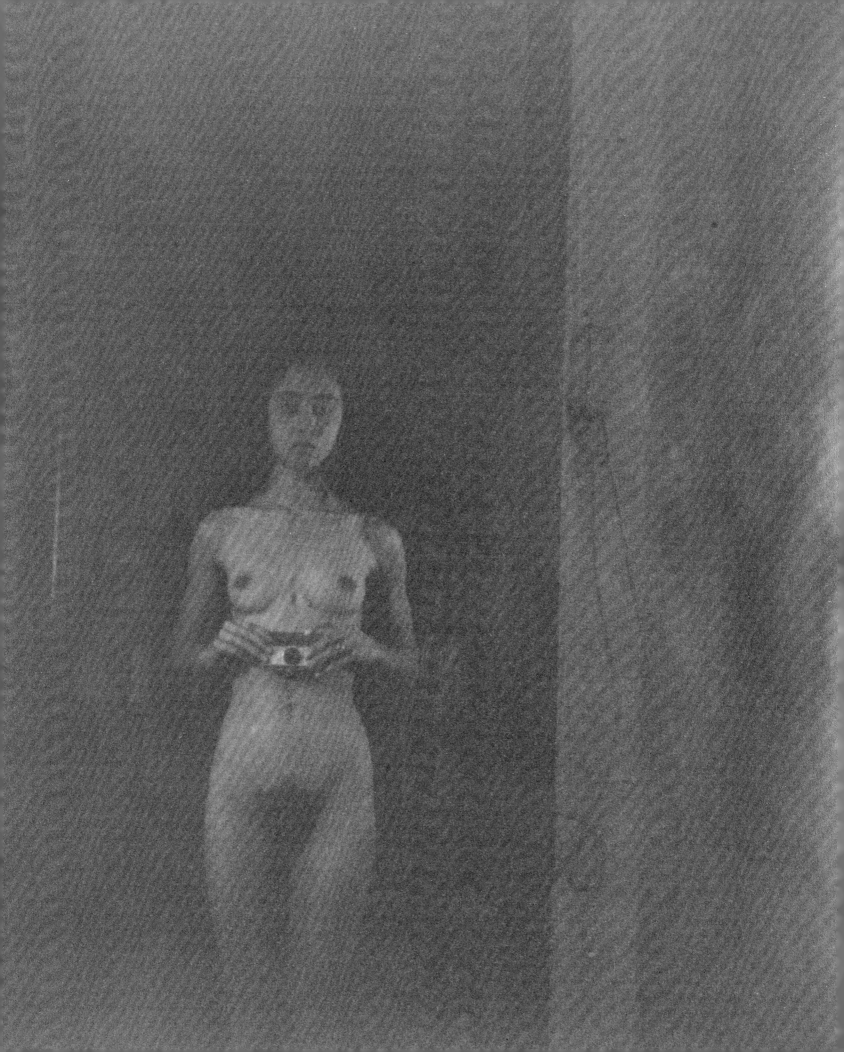

Like Some Silent Catastrophe

Gelare Khoshgozaran

Doris Salcedo, *Atrabiliarios*, 1993. Solo exhibition, Museum of Contemporary
Art Chicago (MCA), 21 February–24 May 2015.

A noise echoes in my head . . . a terrible noise, and I can't stop it. This noise. . . . I have changed cities. I have changed places. I have changed houses. I have changed countries. I have changed friends. I, myself have changed. But I could not make it stop. How long has it been? It's been fifteen years, as long as the war.

These are the opening lines of *Letter from a Time of Exile*. Made in 1990 by Lebanese director Borhane Alaouié (1941-2021), the film opens with shots of serene landscapes in the countryside. What better way to open a film about exile than with shots of landscape? These images ask us to think about *place* in the absence of language and bodies. We try to site landscapes on a map as we are tempted to read them within the cinematic language: generic landscapes, placeholders for "nature" or placelessness. The flora and fauna, the sky and quality of light, the dirt, leaves, and slopes, the details in the way the hills roll onto one another to create curvatures are the only clues we are left with when attempting to respond to the voice in our head asking, *Where is this?*

In Alaouié's film, the less suggestive images of landscape soon give way to those of the urban space. The street signs and noise, the subway stations and sidewalks, make it clear that we are in Paris, Brussels, or Strasbourg. Over such imagery, in a voice-over, the narrator introduces the four characters: the unemployed journalist, the former militia member, the car salesman, and the surgeon. They do not know each other but are portrayed as kindred in exile. A Lebanese filmmaker who lived between Paris and Brussels, Alaouié set out to map exile in his film through the letters these four characters would write home. The letters unfold in vignettes pertaining to each character's past and present, and are read over the footage of people on a street corner, the subway station, a café, or on the road. Through these surrogate storytellers and their letters home, we arrive at the narrator's own exile. The classic Arabic songs fading out over the common footage of the European urban or rural space, the outward silence of a man standing at a corner waiting for a train, the raucous arrival of the subway through the tunnel—these are the only legends we are given to interpret the map of exile.

Watching Alaouié's film, I am reminded of why it is hard to "portray" exile. There is a triviality to the experience that both charges everyday life and makes it difficult to capture. Exile, like other experiences of forced displacement, barely manifests outwardly. It is an internal clock aging like that noise in your head—fifteen years and counting—that makes silence impossible. It exists in the interiority of how one becomes the mediator between one's past and the outside world—an interpretive role not between place and place, language and language, or time and time, but one born of the necessity to translate time and space in infinitum.

The difficulty of portraying exile and the violences that surround and enable it are invoked in numerous works in the Eileen Harris Norton Collection. In the sculpture series *Atrabiliarios* (1993), the Colombian artist Doris Salcedo captures the disappearance of Colombian women during that country's internal conflict in the 1980s. The work renders the disappeared into the fabric of the present time by placing worn shoes into niches in the gallery walls. Between the viewer and the discarded shoes is a thin layer of animal membrane, affixed to the wall with medical sutures. The series is a result of Salcedo's in-depth field research and her practice of collecting the shoes of Colombians who had disappeared through means of covert political persecution. In a broader excavation of conflict and exile, the artist Samira Yamin interrogates war photography of the post-9/11 Middle East by cutting sacred Islamic designs into mainstream media ephemera to create artworks. *October 1, 2001 IV* (2013), *January 11, 2010 IV* (2016), and *(Geometries) Fire IX* (2017) serve as reminders of how for some, the notion of home and the sense of feeling at home is inseparable from constant violence and the ensuing mourning.

The particular noise that Alaouié describes at the beginning of *Letter from a Time of Exile* is resonant with one that reverberates through the works of Mona Hatoum that are in the Eileen Harris Norton Collection. Her early performances, and later works on paper, video, sculpture, and installation, are known for causing a visceral reaction in the viewer, as they foreground the banality of objects and experiences. Through the simplicity of form and narrative, she disarms the viewer: everything is what it appears to be yet incredulity is inevitable. Her earlier work took advantage of time-based media to complicate the idea of the present through anachronistic uses of image, sound, and text. In her later sculpture and installation work, time and space are unsettled through shifts in the scale, position, and orientation of objects. Large-scale sculptures such as *Grater Divide* (2002)—a steel room divider in the shape of a kitchen grater—nod to the ways the avant-garde would unsettle the viewer by defamiliarizing everyday objects by displacing, disorienting, and juxtaposing them. Encountering such objects evokes a sense of friction in the viewer that arises from the violent world we inhabit and which gnaws at our collective imagination until freedom is rendered unattainable.

A singular pivot in Hatoum's career is the video *Measures of Distance* (1988), which she made when she was thirty-six years old. At the time, she was living in London and unable to visit her home in Lebanon. Her family, like thousands of displaced Palestinians living in Lebanon, were enduring the civil war, which raged until 1990. The plurality of "measures" in the title, however, indicates that she is speaking to different types of distance beyond those of geography. Her anachronistic use of sound, text, and image begins with an ambiguous one and a half minutes, which puts the viewer either in a familiar or alienating space until the artist's voice utters the words "my dear Mona."

What to a non-Arabic-speaking audience may feel like an unfamiliar space/time at the start of the video is already a space of intimate joy between a mother and daughter communicating in their language of home.[1] Then

1 I deliberately use this term rather than "mother tongue" or "native language." My intention in choosing this term is to situate language and belonging in frameworks outside colonial borders and imperial nation-states. The "language of home" is a mode of communication that can be hybrid or nonverbal, yet provides a form of identification through collectivity and relation, not geography or national identity.

Samira Yamin, *January 11, 2010 IV*, 2016–ongoing. Hand-cut *Time* magazine; 7⅞ × 10½ in.

Samira Yamin, *October 1, 2001 IV*, 2013. Hand-cut *Time* magazine; 14 × 35⅛ in.

another space opens up to be an epistolary exchange between the two women, interpreted for the viewer in English. Through these letters we learn that the photographs of a woman's body, revealed through the opacities of the handwritten letter, are of the artist's mother. Throughout the video, intervals of silence or spoken Arabic allow viewers to situate themselves within and outside the picture frame—what do we hear and see? The photographs document a time spent together. The way they are layered with the letters and viewed through the grains of the video gives them a haptic quality in contrast with the *Time* magazine economy of photojournalism, which is critically addressed in Samira Yamin's work. The legibility of *Time* imagery intervenes in Yamin's work through the cutting and removal of parts of the images. The viewer is guided from the subject of the photographs to the recognizability of two-dimensional renderings of Islamic architectural patterns. In Hatoum's photographs of her mother, a different economy is cultivated, in which the meaning is sought with the curiosity of eyes that desire touch. The English voice-over offers clues to a visit back home "four years ago." But with time passing, the conversation between the two women continues in letters written in ink on paper. Between each letter being sent and received there is anticipation and desire. Distance affords the two women a different type of intimacy than the one created in the bathroom, where the daughter took photos of her naked mother. These letters are meant for no one but the two of them—mother and daughter—yet we are invited to peek in and listen like voyeurs.

The most legible sound in the video is the artist's voice reading her mother's letters in English. In the background, the recorded conversation between the two women is audible. Unlike the artist's voice reading the letters, which is disembodied and isolated, their conversation is situated in the time and place in which it was recorded. The recorder has indiscriminately picked up the noise of the urban space: the honking of the cars and the motorcycles on the streets in Lebanon, the screeching sound of tires already breaking the space of the public and the private, as if making a resounding subliminal statement that "the political is personal." As such, through the layering of sound and image, the multiplicity of the distances addressed in this work constitutes that between the artist and her home; her Palestinian family and their homeland, to which they are denied the right to return; the intimate dialogue of a mother and daughter that is protected from the patriarchal figure; a family at home and their daughter abroad, who exchange letters over the course of a fifteen-year war; the intimate photographs of her mother and a secret kept from her father; and last but not least, a Palestinian artist from Lebanon making and presenting this work in London, the capital of the state that was instrumental in the ethnic cleansing of Palestine in 1948 and the creation of the Zionist state of Israel.[2]

Measures of Distance is deeply situated in the context in which Hatoum was practicing as an artist, living in London. How far is the distance between living with the possibility and anticipation of return and the abridgment of that right in exile? For Palestinians who, like Hatoum's family, were expelled from their homeland upon the establishment of the state of Israel in 1948, four years before the artist's birth, the possibility of return has been denied not only for the present generation but future ones. "In diasporic lives," writes Nadia Yala Kisukidi, "geopolitics and international relations become family affairs. They run through the affective lives of communities. We must not shy away from the violence of the conclusion: the inequality of worlds sometimes means that one inhabits a society that feeds on the blood of one's own family. The dialectic is poor: to live well requires the negation of the other."[3] How does an artist in the diaspora make work about intimacy when even revealing the most intimate conversations with her mother in Arabic causes alienation in most viewers? There is a distance to be measured between the viewers who find belonging in the first few sentences exchanged amid the gasps of excitement and laughter, and those who are disoriented. Toward the end, the video fades to black as we are left only with the voice of the artist reading one last letter. We learn that the two women's correspondence has to end and adopt a different form because the local post office in Beirut has been destroyed by a car bomb, and the central facility is located in an area that is the target of repeated bombardment. This last letter has made its way out of Lebanon via Bahrain, carried by Hatoum's cousin. The mother suggests calling their house, instead, as "this would be your only way to get your news from now on."

It is no coincidence that the narrator in Alaouié's film measures the duration of his exile with the age of the war. Besides being a main cause of exile for millions of people across generations around the world, war disrupts everyday life by making the simplest tasks the most complicated, if not impossible. Visiting a relative who lives nearby or on the other side of town becomes a life-threatening experience, while communication is interrupted if it is possible at all. Such circumstances, in which everyday objects and one's home or kin are under threat of erasure, produce a sense of hapticality in commonplace objects. It feels as if there is a dialogue between the self and everything one touches: a call and response between the auditory and the tactile.

Measures of Distance ends with a change in the form of communication, necessitated by the conditions of war and exile, and Hatoum goes on to explore different modes of address in a new chapter in her practice through sculpture, drawing, and installation. *Measures of Distance*, which the artist considers a milestone, holds a critical space to understand the works she developed in the following years. In a conversation with Janine Antoni in 1998, Hatoum states: "When I made *Measures of Distance* it felt like I had unloaded a burden off my back. I felt afterwards that I could get on with other kinds of work, where every work did not necessarily have to tell the whole story, where I could just deal with one little aspect of my experience. That's when I started making installation work."[4]

The world that Mona Hatoum went on to build across media through the 1990s contains a profound sense of solitude. It is as if everybody has disappeared and, part ghost/part narrator, she is left to dialogue with the inanimate objects they have left behind. She engages these objects as if to teach them the code-switching that a refugee depends on to survive. Like the work of most diasporic artists, that of Hatoum has predominantly been presented, discussed, and framed in the West. As such, it has been subject to gross generalizations about exile, war, and displacement. But the particularity of her Palestinian experience did not go unnoticed by

2 See Zena Tahhan, "Who was behind the Balfour Declaration?" *Al Jazeera*, accessed June 18, 2022, https://interactive.aljazeera.com /aje/2017/behind-balfour/index .html.

3 Nadia Yala Kisukidi, "Geopolitics of the Diaspora," *e-flux Journal* 114 (December 2020), https://www .e-flux.com/journal/114/364962 /geopolitics-of-the-diaspora/.

4 "Mona Hatoum by Janine Antoni," *BOMB* 63 (April 1, 1998), https:// bombmagazine.org/articles/mona -hatoum/.

one of the few Palestinians to write a catalog essay on her work. For Hatoum's exhibition at Tate Britain, Edward Said wrote:

> No one has put the Palestinian experience in visual terms so austerely and yet so playfully, so compellingly and at the same moment so allusively. Her installations, objects, and performances impress themselves on the viewer's awareness with curiously self-effacing ingenuity which is provocatively undermined, nearly cancelled and definitively reduced by the utterly humdrum, local, and unspectacular materials (hair, steel, soap, marbles, rubber, wire, string, etc.) that she uses so virtuosically. In another age her works might have been made of silver or marble, and could have taken on the status of sublime ruins or precious fragments placed before us to recall our mortality and the precarious humanity we share with each other. In the age of migrants, curfews, identity cards, refugees, exiles, massacres, camps, and fleeing civilians, however, they are the unadoptable mundane instruments of a defiant memory facing itself and its pursuing or oppressing others implacably, marked forever by changes in everyday materials and objects that permit no return or repatriation, yet unwilling to let go of the past that they carry along with them like some silent catastrophe that goes on and on without fuss or rhetorical bluster.[5]

Said's words, written before the September 11, 2001, attacks on New York's World Trade Center, are prophetically resonant when considering the tragedies of the US invasion of Iraq and the ensuing war on terror. Although the condition of exile and the experience of being uprooted as a refugee due to war and violence is unequivocally tragic, there is nothing universal about that experience when race, religion, and ethnicity are taken into account under anti-Black, colonial, and imperial structures. As the recent and ongoing Russian invasion of Ukraine sets millions of refugees into exile and internal displacement, the different treatment of refugees from Asia and Africa by the European Union member states is ever more evident. One example is a 2015 Danish law that was enacted to confiscate valuable items from Syrian refugees, including jewelry, to allegedly "pay for their expenses."[6]

5 Edward Said, "The Art of Displacement: Mona Hatoum's Logic of Irreconcilables," in *Mona Hatoum: The Entire World as a Foreign Land* (London: Tate, 2000), 17.

6 Dan Bilefsky, "Danish Law Requires Asylum Seekers to Hand Over Valuables," *New York Times*, January 26, 2016, https://www.nytimes.com/2016/01/27/world/europe/denmark-asks-refugees-for-valuables.html.

Such laws become less ironic when considering jewelry, gemstones, and other culturally significant ornaments from the Levant are among the most looted and smuggled objects of colonial adventurers. Numerous museums in the West, from the Metropolitan Museum of Art in New York to the British Museum in London, have dedicated sections to such items "found" during excavations in Egypt, Syria, and across Mesopotamia. The ancient objects are kept in these collections for the alleged education of the public, research, and a collective understanding of our past: through rituals and ideas of beauty and functionality. As the discourse of reparations and return of looted objects, and a demand for transparency in the provenance of such collections, are pushed to the fore at major museums in the West, we are faced with a contemporary contradiction regarding the living conditions and the protection of objects over human beings. While numerous museums across the world have engaged in meaningful conversations to reconcile with their colonial and imperial heritage, and some have taken measures to practice restitution and return, the movement of people from the Global South to the North remains a crisis. On the one hand, there are art and cultural objects deemed in need of protection from the perils of war, turmoil, and chaos; and on the other, the human beings in need of fleeing such circumstances are barred entry to Europe or the United States.

In the 1995 sculpture *Hair Necklace*, Hatoum strings twenty-five hollow beads made of her hair into a necklace, displayed on a bust like the ones in jewelry-shop windows. The beads are

Mona Hatoum, Video stills from *Measures of Distance*, 1988. Color video with sound, 15 min. 35 s.,
A Western Front Video Production, Vancouver.

reminiscent of pearls or precious gemstones, and are more or less the same size save for the slightly larger three that create an anchor for the symmetry of the ornament. The necklace is made of organic refuse shed from a body that reproduces its cells on a daily basis. "Rootless" hair, I learn—at the time Hatoum was making this piece—could not be used to identify a person through their DNA. The necklace is a fetish object in the absence of a body, a record of dying organic matter that outlasts its subject.

When put into context, the bust reenacts a similar necrophiliac display as the colonial museum by placing elements of human remains on generically fabricated stands or pedestals. Take, for example, the Wellcome Collection in London, which holds one of the biggest collections of Palestinian amulets in the world,[7] or the numerous necklaces from Hebron in the British Museum's collection.[8] Whether or not it is a direct criticism of such museum collections, Hatoum's work is as much about displacement and exile as the historical and ongoing production of such conditions. In the aforementioned interview in *BOMB Magazine*, she states:

> I have now spent half of my life living in the West, so when I speak of works like *Light Sentence*, *Quarters*, and *Current Disturbance* as making a reference to some kind of institutional violence, I am speaking of encountering architectural and institutional structures in Western urban environments that are about the regimentation of individuals, fixing them in space and putting them under surveillance. What I am trying to say here is that the concerns in my work are as much about the facts of my origins as they are a reflection on or an insight into the Western institutional and power structures I have found myself existing in for the last 20-odd years.[9]

In her sculpture *Doormat* (1996), the word WELCOME is spelled out in stainless-steel pins facing up. Like other works by Hatoum, the doormat materializes an impossibility. When a refugee is confronted with the pins of a welcoming mat, how much choice do they have to step on it or not? The doormat, in Eastern cultures, indicates first and foremost the moment of disarmament, when one takes off the shoes as a sign of respect before entering one's own or another's house. It is in this moment of disarmament that the refugee is faced with the violence of the system that is designed to keep them barred. The pins that spell out welcome are not only physically present at the point of entry—border or frontier—but in a world of capital and domination that relies on the production of refugee and stateless peoples for the fabrication of their myths of sovereignty and protection of citizens. In the case of thousands of Palestinians who were exiled upon the creation of the state of Israel—either for those who remained in the homeland under the occupation and apartheid, the ones living in refugee

7 See Yasmeen Abdel Majeed, "A Symbol of a Lost Homeland," Wellcome Collection, December 1, 2020, https://wellcomecollection .org/articles/X71Z0BMAACMA pbYe.

8 See, e.g., "necklace; amulet," https://www.britishmuseum.org /collection/object/W_As1966-01 -832.

9 "Mona Hatoum by Janine Antoni."

camps or exiled across the world—the impossibility of a home as defined by internationally recognized borders is more manifest.

While *Doormat* is a documentation of the scene before a violent event—in this case, before stepping on the surface that is designed to puncture and bleed—*Untitled (Latin grater)* (2001) shows the evidence of harm. Hatoum made this inkless drawing by wrapping wax paper around a life-size kitchen grater and applying just enough pressure to mark the paper without tearing it. Across these works, it is the seductive familiarity of the objects that draws us in to encounter violence as a current. In the world of Hatoum, we are faced with the remnants of what Said has called a "silent catastrophe." From the restlessness in Hatoum's haptic objects to the impossibility of silence for Alaouié's narrator, exile is trivial and prescient, it is permanent and transient. I return to the words of Edward Said:

> Hatoum's art is hard to bear (like the refugee's world, which is full of grotesque structures that bespeak excess as well as paucity), yet very necessary to see as an art that travesties the idea of a single homeland. Better disparity and dislocation than reconciliation under duress of the subject and object; better a lucid exile than sloppy, sentimental homecomings; better the logic dissociation than an assembly of compliant dunces. A belligerent intelligence is always preferred over what conformity offers, no matter how unfriendly the circumstances and outcome. The point is that the past cannot be entirely recuperated from so much power arrayed against it on the other side: it can only be restated in the form of an object without a conclusion, or a final place transformed by choice and conscious effort into something simultaneously different, ordinary, and irreducibly other and the same, taking place together: an object that offers neither rest nor respite.[10]

10 Said, "Art of Displacement," 17.

Mona Hatoum, *Doormat*, 1996. Stainless steel pins, nickel-plated pins, and blue canvas; 1¼ × 28 × 16 in. Edition 2/6.

Samira Yamin, *Geometries XXI*, 2017. Hand-cut *Time* magazine; 7⅞ × 10½ in.

Pictured: Samira Yamin, *Geometries XXI*, 2017; *(Geometries) Fire IX*, 2017; and
January 11, 2010 IV, 2016.

Feminine Ecologies: Wangechi Mutu, Maya Lin, and Julie Mehretu

Chelsea Mikael Frazier

Maya Lin, *Phases of the Moon*, 1998. Beeswax; dimensions variable.

When Eileen Harris Norton began building her majestic and extensive collection, her impulse was just as political as it was aesthetic. Her interest in collecting was a reflection of the ways that she and her then husband, Peter Norton, connected and enjoyed spending their time, but it also represented an investment in the kind of economic, political, and cultural impact that she was beginning to make then and continues to make now. In a 1998 *Art Wire* profile of the philanthropist, Eileen's philosophy clarified the motivation behind her work:

> You live in the world and if you're aware and you have the ability to do something, you do it. Women's and children's issues, parenting, these are my concerns as a woman and a mother. How do you learn to be a parent? You don't get an instruction manual when you have these little people. If you happen to have a good parent, then you tend to be one. But not all of us are that lucky. So these are the things I care about.[1]

Relatedly, the present mission of the Eileen Harris Norton Foundation is "to achieve social and environmental justice through supporting organizations dedicated to education, families, and the environment."[2] Fortunately for us witnesses and students of the Eileen Harris Norton Collection, its artworks carry meanings and teachings relevant to our most pressing histories and ongoing concerns.

Given Eileen's investment in social and environmental justice, it's not hard to recognize how the works of Maya Lin, Julie Mehretu, and Wangechi Mutu found their way into the collection. In many ways, their work functions on a representational level, illustrating the kinds of colonial and state violence-wrought dysfunction that leads to environmental (which is inherently social) destruction. Even within the collection, the works of Lin, Mehretu, and Mutu resist traditional categorization that would typically disentangle the social from the ecological. Instead, Lin's subtle depictions of nature, Mehretu's slippery abstract landscapes, and Mutu's performative rituals culled together through Eileen's collecting eye reveal an inviting and instructive rubric that understands the crucial connections between artmaking, social activism, and ecological awareness.

1 Susan Cahan, "Eileen Norton: Portrait of a Collector and Philanthropist," *Art Wire* 14, no. 1 (Winter 1998): 7–8.

2 "Eileen Harris Norton Foundation Mission Statement," accessed January 30, 2023, https://ehnfound.org/.

With *Phases of the Moon* (1998), Maya Lin invites us to pause and consider alternative ways of reorienting ourselves to our understanding of time and perception. Lin, a Chinese American sculptor and environmentalist born in Ohio, first came to prominence when she won a national competition to design the Vietnam Veterans Memorial in Washington, DC, at the age of twenty-one. She has gone on to create several memorials, sculptures, and curated landscapes, with many designed to educate the public after first slowing us down. Numbers that represent hours and electronic digits that represent currency pollute our psyches at any given moment. But Lin's cyclical disks in *Phases of the Moon* call to mind a deliberate measure of time that can only be discerned via knowledge of lunar activity. And because of the moon's connection to so many other things that govern and stabilize our lives—water, storms, the climate, etc.—it's a wonder that we pay this element of nature so little attention in our "modern" world.

Each of the eight disks that compose the sculpture are created from beeswax. Crafted under Lin's sculptural hand, the disks take on a delicate energy. Much like the moon, the disks quietly grasp and keep our interest, and make us wonder about their complexities—concealed by the fact that we can only see parts of the moon throughout its cycles. The materiality of beeswax lends itself to this cycle of revealing and concealing depending on one's perspective. Though the moon is spherical, our visual ability to discern the fullness of its cycles as humans is reduced. Lin brings the limitations of our human perception of one of nature's giants to our attention in this work. When viewers surrender to this captivation, its effects are subtle, yet they remind us that there is so much more to the life-giving and life-stabilizing elements of nature that dictate our lives.

Maya Lin's *Silver River Mississippi* (2007) carries a similarly understated effect and asks viewers to reflect on the state of our rivers. In many societies historically, metals and water are revered for their preciousness: metals because of their readiness to function as exchangeable currency, and rivers as a site necessary for those exchanges. The difference between the two, however, is that water is an indispensable substance that we, as humans, would quite literally be nothing without. By contrast, we often treat metals/currency as if *they* are the primary indispensable force composing our very bodies. This misalignment of our values continues to push us into ever more trying ecological catastrophes, as an overinvestment in currency and capitalist consumption directly correlates to the terrible abuse of our fresh water supply. By constructing an aerial view of the Housatonic River in New Haven, Connecticut, Lin again plays with the perception of our relationship to this element of nature. Lin calls our understanding of the river to our attention and asks us to reconsider the amount of space that rivers/water and currency/metals take up in our minds and bodies.

Though not shying completely away from subtlety, Julie Mehretu's work in the Eileen Harris Norton Collection makes use of abstraction to disorient and help us to think and feel through the ways we organize space. In *Landscape Allegories*, for example, Mehretu asks us to consider the ways that our landscapes can hide as much as they can reveal. In Mehretu's larger body of paintings, architectural drawings, and murals, she draws from her experiences as an American born in Ethiopia and as a visual artist interested in the communities and clashes that result from European and colonial histories, as well as the histories of resistance and resilience of both people and land.

Mehretu's most famous piece to date is surely her *Mural*, commissioned by Goldman Sachs in 2010 and housed in the lobby of the investment bank in New York City. Viewers are enthralled by the many colorways and lines that appear to go and come everywhere, mirroring the energy of the city. In *Landscape Allegories*, completed in 2004, there are already whispers of the abstract lines and use of color that have become Mehretu's signature. When viewing all

Maya Lin, *Silver River Mississippi*, 2007. Recycled silver; 35 × 5½ in.

seven pieces together, the gestural marks take on an avian-like quality that visually connects each unique landscape in the series and gives them an otherworldly appeal. Another glance invites the viewer to consider the vegetal quality of the landscapes, which becomes clearer and clearer with each mark. And, with an even deeper glance, the almost faint blues, blush, and sepia tones, along with the lighter, rounded, and rhythmic gestures, invite viewers to see a waterscape or series of waterscapes.

In nearly all the pieces, the rounded and softer gestures come into focus only after an intentional gaze past the more linear and darker lines that protrude upward and outward from the gentle

gestural marks. In so many ways, the piece functions as a comment on the impossibility of social and ecological freedom given the structure of our various interconnected cultures and societies, while also suggesting the possibility of something beyond them—or underneath them. As Mehretu herself explains:

> I don't think anyone, any person from any background is living in this culture and society with the idea of freedom, like in a real kind of liberatory way. . . . To me it goes back to that same source where you're growing up in a context where the idea of your autonomy and the capability of ultimately being free is not a guarantee. And you know that from your daily lived experience—especially as a person of color or as a woman or queer person—whatever it is. And we are constantly negotiating systems of power or [constantly negotiating how to find places of freedom].[3]

The contrast between the size and depth of the lines and a consideration of the title of the series helps the viewer to consider the concealed information that our landscapes continue to hold: whispers of ancestral knowing, practices of ecological stewardship lost, play and pleasure unencumbered by masculinist and capitalist space-making and the lived experiences that make us unfree. Our spaces, though we often forget, are so much deeper and richer than the harsh and violent lines that carve into our soil, our communities, and our very bodies. Mehretu's *Landscape Allegories* encourages us to listen to, remember, and quietly discern different ways of understanding lands—just beneath the very loud lines we use to divide them.

These works of Maya Lin and Julie Mehretu focus on our relationships with our environments that are easily overlooked and that require deepened attention. They have the potential to disorient us, however gently, and provide an invitation to consider the world differently. These pieces viewed in conversation and conjunction with those of Wangechi Mutu provide another layer of this introspective process. Mutu—a painter, sculptor, writer, and performer born in Nairobi, Kenya, and living and working most recently between Nairobi and Brooklyn, New York—has never shied away from deconstructing and depicting women's histories, the archetypes imposed on them, and the ways that women are impacted by our growing ecological imbalance.

One of the most stunning lies wrought by colonialism and state violence is the idea that we can somehow disconnect from our environment. That lie has made way for us to build entire societal and cultural norms atop the idea of disconnection from our environment and therefore disconnection from our very roots. The works of Lin and Mehretu in the Eileen Harris Norton Collection make us aware of that disconnection. Mutu then, via the instructiveness of Africana femininity, maps the social histories that contribute to the disconnection *and* reconnection to and from ourselves, each other, and our environments.

In *Untitled* (2002; page 100), the colors black, white, and red frame the viewer's focus, which lands first, inevitably, on the seductive flesh of our heroine's buttocks, thighs, calves, ankles, and feet.[4] Though her buttocks and legs are exposed, the pointed black high heels that seem to shackle her feet suggest an attempt to keep her body contained even as it is exposed. By contrast, the heroine's torso is entirely concealed by a red and white bodysuit that snakes up her arms, neck, and even her face. Her face is masked, and she sports a gravity-defying and ornate hairstyle with large, brown barrel curls that mimic the roses that adorn her hair and left wrist. And in her left hand she holds a rifle by its butt, leaving it unclear as to whether the weapon is for display or protective use.

3 Julie Mehretu, "2020 Walter Annenberg Lecture," Whitney Museum of Art, 2020, https://www.youtube.com/watch?v=wuYM15Bh8Jw&t=3205s.

4 I use the word "flesh" instead of "body" to draw attention to the processes of racialization that bar certain subjects in the West from bodily autonomy. As the theorist Hortense Spillers notes, "I would make a distinction in this case between 'body' and 'flesh' and impose that distinction as the central one between captive and liberated subject-positions." Hortense J Spillers, "Mama's Baby, Papa's Maybe: An American Grammar Book," *Diacritics* 17 (1987): 206.

Everything about this image is paradoxical: our heroine's legs and buttocks are exposed yet off-limits. She holds a potentially deadly weapon but in a way that neutralizes her ability to use it immediately. Her attire (potentially a costume or even uniform) is intentionally attention-grabbing, yet her grit-toothed "smile" signals an anxiety-ridden discomfort or intense pain. We are then left to wonder, What could be ailing this bewitching figure?[5]

The legacy of chattel slavery, colonial violence, and the ways that both have produced a history of women's—and especially Black women's—sexual exploitation in the West offers clues, barely concealed by her fanciful attire, about how and why the feminine heroine might be ailing. The shackled (albeit stylishly shackled) ankles, thighs, and buttocks signal captivity and perhaps a captured sexuality. Her concealed face and head denotes an absence of a self-defined erotic subjectivity. And the figure's stationary pose and awkward handling of the rifle attests to precarious access to protection and power.

There is a paradoxical nature to being and *doing* Africana femininity. While the figure in *Untitled* (2002; page 100) offers a less-than-idealized representation of that doing, it also offers a compassionate mirroring of the kinds of splintering, cutting, and positioning for sexual consumption that Black women are forced to grit and bear. The piece is both a celebration of the flexibility, strength, and contortions Black women have mastered in their doing. The piece is also a representation of the effects of the pain and anxieties those contortions often produce in Black women's bodies and minds.

The promise of paradox and similar chromatic hues continue into another *Untitled* (page 101), but this work communicates very different ends. We catch a glimpse of our heroine mid-ritual, with eyes rolling back in ecstasy as she uses a wooden tool to pierce through her open mouth and the back of her skull, releasing red blood into a small pot. Unlike the restrained and meticulously coiffed hairstyle worn by the woman in *Untitled* (page 100), this heroine's unruly mane seems to have a mind of its own. Though she bends her head downward, her blonde, free-flowing tresses defy gravity by sweeping upward, careful not to be sullied by blood. Behind her is a full chord window filled with the sight of lush clouds, but the white of the background leaves our heroine's location ambiguous. She takes a seated position with widespread legs in black stiletto heels. A full white skirt and cream lace-ruffled top frame her bare belly and chest, and in her left hand she carries a bouquet—perhaps a sacrificial offering—of roses in blush tones.

The graceful gestures, bodily positioning, and colors of the figure in this *Untitled* are reminiscent of those in Mutu's 2012 short film *Eat Cake*.[6] When asked about her choices in that film, Mutu explains:

As you know, I often think about West African deities; there are certain deities who have retained their meaning and their history more than many others in Kikuyu culture—I was thinking about Papa Legba or Elegba of the Greedy Trickster and the idea of not being satisfied, no matter how much they're given, and about teaching lessons through tricking people. People's ways of seeing depend on where they're looking from, you know. So even though the piece is in black and white, the colors of Elegba, the red and the white, are still in there.[7]

5 My reading here is informed by Spillers's concept of the pornotrope. Pornotroping is a process of objectification rooted in racialized hierarchical systems. Spillers explains the process of pornotroping as such: "(1) the captive body becomes the source of an irresistible, destructive sensuality; (2) at the same time— in stunning contradiction—the captive body is reduced to a thing, becoming being for the captor; (3) in this absence from a subject position, the captured sexualities provide a physical and biological expression of 'otherness'; (4) as a category of 'otherness,' the captive body translates into a potential for pornotroping and embodies sheer physical powerlessness that slides into a more general 'powerlessness,' resonating through various centers of human and social meaning." Spillers, "Mama's Baby, Papa's Maybe," 67.

6 Wangechi Mutu, *Eat Cake*, 2012, video installation, beta master tape and two viewing copy Blu-ray discs, loop, 12 minutes, 45 seconds; wooden pallets, 2012, 2014.9, Brooklyn Museum, Contemporary Art, https://www.brooklynmuseum.org/opencollection/objects/214447.

7 Trevor Schoonmaker, "A Conversation: Wangechi Mutu and Trevor Schoonmaker," in *Wangechi Mutu: A Fantastic Journey* (Durham, NC: Duke University Press, 2013), 95–117.

8 Allison Sellers and Joel E. Tishke, "The Place of Esu in the Yoruba Pantheon," in *Esu: Yoruba God, Power, and the Imaginative Frontiers* (Durham, NC: Carolina Academic Press, 2013).

9 Teresa N. Washington, *The Architects of Existence: Aje in Yoruba Cosmology, Ontology, and Orature* (Orifin, Ilé Àjé: Oya's Tornado, 2014).

Conversantly, the references to Elegba through the use of the phallic stick and white, black, and red affirm that an important ritual is taking place. It also points to an unbridled erotic energy and the kinds of paradoxes endemic to spiritual happenings.[8] It is very common in many cultures globally to use blood sacrifice as a means to communicate and build bonds with more-than-human forces. Upon first glance, the scene can be read as quite gruesome, but the figure's face asks the viewer to more deeply consider the event they are witnessing. As the theorist and cultural critic Teresa N. Washington notes, "Blood is a central element of African spiritual systems, rituals, medicines, and technologies because it carries the unique and personal biological and spiritual code of its bearer."[9] For many, rituals that require or signify blood sacrifice are conduits of healing and fortification, and create pathways to experience pleasure—sexual or otherwise. Given our heroine's euphoric facial expression and references to the erotic healing power attributed to Elegba, we are free to understand this figure as an exemplification of the kinds of restorative (spi)rituals that predate colonial violence and chattel slavery.[10] Moreover, this heroine embodies an extant restorative Africana femininity and/or Neo-HooDooism that exceeds the shackles of those dispossessing legacies.[11]

In *Untitled* (pages 102–3), gruesome histories and restorative presents give way to a more speculative and idealistic rendering of potential Africana feminine futures. The smooth, tattooed legs and exposed buttocks of this third heroine draw our eyes to the center of the canvas while the reddish-brown mottled flesh of her torso, chest, and neck support her bewigged head. Roses, sunflowers, and other flora in hues of lilac, yellow, and pink compose what appears to be a car, with larger roses taking the place where wheels might be on a conventional automobile. The figure's windblown hair suggests that this contraption is in motion, and its composition of collaged organic plant life asks us to wonder what is propelling it. Perhaps the fully bloomed roses and sunflowers—as they open to the sun and sky—are functioning as the most efficient power-transmuters available. One can almost smell the fragrance of the petals solar-powering this vehicle. And in our roughly $6-a-gallon inflationary world that often hits Black women much harder than other demographics, that efficiency is beyond seductive.[12] One can almost smell the fragrance of the petals propelling the car in ways so sustainable that they can yet only live in Mutu's speculative imaginings.

Our heroine's body is reclined in a way that suggests relaxation. The alert positioning of her head, however, shows that whether driving or being driven, she knows exactly where she is going. In addition to the fragrant and fuel-efficient ride she's experiencing, the moist tongue of a white dog licks her ankle from a head protruding from the side of the plane. Within Black diasporic communities, people that embody toxic masculine traits are often colloquially referred to as "dogs," as they behave in ways that uphold a short-sighted, extractive, and patriarchal conception of women's pleasure. But in Mutu's vision, the dog appears to be of service and is all white—perhaps indicating a purification or purging of patriarchal toxicity that gives way to a masculinity capable of serving the social, economic, and erotic pleasure of women. Unlike our heroine in *Untitled* (page 101), who surrenders to the pleasure of the (spi)ritual, this figure does not appear

10 Though Mutu hails from Nairobi, Kenya, the artist's inspiration and references to Elegba—a deity and cultural figure that originated in Yoruba-land and spread throughout the West—also situates her within a diasporic formation that Greg Tate might call a Black cultural nationalist imaginary. That is to say that rather than being beholden to a particular nationalist preoccupation, Mutu's work speaks to the interplay between various Black/African diasporic cultural formations that exceed national borders. Moreover, by drawing our attention to the critiques, commentary, ideas, and speculative ideals imbued within our extant Black cultural nationalist imaginaries, Mutu's enticing heroines usher us through portals that ask us to deeply consider the possibilities and hindrances of making those imaginaries real. For more, see Greg Tate, "The Gikuyu Mythos versus the Cullud Grrrl from Outta Space: A Wangechi Mutu Feature," in *Flyboy 2: The Greg Tate Reader* (Durham, NC: Duke University Press, 2016), 216.

11 Ishmael Reed provides a multivalent definition of Neo-HooDoo. One of the most relevant to this discussion is, "Neo-HooDoo is sexual, sensual, and digs the old 'heathen' good good loving. . . . Which doesn't mean that women are treated as 'sexual toys' in Neo-HooDoo or as one slick Jeho-vah Revisionist recently said, 'victims of a raging hormone imbalance.' Neo-HooDoo claims many women philosophers and theoreticians which is more than religions like Christianity and its offspring Islam can claim. When our theoretician Zora Neale Hurston asked a Mambo (a female priestess in the Haitian Voodoo) a definition of VooDoo the Mambo lifted her skirts and exhibited her Erzulie Seal, her Isis seal." It is with this insight that Reed distinguishes Christian sexual repression in Black women (a result of ongoing colonial violence and chattel slavery) from a sovereign feminine sexual expression rooted in African traditional religions. For more, see Ishmael Reed, "Neo-HooDoo Manifesto," in *The Norton Anthology of African American Literature*, 2nd ed. (New York: W. W. Norton, 2003), 2062.

to be enraptured in ecstasy. Instead, her nonchalant expression suggests that her pleasure is an expected if routine treat rather than a rare privilege.

And in stark contrast to the softness of the organic matter and fleshy sensuousness of our heroine's body, tucked between her manicured fingers is a large handgun. Handguns, while dangerous and potentially deadly, are primarily used for protection.[13] The fact that she appears to be prominently displaying this gun while luxuriating in this indulgent ride marks an inextricable link between her preparedness to use protective/deadly force *and* her relaxed, fuel-efficient pleasure. In the face of Black women's stagnated economic mobility, inflation-driven financial pressures, and threats of heteropatriarchal sexual violence, the scene we witness here exhibits a speculative Africana femininity whereby Black women's bodily protection, erotic nourishment, and sustainable mobility are not fodder for charged sociopolitical debates, but rather facts of life built into a new world.

What connects Eileen and the fabulously brilliant artists who populate her collection is an investment in world-building. And that world-building is anchored in the principles that undergird her foundation: women, children, families, and the Earth. Their perspectives, tools, and creations couldn't be more distinct, but what brings these creators together are their consistent contributions to building the world anew. Using aesthetic, educational, and conceptual tools that are often overlooked and underestimated in terms of their potential impact on the transformation of our present world, Maya Lin, Julie Mehretu, and Wangechi Mutu encourage us to take deeper and deeper looks at who we are. As we do this, we become ever more equipped to operationalize art's potential to arm us with the tools to imagine radically healed futures.

12 John McCormick, "Inflation Is Taking Biggest Toll on Nonwhite Voters, WSJ Poll Shows," *Wall Street Journal*, sec. Politics, accessed July 13, 2022, https://www.wsj.com/articles/inflation-is-taking-biggest-toll-on-nonwhite-voters-wsj-poll-shows-11647255601.

13 According to Kevin Yuill and Joe Street, "Shotguns are generally used for hunting birds but can be deadly weapons when used against persons in close proximity. Rarely are either used in the commission of crimes. In 2014, according to the Federal Bureau of Investigation (FBI), out of a total of 8,124 murders using firearms, 262 murders were committed using rifles (including assault weapons) and 248 by shotgun. Handguns were used in nearly all other cases. Yet while they are the commonest weapon used in homicides in the United States, less than 0.5 per cent of them have ever been used in any homicide. So their primary purpose is as protection or security." For more, see Jon Yorke and Anne Richardson Oakes, *The Second Amendment and Gun Control: Freedom, Fear, and the American Constitution*, ed. Kevin Yuill and Joe Street, 1st ed. (New York: Routledge, 2017).

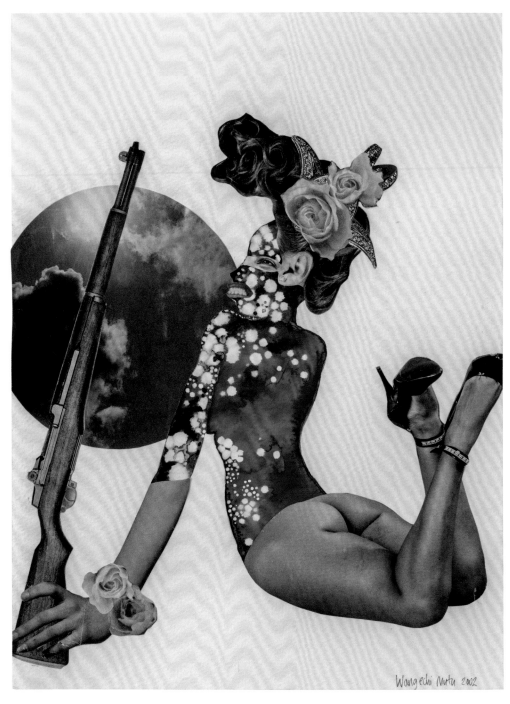

Wangechi Mutu, *Untitled*, 2002. Watercolor on collage; 22¼ × 25¼ in.

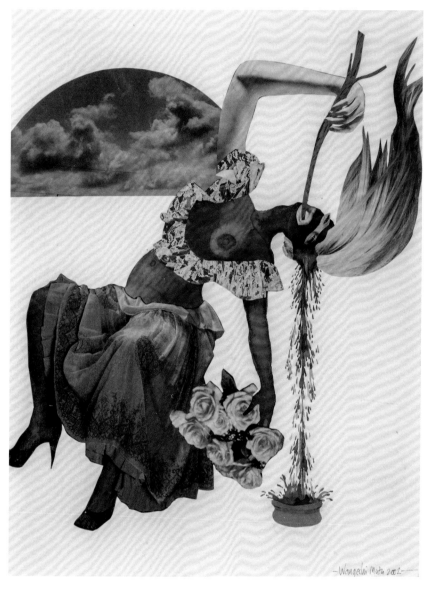

Wangechi Mutu, *Untitled*, 2002. Watercolor on collage; 19¼ × 16½ in.

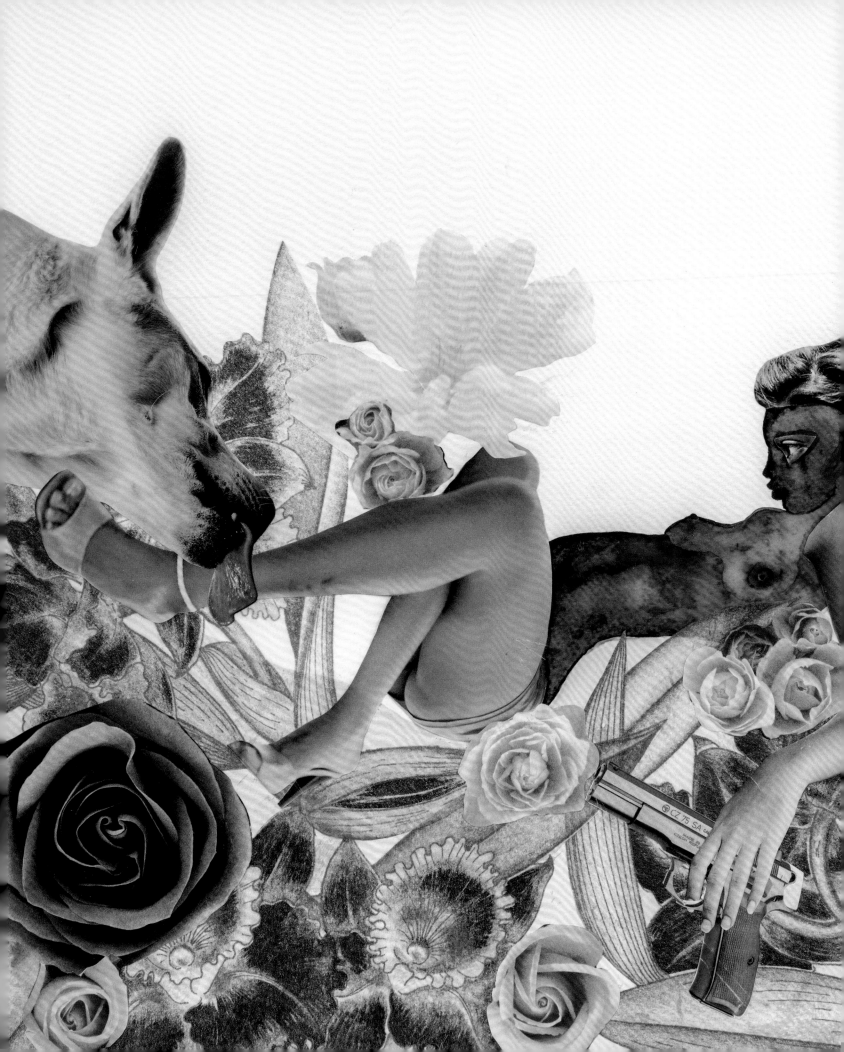

Wangechi Mutu, *Untitled*, 2002. Watercolor on collage; 19⅓ × 16½ in.

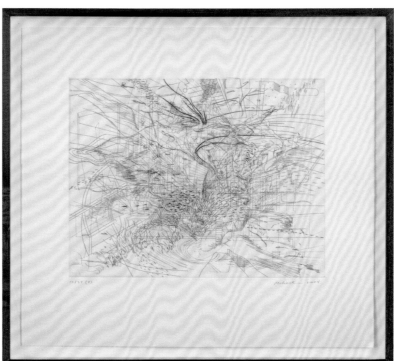

Julie Mehretu, *Landscape Allegories*, 2004. Suite of seven copperplate
etchings, with engraving, drypoint, sugar-bite, and aquatint; each:
19 × 21⅝ in. Edition 12 of 35.

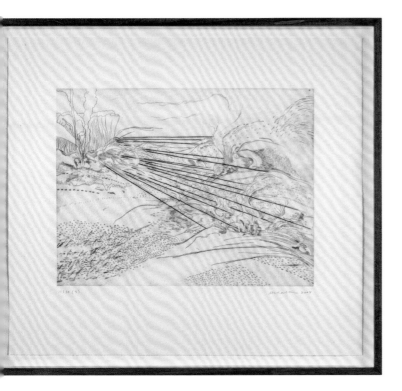

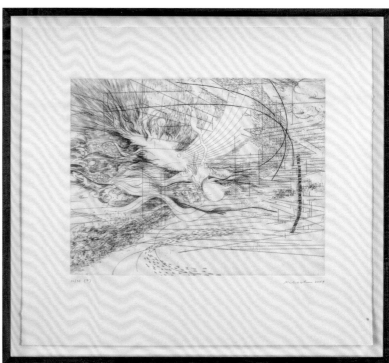

Variations on Womxnhood

Legacy Russell

Pictured: Kara Walker, *Freedom, a Fable: A Curious Interpretation of the Wit of a Negress in Troubled Times*, 1997.

In her 1997 storybook *Freedom, a Fable: A Curious Interpretation of the Wit of a Negress in Troubled Times*, the artist Kara Walker writes, "Thinking her deed done she soundly settles into / a deep meditation on the nature of her New World." Walker's pop-up illustrations engage the visual vernacular of a classic children's publication but reveal across its pages a complex modern history of an enslaved woman who, upon being emancipated, is faced with the reality of a subjection that is densely raced and gendered. Thus, Walker instructs, through a layering of text and imagery, the "fable" and fiction of "freedom" as a mythology, indicating that Black womxnhood must renegotiate and reimagine its own liberation, an expanded consciousness that requires a multivalent strategy of collective deliverance. Black womxnhood, therefore, becomes a critical agent of labor for a reversioned feminism, an impossible postindustrial self that must forcibly seize its personhood and citizenship in America, not having been historically—and perhaps, even not presently—included as a person or a citizen in the first place. In this essay I gather works from the Eileen Harris Norton Collection that render such reimagined and revised selves in this terrain of noncitizenship.

In the printmaker, painter, and art historian Samella Lewis's *Couple* (1943), the artist shows us, through a remarkable turn, three portraits blended into a fixed frame. The central one is of a Black couple, read as the primary portrait and the clear root of the work's title; the next is of a Black woman, set into the background; and the last is of a Black man, positioned in the foreground. The sight lines between the two main figures suggest they are intended to set eyes on each other and, given this, are perhaps situated within the same room, a domestic space, as implied by the corner of what appears to be a mantelpiece to the left. The print, litho crayon on paper, calls forth via its formal elements—the expressive line work, the spirited relationship between light and shadow—the style of the late Los Angeles artist and educator Charles White, a close mentor and friend to Lewis, and an early partner to Elizabeth Catlett, whom Lewis also called a mentor. Still, while Lewis draws on White as an active influence, she makes the figures truly her own, stepping away from White's distinctive technique that he continued to hone and expand as a visual language across his to-scale Works Progress Administration (WPA) works as he advanced in his career throughout the early half of the twentieth century. In this work, Lewis tenderly renders her figures with an expressivity that initially proposes

Samella Lewis, *Couple*, 1943. Litho crayon on paper; 15¼ × 11 in.

the intimacy of their relationship, codependent on their physical proximity; simultaneously, she abstracts their positionality in a way that transforms the traditions of "American scene painting," alchemizing into a work that subverts and redefines the "American scene" altogether. Thus, Lewis challenges a viewer to question the contours of an assumed reality as it is being performed—we are urged to take a closer look. The artist constructs a new and surprising dimension, one that makes it unclear which of the two figures might be drawn from realness and, further, whether the two exist—or could ever mutually exist—in a shared space and time.

Lewis's impossible couple thus becomes an editorial exercise, a collaged system of technological imaging that splices together two distinct worlds of Blackness. Read through this lens, *Couple* can no longer be dictated through its implied intimacy, but rather becomes a struggle for visibility, representation, and equity—a striving for a foreground that cannot accommodate a woman as its principal character. A gendered mash-up of domesticity, Lewis's print makes art historical nods to work she likely would have encountered across her studies as both an artist and art historian, ranging from tessellated Byzantine representations of the Virgin Mary (c. 400–1000), with its bold delineation of the eyes and a celestial orb that seems to encapsulate the duo, only furthered in its textured aesthetic by the mosaic-like crosshatch of the female protagonist's housedress; to Grant Wood's American scene painting *American Gothic* (1930; Art Institute of Chicago), which depicts a father (foregrounded with a direct gaze) and daughter (set back, sightline directing us toward her father) in front of their neo-Gothic home, another complex portrait known for blurring the line between fact and fiction. At the same time, Lewis's title of "Couple" supports in its artifice, and breaks apart in its dissent, assumptions of *partnership* and *coupledom*. To muse further: the artist could have called the work something that would have pronounced more directly the nature of the relationship (e.g.,

Mariko Mori, *Subway*, 1994. Fuji supergloss print, wood, and pewter;
27 × 40¾ × 1 in. Edition of 5.

"Lovers"); instead, Lewis triggers reflections on the labor of "couple" as a noun (e.g., "a couple,"
"the couple") in opposition to, and exchange with, that as a verb (e.g., "to couple," as in to
combine). The combination here, then, is one that is strategic as a formal device within the
artwork, intersectional with it being an economic, cultural, and social device of Black kinship,
a provocation of *woman*—and Black womxnhood—long holding the position of support beam
within the interior architecture of life and art alike.

Mariko Mori's *Subway* (1994), *Last Departure* (1996), and *Star Doll* series (two works; both
from 1998) negotiate differently the relationship, and thin line, between *fiction* and *reality*,
the surreal and *the real*. Mori's multidisciplinary creative practice explores performance as a
prompt, tool, and medium, engaging the language of *cosplay* (a Japanese portmanteau of the
English words "costume play")[1] as a means of unspooling the forms of—to
call on the words of Irving Goffman's 1956 sociological study and book of the
same name—"presentation of self in everyday life." While cosplay is often
adversely stereotyped by those unfamiliar with its politic as being stripped
of intellectualism, thereby relegated to *play space* by "the world beyond," the
labor it enacts is one that in fact does rigorous and critically queer work,
allowing for new imaginations of world space to be shaped and for the rules
of gender, race, class, and sexuality to be challenged, bent, and often broken
entirely. Mori's work across the 1990s in establishing cosplay, in particular, as
a contemporary art material, performative action, and affective intervention
with radical potential ran concurrent with the rise of "maid cafés" in
Japanese culture. The artist's *Star Doll* series functions as a study toward this phenomenon,
an extrapolation of a gamified culture that restructures the ceremony of presentation and
suggests new ways of relating to one another.

The Japanese maid café as a site was not developed to enact a marginal or counterculture,
but rather to provide a counterposition to the corporate misogyny of the "hostess club," a

1 The word was first coined in 1984
by the film producer Nobuyuki
Takahashi in response to his
visit to the 1984 World Science
Fiction Convention in Los Angeles.
Takahashi proposed *cosplay* as a
neologism in lieu of *masquerade*,
as the latter signifies a classed,
aristocratic costumery that
Takahashi felt was inconsistent
with the engagement of popular
culture as manufactured within
the broader forum and network
produced by cosplay as an
expanded culture.

Mariko Mori, *Star Doll*, 1998. Plastic doll with microphone, earphones, white boots, black and white, transparent bracelets, yellow shoulder pads, brooch, and hair; height: 10¼ in. Edition 75/99.

site of typified heteronormative commerce contingent on sexual activity between male- and female-identified persons as a core component of exchange therein.[2] Conversely, the maid café strives to redefine intimacy, turning what would be a closed, private space of the hostess club inside out, stripping it of any association with sexual pathology. The maid café of the 1990s created the possibility of an integrated space across genders, wherein cosplay of those in service to public visitors creates an opportunity to transgress assumptions of "real life" and instead collectively explore, experiment, and discover through the channels of fictional characters who, in the very impossibility of themselves, allow for a newfound freedom from the constrictive and often (culturally, socially, economically) extractive mores of the everyday. The maid café as an invention was intended to exist in physicality ("meat space") and be more dramatic than hypersexual in what it aimed to simulate. Its inspiration, however, originates digitally, from the anime computer game *Welcome to Pia Carrot!!* (1996) that engages techno-intimacy as a catalyst, with the core characters as high femmes adhering to a version of binary kawaii-

2 Patrick W. Galbraith, "Maid in Japan: An Ethnographic Account of Alternative Intimacy," *Intersections: Gender and Sexuality in Asia and the Pacific* 25 (February 2011), http://intersections.anu .edu.au/issue25/galbraith.htm.

3 *Kawaii* is Japanese in its etymology, meaning "cute," "tiny," "lovable," and often engages the tropes of the cartoon in physical or aesthetic presentation.

babedom[3] that assumes the consumption of a masculinist gaze.[4] Mori's *Star Doll* bridges the corporeal and virtual, twinning miniatures that turn the lens on Japanese celebrity and the manufacture of gendered ideals therein, what the artist has deemed a "virtual pop star."[5] The artist's investment in a sort of consumerist simulacrum as an essential engine of place-making underscores what the French philosopher Jean Baudrillard states plainly in his 1981 treatise *Simulacra and Simulation*: "simulating is not pretending."[6]

While one could argue that the simulation made in Mori's works interacts directly with a world shaped by postindustrialism, postmodernism, and neoliberalism (and even, perhaps, casts these as being active collaborators within her "sets" as staged constructions), Mori's *Subway* brings the weird fantastic of womxnhood as a silver cyborgian being to the fore, a dreamscape of a future body. Here, Mori performs as a celestial space traveler or alien species on Japanese public transportation, documented as moving through the car alongside Japanese businessmen and other passengers, all of whom appear not to notice that she is standing in their midst. The interiority of the train car is made more pronounced by the subway doors open to the platform, where three figures look on, the only people in the frame who seem to acknowledge the presence of the artist and, perhaps, the person behind the camera. *Is she invisible—and does she exist?* The lack of reaction to Mori's presence is in and of itself alien, suggesting that perhaps the other passengers have themselves traveled from another planet. The artist's inversion of the ordinary and extraordinary via this extraterrestrial turn shifts the power dynamic in her own self-representation; Mori's self-portrait, then, establishes a visual narrative that runs counter to the acts of looking as depicted across art history. The artist presenting in a femme form is not used as a prop or trick to produce or reify the formal elements of the image, but rather her very presence underscores the exhausting performance of *normal*, a classed and gendered simulation that renders extinct the potential life of new species both on this planet and beyond into interstellar outer space. Mori's otherworldly adventuring is furthered in *Last Departure* (1996). This series of photo-manipulated images stages the artist in triplicate in what appears to be a spaceship, but structurally, in its steel buttresses, fluorescent strip lights, and reflective glass, infers the modernity of a new-age airport or deserted shopping mall at midnight. Mori's commitment to, in the artist's words, "someone who needs to be created"[7] suggests that the impossibility of womxnhood (and femmehood) as being made absent from the shaping of what human should be defined as creates an opportunity to propose new directions. These refractions structurally queer the body of color as a cosmic architecture antagonistic to a traditional blueprint. To call on Busta Rhymes and Janet Jackson's futuristic 1998 music video, which echoes Mori's cybertypic-bionic aesthetic, "What's it gonna be?"[8]

Women of color, constantly in a cooperative struggle for new freedoms, experiment, discover, and territorialize through the delineation of a remodeled or remixed self-image. In the mixed-media artist Paula Wilson's *Remodeled* (2007), the artist brings together the techniques of woodcut, offset lithography, silkscreen, and collage in a rendering that depicts a female-presenting Black person in the middle ground gazing up and into what appears to be a Greco-Roman vessel in the hydria or amphora shape. Reimagined by the artist in its decoration and departing from the well-recognized geometric patterning or mythological characters of such objects, Wilson's vessel, positioned in the foreground and with elevated hierarchy to all else in the frame, presents a pastoral scene of femme frolicking in flora and avifauna. The relationship between the vessel and the figure suggests a domestic albeit aristocratic interiority; however, the background, cragged with colorful hues of red and blue mountains, dotted with a wild terrain

4 Erica Baffelli and Keiko Yamaki, "Maids in Akihabara: Fantasy, Consumption, and Role-playing in Tokyo," *Journal of International Economic Studies* 32 (2018): 117–37.

5 "Star Doll (for Parkett no. 54)," MoMALearning website, https://www.moma.org/learn/moma_learning/mariko-mori-star-doll-for-parkett-no-54-1998.

6 Jean Baudrillard, *Simulacra and Simulation*, trans. Sheila Faria Glaser (1981; Ann Arbor: University of Michigan Press, 1994).

7 Dominic Molon, *Mariko Mori* (Chicago: Museum of Contemporary Art, 1998), 3.

8 Busta Rhymes and Janet Jackson, "What's It Gonna Be?!," 1998, video, 1998, 4:31, https://www.youtube.com/watch?v=hUxNoK1ykNo.

of silvery trees, and with a glittering amber-yellow horizon, shows a landscape that appears to be untouched by the colonial imperiality of civilization, a world that blurs an environmental utopia with a Jurassic fantasy, as suggested by the two Brachiosauruses arcing necks toward each other, sited at the distant shore. Thus, the Black woman in the center of the frame is suspended between two worlds, time-twisted with her back against a prehistory that, as she looks upward and outward, exists only in the decoration of objecthood made material by the vessel set onto the table before her.

Whereas in Samella Lewis's *Couple* the relationship between the two main figures must be negotiated through their gender performance, in Wilson's work we see the artist propose a new type of self-portrait, rendered through a mirrored image, with the Black woman encountering the decorated vessel as if peering at her own reflection. If Claude Cahun's *Self-portrait (reflected image in mirror with chequered jacket)* (1929) broke a mold in showing us the mutability of white lesbian representation—the French photographer depicting herself in a man's jacket, confronting the gaze of the viewer while their mirrored image creates a novel window, a view to a world beyond this world—Wilson shapes a conceptual and historical dialogue of Black womxnhood through the duality of *Remodeled*. The artist draws a line between *Blackness-as-object* and *Black-woman-as-objecthood* in this mirrored vision as it is cast. The vessel, then, assumes the heavy laboring of holding up a reflection to all that lies in the background, bringing into lively being and becoming an unrestrained and playful version of femininity and womxnhood that historically Blackness has not been an empowered agent within, and which Black womxnhood, rarely lent the agency of a holistic humanity, has been excluded from altogether. Wilson's decadent vessel thereby *is the remodel*, a daring turn in its excusing Black womxnhood from having to carry the responsibility of, to heed the artist Lorraine O'Grady's words, "Olympia's maid . . . a robot conveniently made to disappear into the background drapery."[9]

If Mariko Mori's cyber-infused simulations instructs us toward, as Jack Halberstam might indicate, "prosthetic extension, dildonic substitution, inauthentic routes to non-redemptive, anti-capitalist, somatic insurrection,"[10] the Cuban American performance artist, sculptor, painter, and video artist Ana Mendieta flips the broadcast of a Fordist cyber-celebrity as a potential counterposition to the failed state of womxnhood, airing live on a different channel altogether. In Mendieta's series *Untitled (Cosmetic Facial Variations)* (1972), featured in the plates section of this volume (page 183), the artist makes use of ordinary materials—a brown stocking with runs pulled over the artist's face, a wig in myriad formations, shampoo that makes a sculpture or mask out of the artist's hair—to transform herself into someone—some*thing*—else. Mendieta in these remodeled self-portraits does not strive to achieve a humanness but rather leans into and gears toward a wild strangeness of presentation that destabilizes and alienates any pattern of bodily recognition.

The playfulness of the artist's images of her instrumentalizing her hair as an artistic medium—an antenna, a helmet, a pair of goggles—stands in sharp contrast to Mendieta's photograph of herself with a stocking pulled over her head. In this image, the stocking distorts the artist's facial features into a ghoulish combination, a gentle action of using a gendered material in a "failed" function as it is applied on the head, rather than the legs, that makes the constrictive force of the material a newfangled violence to Mendieta's corporeality. The artist's unwillingness to allow for the act of imaging herself to be flattened as aesthetic or made complacent is further expanded in the series of photographs wherein the artist dons different colored wigs. Mendieta here becomes an impish redhead, a demonic blond, and a brunette whose facial

9 Lorraine O'Grady, "Olympia's Maid: Reclaiming Black Female Subjectivity," https://lorraineogrady.com/wp-content/uploads/2015/11/Lorraine-OGrady_Olympias-Maid-Reclaiming-Black-Female-Subjectivity1.pdf.

10 Jack Halberstam in foreword to Paul B. Preciado, *Counter-sexual Manifesto*, trans. Kevin Gerry Dunn (New York: Columbia University Press, 2018), xiv.

distortion haunts and unseats any gendered expectation of a "pretty picture." Through this turn, the artist refuses the theft of looking, electing an oppositional gaze. Mendieta reveals through the ritual of these performative exercises only a small selection of the multitude of selves concealed by the insistence of a singularity of gendered form. In this way, she shifts the application of cosplay, the act of costumed playtime no longer contingent on a simulation that draws from elsewhere, but instead draws its root of origin from within and seeks to chart, map, and diagram its endless possibilities. Mendieta's photos are a record of this wilderness, an endlessness uncontained.

The Japanese author Yukio Mishima writes in his 1960 novel *Star*, "Eyes, countless as the gravel at a shrine, pressed in all around me. They found their center—my image coalesced.... I became a sparkling apparition, like a scepter thrust against the sky. The apparition is ravaged by the business of the performance." The apparitions offered by Lewis, Mori, Wilson, and Mendieta in the Eileen Harris Norton Collection are variations on womxnhood, instructions for future bodies, protections against the ravaging of performance as business rather than a right of being.

Paula Wilson, *Remodeled*, 2007. Relief woodcut, offset lithograph, and silkscreen with hand-coloring and collaged elements; 27½ × 34 in. Edition 6/15.

Kara Walker, *The Means to an End . . . A Shadow Drama in Five Acts*, 1995.
Aquatint and etching on light cream Somerset Satin wove paper; each: 34⅞ ×
23⅜ in. Edition 1/20. Publisher: Landfall Press, Inc., Chicago.

Roundtable Discussion

Taylor Renee Aldridge
Susan Cahan
Kellie Jones
Kris Kuramitsu
Lowery Stokes Sims

Taylor Renee Aldridge (T.R.A.):
Let's begin by stating your name and where you are in the world at this moment, then I'll go into the questions. Kellie, do you mind starting?

Kellie Jones (K.J.):
I'm Kellie Jones, Hans Hofmann Professor of Modern Art and chair of African American and African Diaspora studies at Columbia University in New York, on the ancestral home of the Lenape. And we pay homage to them.

Kris Kuramitsu (K.K.):
I'm Kris Kuramitsu, and I'm an independent curator based in Los Angeles.

Lowery Stokes Sims (L.S.S.):
I'm Lowery Sims, sitting in my favorite chair with a heating pad on my back, in Baltimore. I was an educator and curator at the Met, the director of the Studio Museum in Harlem—when I met Eileen Norton—and then chief curator at the Museum of Arts and Design. I am an independent curator and art historian.

T.R.A.:
Absolutely. Love it. Susan?

Susan Cahan (S.C.):
Susan Cahan. I'm currently the Dean of the Tyler School of Art and Architecture in Philadelphia, and I am also speaking to you from the ancestral home of Lenape.

T.R.A.:
Lovely. Lovely. And I'm Taylor Renee Aldridge. I am the Visual Arts Curator at the California African American Museum (CAAM). I am currently in my office here in Los Angeles. So let's begin by grounding the conversation in some history, and specifically the scholarship of Susan and Kellie. The history you have both offered up about postwar art in Los Angeles and New York, respectively, featured in your projects *Mounting Frustration: The Art Museum in the Age of Black Power* and *South of Pico: African American Artists in Los Angeles in the 1960s and 1970s*, really colors the backdrop of the art world that Eileen Harris Norton grew into as a collector and later influenced in the 1980s until the present. Can you briefly describe the climate of the art world for artists of color and women artists working in the avant-garde during the 1960s and 1970s, and how this was or was not recognized by museums?

K.J.:
Yes, as you're saying, how were women artists recognized . . . or not? I think they were beginning to gain more recognition in the 1970s and 1980s. However, so much has been revealed since then in recent projects like *We Wanted A Revolution: Black Radical Women, 1965-1985*, curated by Rujeko Hockley and Catherine Morris, Brooklyn Museum (2017); *Howardena Pindell: What Remains to be Seen*, curated by Valerie Cassel Oliver and Naomi Beckwith, Museum of Contemporary Art, Chicago (2018); *Just Above Midtown: Changing Spaces*, curated by T. Lax (Thomas [T.] Jean Lax) and Lilia Taboada,

Museum of Modern Art (2022); and recent solo shows of the work of Senga Nengudi, Betty Blayton, and Maren Hassinger, to name a few.

We see artists like Carmen Herrera get a solo show at the Whitney Museum of American Art at 100 years old; luckily, she lived to be 107 so she could experience that success. Betye Saar is another one; she gets her first European show when she's in her nineties. You can add to that Lowery's being the first, and for decades, the only, Black curator at the Metropolitan Museum of Art. That really speaks to what women have faced.

To paraphrase a statement by critic Lucy Lippard when she first turns to the work of women artists, she says she finds women artists working in the corners of men's studios or in kitchens and storerooms. If you look at one widely circulated photo of Betye Saar, she's right next to a refrigerator with all these works, one of which is *Black Girl's Window*, now in the collection of the Museum of Modern Art. So I think it shows you that while some women artists were certainly making strides, these advancements were hard-fought.

As a professor, I was struggling to diversify the canon and maybe not thinking as much about the gender piece. Over time I began to think more along the lines of: "What if the history of art was taught as the exploits of women, the successes of women, the works of women?" I was spurred on by students who said, "You discuss a few women artists, but we really want to know more." That kind of dialogue has helped expand my research.

S.C.:

I would say that the word you used in your question, Taylor, is *communities* plural, because there were a range of places outside the museum world that were showing work by artists of color and work by women, even commercial galleries—like Cinque [Gallery] and Acts of Art, Inc.[1] But attention being paid to, say, African American artists—mostly men, but also some women—didn't really begin until the late 1960s. And it was in response to lots of pressure, lots of protest, and changes in cultural values. It was no longer acceptable for museums to ignore what was going on in this society at large. And so there was this moment in the early seventies when most big museums did something. One of the first programs was The Brooklyn Museum's Community Arts Gallery. There was the show at the Whitney, *Contemporary Black Artists in America* in 1971. The Brooklyn Museum had a community arts gallery. Of course we should talk about the Studio Museum because it was a forerunner in all of this, founded with support of the Junior Council at the Museum of Modern Art. But after this burst of activity, by the mid-1970s, things really came to a grinding halt. And there have been a number of theories about why that happened. I think this is because the efforts to integrate museums were being executed by people who did not have deep knowledge. Most of the curators who were employed in the major institutions knew very little about art that was outside the canon. If you look at the big shows at major museums that were done in the early 1970s, you'll see a lot of the same artists reappearing. There wasn't capacity for more inclusive exhibitions without major structural change. And that's why Lowery's appointment at the Met was just so pivotal. When the big shows stopped, a new phase began, in which exhibitions of work by artists of color and women artists became tacked on. The integration of museums became a new kind of segregation. So you would have a projects program where artists of color and women would be shown, not in the main galleries, not in big exhibitions, but in these ancillary areas. These programs were often framed as being for emerging artists. And that raised the question: "Well, why is it that artists of color and women are always characterized as emerging?" <laughs>. And I think that that speaks to what Kellie is talking about: a hundred-year-old artist being characterized as an "emerging" artist. What we've seen in recent years is due being given to many artists who were showing in the early seventies in museums and in commercial galleries, and who then stopped having opportunities. We're seeing a resurgence, and Kellie has played a big role in exhibitions that she's done. Like the . . . What was the abstraction show, Kellie, at the Studio Museum?

K.J.:

Energy/Experimentation: Black Artists and Abstraction 1964-1980, Lowery's introductory essay I've revisited recently. Lowery's on-the-ground narration of how that took place, I think, is important.

S.C.:

To move a little bit forward in time, Eileen became active in contemporary art when people who had been part of that moment in the early seventies moved into positions of greater authority and influence. For instance, Marcia Tucker, who got fired from her job at the Whitney Museum for organizing what were considered "radical" exhibitions.

1 Cinque Gallery was founded in 1969 by artists Romare Bearden, Ernest Crichlow, and Norman Lewis to exhibit African American artists and offer educational programs. The gallery was named after Joseph Cinqué, the leader of the *Amistad* revolt of the 1830s. For over thirty years, Cinque organized more than three hundred exhibitions in a variety of New York City spaces, as well as regional traveling exhibitions, before closing in 2004. Acts of Art, Inc. was located in Greenwich Village, founded by artists Nigel L. Jackson and Pat Grey. Acts of Art, Inc. focused primarily on exhibition work by Black Americans and was integral to the Black Arts Movement of the 1970s. https://www.aaa.si.edu/exhibitions/expanding-the-legacy-new-collections-on-african-american-art/cinque-gallery-records.

She founded the New Museum of Contemporary Art in 1977. She was a torchbearer. I and others were drawn to the New Museum because it was an institution devoted to rethinking value systems in the museum world. Eileen joined the New Museum board of trustees in the late eighties. I think it might have been 1988 or 1989. I was the Curator of Education when she joined the board's Education Committee. And it was just fantastic to have her there because she had both an art world perspective, but also a human perspective. Having been an ESL [English as a Second or Foreign Language] teacher. She really understood the value of art within education and the value of education in general.

T.R.A.:

Kellie, did you want to chime in a bit more on that question?

K.J.:

Yes. I forgot to speak about LA because I got so passionate about the general idea of women <laughs>. Going back to my own book [*South of Pico*], I write about women who animated a lot of the change—people like Suzanne Jackson, Samella Lewis, and Ruth Waddy—and I can't wait to talk further about that kind of connection with Eileen. Thinking about Eileen in California and that time and also comparing institutions like the Whitney and the Los Angeles County Museum of Art [LACMA], and how LACMA did things a little bit differently. LACMA did have Black board members they started to bring on in the 1970s. It was a municipal museum; it had different people to answer to. So I think the response was different. LACMA had Black guest curators earlier than some place like the Whitney. The LA art community, as I argue in *South of Pico*, was different because it had the luxury to be more experimental, in some ways, because New York was the center of things. These were both strong communities of Black artists and certainly the driving force of women, and a lot of this is important.

T.R.A.:

Thank you for bringing up the women's movement, in particular. I'm thinking a lot about the New Museum, and Faith Ringgold's recent retrospective, which was long overdue, and how she, as well as her daughter, Michele Wallace, were so integral to a lot of those protest movements in the seventies in the art world. I want to bring in Lowery here on this next question. Lowery, you lived and made insurmountable impacts on museums during many radical shifts that took place in the wake of the exhibition *Harlem on My Mind* (1969), which received a lot of criticism because it was primarily an anthropological sort of survey from the outside looking in on the Black community in Harlem, in New York, in the 1960s. And you came to the Met in the wake of this exhibition after a bit of controversy. This was also in the midst of the Black Arts Movement, the women's movement, civil rights movement of the 1960s and beyond. In the oral history belonging to the *!Women Art Revolution* archive at Stanford University, which was recorded in the early 2000s, you talk about the impetus for your curatorial career and how it was rooted in this desire to contribute to the record, and the influence of acquisitions of museum collections, and how the curator has power to really influence that particular record within museum institutions. Can you share what was guiding your acquisition desires as a curator during the beginning of your tenure in the 20th Century Department at the Met Museum, and how it might have changed over time before you left in the 1990s?

L.S.S.:

In the seventies through the eighties, my work was haunted by *Harlem on My Mind*. I think that I was lucky to start out in the Community Programs Department at the Met. That was controversial because I was really hired to replace another Black woman, who had been let go. The Met was trying to avoid the appearance of a racist, gendered situation, which I knew about from the beginning. So from the beginning of my time at the Met, I had to define how I was going to deal with the administration. Coming into Community Programs at the time, which was headed by Susan Bader (who ironically ended up here in Baltimore) and then by Cathy Chance. What that did was it gave me an instant opportunity to meet artists, because we were doing workshops and outreach into the community, and the people who we were hiring were artists. I was also doing exhibitions with smaller arts organizations like Snug Harbor and the American Indian Community House. The Met was almost instrumental in starting the Bronx Museum and the Queens Museum. So, in the midst of dealing with artists and their needs and their desires and their ideas about institutions, I was often taken to task for things. Benny Andrews was my friend, and my nemesis, in this. It was a kind of lucky start for me because I began to sort of develop a cohort that really has stayed with me till today. You know, we're talking about women artists not getting their due. I mean, I just got back from spending time in Europe with my sister, and almost immediately, got on a plane to go out to Berkeley for the opening of Amalia Mesa-Bains's first full retrospective—at the age of eighty. Jaune Quick-to-See Smith is going to open in April at the Whitney, and she is eighty-one, almost eighty-two. So we

used to have a joke about women artists, that all you had to do was live long enough <laugh> and you might get your show. Thank God it's changed for the generation that really emerged after 2000.

But the first move for me was to get from Community Programs into a curatorial department. And that was the hardest thing to do. And it didn't necessarily have anything to do with my color. It had to do with the usual museum relationships between education and community outreach and curatorial departments. The line was drawn. Fortunately, I made friends with Henry Geldzahler, the pioneering Met curator of 20th Century Art. Even when the museum hesitated, my advancement was helped by the fact of the politics of the funding for the museum by New York City. Eleanor Holmes Norton was running the Equal Opportunity Commission for the city and really had said to the Met, if you want this money from the city, you have to do something to diversify your institution. So I was essentially the right person at the right time. It was kind of messy the way these things always are, but it all resolved itself. But it was tough. So I became curator in 1975. It wasn't until Henry left the Met and Bill Lieberman, a curator at MoMA, came in 1979 that I could even begin to have conversations about acquisitions. I was just trying to get my bona fides, trying to establish relationships, trying to normalize things, doing all sorts of research in the archives. Trying to figure out how Black artists fit into this whole history.

Tom Hess came to the Met as a kind of consulting chairman. He unfortunately died in the office after five months. So I'm appointed assistant curator, acting in charge of the department while the administration and trustees were trying to figure out what to do with the department. So I basically saw my job as holding the department together. There, during that moment, one of the best things that happened was I did a studio visit with McArthur Binion. And Mack had done these interesting groups of drawings, and I said, "Mack, how much are these drawings?" He said, "They're a hundred dollars." And I said, "Oh, hmm." He says, "I need some money, Lowery." So I went home that night and called ten friends and told them to send me a hundred dollars, and I got a thousand dollars. We got the drawings, but otherwise the museum did not allow me funds that were available to the department. When Bill Lieberman came—Bill was a very complicated person, but he prided himself on being a liberal. So Bill and I would negotiate things, back and forth, and I was able to initiate some great acquisitions of work by Faith Ringgold,

Kay Walkingstick, Jaune Quick-to-See Smith, Elizabeth Catlett, Beverly Buchanan, Betye Saar, Lorna Simpson, and Magdalene Odundo—not to mention male artists like Robert Colescott, Bill Traylor, McArthur Binion, and Fred Brown. When Sheena Wagstaff took over the department, she wanted to know how did I get all these women and all these artists of color into the department? She asked me what my strategy was. And I told her there was no strategy: each one of those acquisitions was a crime of opportunity. That's exactly what I did. And slowly we began to build the presentation of BIPOC artists.

So throughout the 1980s, while I'm working at the Met, my real work was happening outside the Met due to all those relationships that I had built up during my years in Community Programs. This is the moment of postmodernism, the deconstruction of the canon, identity politics, and stuff. So I was building up a cohort of friends, and I would say over the rest of the period till I left the museum in 2000, they were important resources for me. I was able to get acquisitions of their work slowly and really build up a sense of community. I was thinking about how, by the time I get to the nineties, there are a couple of shows that really defined . . . Susan, you know about *The Decade Show* (1990), which was the statement about identity. The beautiful thing about it then was that it was all us people of color coming together. And in that weird convection, women artists did have a good presence, I would say. Wouldn't you say that, Susan?

S.C.:

Absolutely, absolutely. And I think that might have reflected the fact that the three museum directors who worked together, Kinshasha Holman Conwill [Studio Museum in Harlem], Nilda Peraza from MOCHA [Museum of Contemporary Hispanic Art], and Marcia Tucker [The New Museum], were women who were feminists.

L.S.S.:

Exactly.

S.C.:

Yeah. And it was a very inclusive show because it was a collaboration between a museum that was Black identified, a museum that was Hispanic identified—the Museum of Contemporary Hispanic Art—and the New Museum, which was predominately white but trying to be more. The show also included Indigenous American artists and Asian American artists and talked about issues of gender identity and sexuality, and was trying to be as inclusive as possible across many dimensions.

L.S.S.:

Right? And coinciding with that, you had Jeanette Ingberman and Papo Colo at Exit Art doing this program that they call Parallel Histories, where they were using this idea that there wasn't a single canon, that there were many canons that came together, and that it was really about an inclusive art history. And then right soon after *The Decade Show* opened in 1990, they opened their show called *The Hybrid State*, which was really sort of talking about this hybridity there that would happen when you got all these different cultures together, and the commonalities as well as the distinctions that would emerge from that. Then by the end of the nineties, I was on the board of Art Matters and we published a book. I think it was called *Art Matters: How the Culture Wars Changed America*. And essentially that was a compendium of essays talking about all the issues that came up because of the culture wars about appropriate imagery, sexuality, especially the HIV/AIDS epidemic. So these are the kinds of experiences that I was having outside the Met that were really informing my point of view. I would say that by 1995 when I finished my doctorate, thanks to Jennifer Russell, I finally got promoted to full curator. The museum sort of changed. They started paying attention to the art I cared about. I think in that sense, the curatorial grant that I got in 1998 from Peter and Eileen was the affirmation of a lifetime.

T.R.A.:

Thank you so much, Lowery, for speaking to the sort of creative insurgency you had to do to allow the institution to catch up to you so that you can empower them in perpetuity. I want to transition to talking about the other side of the art world. We've grounded the conversation in the museum side and curatorial work. Now I want to transition into talking about patrons and the Norton Family Foundation. Susan, you worked with the foundation as curator of the Norton Family Collection from 1996 to 2001, and Kris, you began working with the collection in 1996 as assistant curator and more exclusively with Eileen's collection in 2001. Can you both describe the contemporary arts landscape during your respective tenures and how that informed your engagement with the collection? And if you can recall some of the most memorable pieces by women artists that you acquired during your time with the collection?

S.C.:

I started working with the Nortons in 1996, and I met Eileen through her and Peter's involvement with the New Museum of Contemporary Art. As Lowery mentioned, *The Decade Show* opened in 1990, and that was a really big event within the art world. It was unlike anything that had, I think, ever happened before. Because not only was it a collaboration amongst three museums, but the installation of the work was not segregated. There were themes that mixed up artists from different backgrounds and different identities, or who identified in different ways. Each of the three venues had a mixture of artists that were presented thematically. And so the idea was that that type of installation would encourage the constituents of each of the institutions to visit the other institutions and mix. So when the Nortons invited me to come and work with them in 1996, I knew that there was a great affinity in our points of view. I never had to ask them to define what they were interested in and they never asked me to define <laugh> what I was interested in. It was really a like-mindedness and a shared interest in art that didn't necessarily conform with what was being recognized by the art market or by the art establishment. A lot of the artists that interested them were making strong propositions in their work and doing so very boldly and not shying away from confrontation. For example, there was a piece hanging in the house in Los Angeles, right next to the front door, that was a flag made out of nooses by Gary Simmons. Their approach to collecting was not held back by any self-censorship or constraints. That was really exciting. The first acquisition that I ever proposed was Kara Walker's *African't* (1996). It was on display in SITE Santa Fe. This was September of 1996. I had been working with them for I think three days <laugh>. *Selections from the Norton Collection* was on view at SITE Santa Fe in addition to the biennial. And this piece was presented in the biennial. It was a fantastic piece. I recommended that they buy it, and they did. And I think they were a little stunned that I suggested that piece because it was probably like the biggest, most ambitious piece that they collected. It was a turning point for the collection, where they were going beyond what they used to refer to as "apartment-sized art," even though of course their home could accommodate pretty much anything. So that was really important. Taylor, in your [*All These Liberations*] introduction, you talk about Liza Lou's *Kitchen*, which also is the kind of artwork that is not super practical for most art collectors unless they have an exhibition space. And that would be an example of how the Nortons used their resources to support artists working on a large scale. Because I thought the vision of the Nortons was so important, and Eileen's vision was so important, that I really advocated for them to be more ambitious in their collecting. When I started working with them, I thought, I'm going to go work for the Nortons. I'm going to find out what makes them tick, and then I'm going

to go back into the museum field and I'm going to cultivate art philanthropists that are as adventuresome as they were. And after working with them for a couple years, I realized that, no, this is unique. You can't replicate that combination of generosity and daring because it's rooted in who they are. I would say that one of the big points of emphasis in the collection had to do with confounding notions of identity and breaking out of boxes. You know, looking at identity as a construct, as something that is almost playful. A lot of work in the collection has this incredibly strong sense of aesthetics, materiality, and inventiveness, coupled with political content. I would call it social commentary with world perspectives that didn't necessarily otherwise have a platform in the mainstream art world at that time.

T.R.A.:

Yeah. Thank you for that, Susan. Kris, I'm really excited to hear from you as someone who worked with the collection more recently. Are there any memorable pieces that you want to remark about and share with us?

K.K.:

It was so nice to hear Susan talking about the collection and the work that we did together. This whole conversation is really a trip back in time to the very beginning of my career. I started working for the Nortons when I was a graduate student. My initial job was filing slides and typing letters to galleries when there were still slides <laugh> and when we still wrote letters. It was truly an amazing education. The role that Eileen has played in the art world—as a patron and a collector—I think articulated and instantiated a shift in the art world as a whole. Eileen's collecting and philanthropy became a powerful platform to amplify a very expansive notion of art. When Eileen would collect an artist's work, that act would draw a lot of attention. She became a trendsetter in the most positive, generative way. I particularly remember an early visit to Wangechi Mutu's studio, looking at her collages and drawings, which led to Eileen's early support of her work.

T.R.A.:

Thank you Kris for invoking the Mutu *Untitled* works in the collection, which I believe were made around the time of her solo show at the Jamaica Center for Arts and Learning?

Susan, I want to come back to this point of play with regard to identity that you brought up a short while ago, to discuss one of the Adrian Piper pieces in the collection: *Self-Portrait Exaggerating My Negroid Features* from 1981, which later influenced the [Glenn] Ligon piece by a similar moniker, *Self-Portrait Exaggerating My Black Features and*

Self-Portrait Exaggerating My White Features, made in 1997. Both works have connections with Eileen's collection over time. The Piper piece is in Eileen's collection and featured in this volume. Can you talk about your engagement with the Ligon piece and how it configured into your work with the collection specifically?

S.C.:

The Nortons had been collecting Glenn's work at the time of his exhibition at the ICA in Philadelphia, his first survey show. And there was a piece in the exhibition, *Self-Portrait Exaggerating My Black Features and Self-Portrait Exaggerating My White Features*, which engaged with other works in the collection that challenged essentialist notions of identity. Such as Yasumasa Morimura, who makes photographs

Adrian Piper, *Self-Portrait Exaggerating My Negroid Features*, 1981. Pencil on paper; 10 × 8 in.

of himself as female characters, and Cathy Opie, whose photography, her very dignified portraits of transgender people, and gay and lesbian people, as well as people involved in the S/M community, really confounded the way in which marginalized communities were represented in the art world. So Glenn's piece, as you mentioned, was kind of riffing on Adrian Piper's *Self-Portrait Exaggerating My Negroid Features*,

which Thelma Golden was responsible for bringing into the Norton collection. The two pieces confound notions of racial phenotype—the idea that race is based on observable characteristics. In Glenn's case, there are two identical self-portraits with texts that, paradoxically, almost whimsically, separate racial identity from physicality. Both Glenn's and Adrian Piper's pieces play with the idea of race.

And I would wholeheartedly agree with what Kris said about Eileen, she really was—is—fiercely independent, even though she enjoys engaging and exchanging ideas with all types of people. She has a very strong sense of groundedness. And within that groundedness there's a kind of freedom to play with ideas that are not necessarily at the center of the mainstream art-world discourse. Actually, there's one more piece that I want to talk about. The Mona Hatoum *Silence*, which is a crib made out of glass. I believe I recommended it for the collection. Kris, It might have been you <laugh> but that piece, I felt very much spoke to Eileen's sensibility as a mother, because she is a very, very caring mother. And in my observation, she was always like that. That piece talks about the fragility of childhood. It talks about the fragility of mothering. It also talks about transgressing taboos and breaking silences. So that piece to me is always identified with Eileen's identity as a collector and a mother at the same time.

T.R.A.:

Thank you for that, Susan. I'm also thinking about *Measures of Distance* and the intergenerational conversation that happens there between mother and daughter about gender, sexuality, and patriarchy; these really taboo things, which are present during political upheaval in Beirut.

S.C.:

Yeah. And you know, I think with *Measures of Distance* there's an intimacy. There are images of Mona's mother in the nude but obscured by Arabic text.

T.R.A.:

Yes, Mona reads her mother's letters addressed to her, but in English, while the images and Arabic text display.

S.C.:

And they're talking about Mona going into exile, and migrating to London.

T.R.A.:

Right. So Hatoum had visited London in 1975 and became exiled as a war broke out in Lebanon. She was born to Palestinian parents who were exiled in Beirut. And her mother was still there with her family. Given the political

Mona Hatoum, *Untitled (Latin grater)*, 2001. Wax paper; 17 × 21 in.

restrictions, they weren't permitted to communicate about such things—like women's sexuality—in this way.

S.C.:

Yes, so one of the things about that piece that I think speaks to the character of Eileen's collecting is that it depicts such an intimate exchange. Yet because it's an artwork, the exchange becomes public. That idea of externalizing and making visible vulnerabilities and truths that are often not visible in public forums is also a quality of works in Eileen's collection.

T.R.A.:

Absolutely. I want to come back to the curatorial grants that the Nortons offered to curators at museums, allowing them to purchase works of their choosing. And specifically, we were just talking about acquisitions of Glenn Ligon's works. Lowery, you were able to acquire some of the first Glenn Ligon and Lorna Simpson pieces for the Metropolitan Museum of Art, which we all know is an encyclopedic institution. And, you know, bringing in contemporary art at that time, I imagine wasn't the easiest thing to do. Can you speak a bit about that? And likewise, Kellie, you were able to acquire a generous amount of works by Howardena Pindell for the Walker Art Center, including the *Video Drawing* series and the germane performance and video work that she made, *Free, White, and 21* from 1980. Then you also acquired for the collection Pepón Osorio's *100% Boricua*, and he's now about to have a retrospective at the New Museum. So again, these cyclical sorts of things happening. That piece was featured in the 1993 Whitney biennial soon

after you acquired it. So I wonder if each of you can maybe shed light briefly on the traditional acquisition process in encyclopedic and mainstream museums, in particular, and how cumbersome they can be. As a person who's worked at encyclopedic institutions, I've been in those rooms, it's historically a difficult process to advocate for contemporary artworks that haven't had market recognition. So I wonder if you can speak to that process a bit and maybe shed light on that process, and particularly these works and why you chose them for the collections.

L.S.S.:

At the Met, we had a lot of layers of approval that would allow more flexibility than expected when I was there. I mean, the kind of limits of spending that would go to the trustees is laughable. It was $50,000. That's nothing these days. I think it was like $10,000 that your department head could sign off on. Somewhere between ten and fifty [thousand]. The director had to sign off on it also. Essentially, it was a negotiation between you and your department.

[Eileen and Peter's] presence in the New York art world was a way of bridging that continental divide [between Los Angeles and New York] at a time when that wasn't common—an idea that we now take for granted. But in the eighties and nineties, that was a big deal to a certain extent. We can't underestimate how there was that kind of fertile interaction about West Coast artists versus East Coast artists. The way Eileen, in particular, worked with Thelma Golden on acquisitions for the Studio Museum is important. And how many of the artists [in the collection] went to school in California and then came to New York. So I think that the Nortons as a group, and particularly Eileen, were really important.

As we're talking about women artists, I was really struck and touched by the fact that Eileen gave money to the Baltimore Museum of Art just at the moment when they had institutionally determined to collect only women artists. I thought that was a cool moment to have her give this operational grant to help with expenses for the museum at a moment when the museum was actively collecting women artists exclusively for that time.

T.R.A.:

Yes, thank you for that, Lowery. What I've gathered in my study of Eileen in these recent years is that she is very covert and stealthy in how she supports museums, artists, and creative endeavors in general. She doesn't like the big announcement, right? But she's very happy to

be generous in a quiet way. So to see these permutations and outcomes happen within institutions is so impactful for the future record. Kellie, how about you with regard to the curatorial acquisitions?

K.J.:

What I'm loving about this conversation is to really see these acquisitions and this collector activity as trendsetting; not announcing itself boldly, in Eileen's case, but to just get in there and change the dialogue. That was clear from looking at Eileen's collection with an emphasis on women. We mentioned Wangechi Mutu. Right after graduate school,

Mona Hatoum, *Grater Divide*, 2002. Mild steel; 80¼ in. × variable width and depth.

she was making these breakout collages that have led to the monumentalizing sculpture that we see now (she was always making sculpture, however). I also love the idea of challenging the East Coast, West Coast divide in the collection that Lowery brings up. My own acquisitions for Walker Art Center are now canonical in some ways. I was glad to remember the Howardena Pindell *Video Drawings* and think about what the works tell us about conceptual practice. But also the video *Free, White, and 21*, which when I started teaching full-time, I taught for years and years and years before it gets picked up as such a significant work historically.

In a recent show *Rope/Fire/Water* (2020) at The Shed in New York, curated by Adeze Wilford, Howardena finally gets to make a second video piece that she's had on her mind for over two decades. So to be able to see that

move toward greater exposure as part of the Walker Art Center's acquisition is significant. In terms of the process of acquisition, I don't remember being so much party to it, because I worked at the Walker for almost a decade as an adjunct curator. I tell people I've been a deinstitutionalized curator for longer than I was ever an institutionalized curator. In that role you have to step back from certain things because you are not necessarily part of the daily rhythm of the museum. You're still kind of an advisory piece.

I do know that these Norton Curator funds made certain acquisitions possible that might not have been the preferred acquisitions of artists of color at that moment; they were cutting edge in their way. For instance Pepón Osorio's *100% Boricua*, 1991, is basically a china cabinet (a *chinero* in Spanish) filled with tableware and knickknacks that speak to the entanglements between New York and Puerto Rico, the artist's birthplace. It shows up in the now infamous 1993 Whitney Biennial as part of the artist's larger installation.

I believe this goes along with that idea of a stealth kind of collecting mode. Eventually such pieces do have a greater visibility. There's a similarity to the type of acquisitions that Lowery was able to do decades earlier in her time at the Met. I made it a point to seek out and highlight these types of acquisitions for shows I organized, like *Energy/Experimentation* and *Now Dig This!* They were objects that had been acquired sometimes for political reasons. And then they lay dormant in the institutions, but they were well cared for. And that second aspect was wonderful for my shows. Similarly, the Walker Art Center's Pindell and Osorio acquisitions in the 1990s have had an impact on art history and exhibitions. It's an honor to be a part of that.

T.R.A.:

In thinking about things that you were a part of, I want to transition and talk about the Second Johannesburg Biennale in 1997. One of the other philanthropic efforts that the Nortons facilitated were the traveling curator workshops, where they invited a group of museum curators—who were influential to the field—to come and travel with them to see these landmark shows. There's a wonderful photograph that Lorna Simpson took of all the curators [see pages 28-29], and it's just iconic. Okwui Enwezor had curated this wonderful show at the 1997 biennale in the wake of the ending of Apartheid, *Trade Routes: History and Geography*. Kellie, you were one of the collaborating curators for one of the exhibitions that belonged to the overall presentation entitled *Life's Little Necessities: Installations by Women in the 1990s*, and the exhibition included works by artists who are

in Eileen's collection, such as Simpson and Fatimah Tuggar. Kellie, can you talk a little bit more about that trip and how pivotal the biennale was for transnational contemporary art at that time? Susan, you organized and were also on that trip—can you also talk about the planning for that endeavor and your experience in South Africa at that time?

K.J.:

Well, for me, it was an amazing opportunity having grown up as a child knowing about Apartheid. It was the hardest show I have ever done. But at the end when it was all installed, and all the festivities were over, I went to Robben Island to see where Nelson Mandela spent eighteen of the twenty-seven years of his prison sentence. I saw that the space is the size of a king-sized bed, and I said to myself, "Okay, what I just did wasn't hard." It put everything in perspective. The show *Life's Little Necessities: Installations by Women in the 1990s* was an all-woman show, and of course there was critique. "Why are you doing an all-woman show? We don't need those anymore." One of the great things that I remember is telling all the artists to bring their own tools, preferably cordless. I had been the curator of the US exhibition at the São Paulo Biennial in 1989 in Brazil, where I presented the work of Martin Puryear. That was one of the reasons why Johannesburg commissioner Okwui Enwezor wanted me to be involved, because he knew I had that kind of experience. It was exciting to be there and to present work by women in that space, the Castle of Good Hope, the oldest Western-style building in Cape Town, South Africa. Later, I found out that an Indigenous woman, Krotoa, was buried on that site. And that made it even more fascinating to be there in community with all these women with their tools <laugh>, including Lorna Simpson and Fatimah Tuggar.

The show featured an international group of women. People from the Netherlands, British people from Mexico, such as Melanie Smith. People like Pat Ward Williams, and Berni Searle, who was going by Bernadette Searle at that time. My participating in the Johannesburg Biennale enabled me to write several articles based on my experience in South Africa, one being a roundtable with different artists about the figure of Saartjie Baartman, because that's what I originally wanted my show to be about. However, Okwui told me that was a bit too hot of a topic in South Africa at the moment, and he was right. But the visit allowed me to keep diving into the idea of women artists, the idea of a global dialogue with women on art. It was a great opportunity to share that experience with so many of my colleagues.

S.C.:

I'll talk about the curators' workshops more broadly and then lead us to the curatorial trip to the Johannesburg Biennale. I want to mention that Lowery, you traveled to Africa in the seventies, and so there's a way in which things sort of go in cycles <laugh>. And at the moment where multiculturalism is taking root in the United States, there were intrinsic reasons to go to the Johannesburg Biennale, but there also was this sense of wanting to participate in a more global art world that became significant. And I think that that is something that echoes what was happening in the early 1970s that maybe, Lowery, do you want to speak about that just for a moment?

L.S.S.:

I had been at the Met for a short time, and Met leadership basically said, "A donor has given us money to have staff travel to Africa." I was just getting to know Howardena [Pindell], my counterpart at MoMA, and she said, "Well, you know, I can get some money from the Junior Council at MoMA." Through her contacts in the Junior Council, we were able set our itinerary to travel to Kenya, Nigeria, Ghana, Ivory Coast, and Senegal, meet a number of artists, and experience Africa in the raw. We did it in 1973, so that was before FESTAC [Second World Black and African Festival of Arts and Culture in 1977]. We're just two Black women over there, <laugh> doing our thing. I know it really impacted Howardena, in terms of the art that she made from it. And I think it probably spurred her on to her further travels when she went to Asia and other places like that. But it was a truly personal journey for us as African American women to experience how our presence would be perceived in Africa at that time. But the whole idea of who I could have been as a global person of African descent was formulated by that trip.

S.C.:

Thanks, Lowery. Okwui was selected to direct the Second Johannesburg Biennale; the first had been in 1995, right after the end of Apartheid. One of the purposes of the biennale was to reconnect the South African art world with the global art community. It seemed like it was essential for the Norton Foundation to participate in that movement within South Africa, making it available to curators in the United States.

Okwui put us in touch with a young man who now is a curator in the United States, Tumelo Mosaka. He organized our entire itinerary. We went to see the [exhibition] venues in Johannesburg and Cape Town, and we met with all the

curators. We went to Soweto to see the site of youth uprising in 1976. We made the trip to Robben Island. We went to Cape Point, which is where the Indian and Atlantic Oceans meet. We also went to Linda Goodman Gallery. And we picked up people along the way who joined us, such as artist Isaac Julian as well as artist and scholar Mark Nash.

[The Johannesburg Biennale] created a fundamental change within the United States art world for a number of reasons. For one thing, I think we had about ten curators with us, and they were curators who had received Norton Foundation

Fatimah Tuggar, *Twig Whisk*, 1996. Electric mixer, bulugari (miniature traditional whisks); 6 × 4 × 12 in.

grants. And it was a heavy-hitting group of people who were based within institutions and making real impact—sharing that experience together. With Kellie and Okwui as well as the other curators, our trip created a kind of common knowledge base that made, I think for many of us, our view of the art world much larger than it had been before. And decentered Europe and the United States into a more global frame of reference.

K.J.:

One of the other artists in *Life's Little Necessities* was Wangechi Mutu; she couldn't travel because of visa issues. So the materials were shipped and we installed things. I have an essay in her new book from Phaidon which revisits that moment of working with Wangechi. So you can imagine Eileen seeing this work in 1997 where Wangechi's still working with sculpture, she's working with small sculpture and installation, of course. María Magdalena Campos-Pons was also in the show and, like Wangechi, she could not travel to South Africa.

It was the first time Zarina Bhimji had been back to the continent since she was forced to leave Uganda as a child. So that was poignant. Later she goes back and makes *Out of Blue*, 2002, among her first pieces in video, that is so vivid and touching. For some of these artists that moment was pivotal. I also met and worked with Tumelo Mosaka, who was an up-and-coming curator in Johannesburg. He's working with me now at Columbia, on my Black Curators Matter project. So we've come full circle. That biennale was a moment for so many people to connect, and the exhibitions have a lifespan that continues in my work as a curator, as well as people's work as artists.

S.C.:

It was quite an incredible moment to be in South Africa [then] because the Truth and Reconciliation Commission was doing its work. It was also a powerful experience to be in a country where such atrocities and the wrongdoings were being reckoned with. I really wish that the United States could have a truth and reconciliation commission about so many things. So it was a powerful moment to be there in that regard.

One night during our trip, William Kentridge had our group over for dinner. His father was the lawyer who led the inquest into the death of Apartheid activist Stephen Biko. In that experience—it was incredibly inspiring to see the living connections between art and politics.

T.R.A.:

That's a beautiful segue because I want to engage Kris again to talk about transnationalism in your practice. I speculate that so much of your own work as a curator has spilled over into Eileen's collection since 2001. Much of your practice considers transnational narratives, specifically artists belonging to the global majority. I'm specifically thinking of artists Aiko Hachisuka, Beatriz Milhazes, Wangechi Mutu, Julie Mehretu, and Yunhee Min, whose works were acquired by Eileen in the early 2000s. I think your practice

really codifies a lot of the pedestrian nature that informed Eileen's collecting. She's someone who encounters art in an almost pedestrian way, specifically within California, by just walking into galleries and discovering artists serendipitously. So I want to hear you talk a little bit more about the amalgam of cultures that are specific to the American West, utilizing it as a particular lens for looking at transnational art. And in your view, how does this land consider multiple intersections of identities and borderlands?

K.K.:

Yes, definitely. Eileen is a born and raised Angeleno, and her worldview has always been centered in Los Angeles—deeply rooted in the African American community but also decidedly global. She is mulitlingual and was an [ESL] teacher, which makes sense when you look at her collection and philanthropy. She really understands the connective tissues between people, which is reflected in the way her collecting and community engagement has blossomed over these many decades. I think of Eileen as very grounded in Los Angeles but also incredibly worldly, you know? Her engagement is very personal but always outward looking.

T.R.A.:

Thank you for bringing up her history as an educator for English to Spanish-speaking communities, particularly communities that were immigrating during political upheaval in Central America spurred by US involvement to disempower Communist movements during the 1970s and 1980s. Also, Eileen started traveling with her family at a young age, which I write about in the introduction of this book. But her mother, who was primarily a single mother—they lived in a home in Watts that Eileen's grandfather built. Eileen was raised in the home with her maternal grandfather and her two uncles who had served in the army. And because of their army backgrounds, they were all very global in their outlook as well. Through the facilitation of her mother and uncles, Eileen was traveling to Africa, traveling to Europe, as early as high school. A lot of that early exposure to the world seems to inform the way that she collects. It's not really limited to her scope locally, although I think she considers the local and thinks locally, but she acts globally in her collecting style and consideration. Thinking of this, there was a 2005 exhibition that you organized, Kris, of both Eileen's collection along with Peter's, entitled *Linkages & Themes in the African Diaspora: Selections from the Eileen Harris Norton and Peter Norton Art Collections*. Can you talk about that show and how the Black diaspora is celebrated in the collection? I believe Belkis Ayón's pieces were presented in that exhibition, which were acquired shortly after Eileen

traveled to Cuba and actually met the artist before her unfortunate passing. And so, can you speak to some of the works in that show and how it maybe speaks to your own practice?

K.K.:

I think the Belkis Ayón example is a really good one, reflecting her embrace of an international African diaspora grounded in personal connections with artists. I was really interested in emphasizing this dynamic in the exhibition. The local and international are always intimately intertwined, as are art and community work. In fact, her co-founding of Art + Practice feels like a real culmination of the kind of work that she's done as a collector and philanthropist all along, quietly behind the scenes. She's been such a remarkably strong, steady supporter of art understood within the context of community.

T.R.A.:

The work at Art + Practice is present in Eileen's patronage of artists and general philanthropic work that goes beyond the art world. There they support unhoused youth, and their social impact work has expanded beyond LA recently. A lot of consideration around lived experiences guides the kind of artworks that are exhibited in the space. It's rarely, if ever, apolitical.

Kellie, I want to invoke your germane 1990s essay "In Their Own Image" to specifically remark about artist Pat Ward Williams, whose work is featured on the cover of the volume.[2] In your essay, you write about Williams and the methodology of "word biting" or reappropriating language and photography to sort of speak to memory and narratives. And I think that practice and the way you write to it in your scholarship really foreshadows a lot of the work that's represented in the collection by more recent artists. I'm specifically thinking of Sadie Barnette, Samira Yamin, and Brenna Youngblood, in particular. They all remark about memory in their own respective ways, speaking to obscure narratives and their work through appropriated ephemera materiality. I wonder if you can reflect on your essay in light of how it speaks to the present and perhaps how the art world has opened up more to narratives belonging to the "minority" or what we should call the global majority. Your essay really embodies the art historical and communal presence of Eileen's collection, with scholarship on works by artists in the collection, such as Lorna Simpson, Carrie Mae Weems, and Williams. And it also writes to other canonical women artists: Clarissa Sligh, Zarina Bhimji,

2 Kellie Jones, "In Their Own Image," *Artforum* (November 1990), https://www.artforum.com/print/199009/in-their-own-image-33975.

Roshini Kempadoo, Ingrid Pollard, and Mitra Tabrizian. Lowery, you're quoted at the beginning and grounding the thesis in the piece, which I love. So Kellie, can you talk about this essay and how it feels to revisit this specific scholarship in light of how this art world has finally opened up to a global, more global maturity narrative or series of narratives, community of narratives, for us to consider?

K.J.:

Thank you for that, Taylor. It's interesting to see your perspective on it. Thanks to Lowery, I'm quoting your piece where you're talking about the mirror and Lacan, that was in *Artforum*.[3] What I was doing in my essay was introducing an international group of women of color, Black women into the debate around photography at that time, people like Mitra Tabrizian, Ingrid Pollard, Lorna Simpson, Carrie Mae Weems, Zarina Bhimji, Pat Ward Williams, Roshini Kempadoo, and Clarissa Sligh. I was thinking about how there's this whole debate around photography at that time. Now canonized as the *Pictures Generation*, it continues to cut out women of color who were working in this way. I think it's kind of perverse the way some canonical art history does this: it draws a line around what is the beginning and what is the end of an art movement so that people of color look like they're just late to the party rather than thinking more inclusively. So this was my way of speaking back to the strictures of discourse. Of course, Barbara Kruger is working in this way. You can see Cindy Sherman in dialogue with these artists as well. This way of working is very germane to this group of artists who are basically contemporaries of many of these people. Who, like Cindy Sherman, are also invoking people like Adrian Piper. I was talking about the word and image conjunction with photography, but also, particularly those who were working with more of an installation practice. To some degree they were all moving in that direction. But I think Pat Ward Williams's and Zarina Bhimji's approaches were the most developed at that time as installation. It was a way for people to bring a larger understanding of the photographic object, the art object and the work that it did in terms of communities of color, in terms of global communities, and as a space for women to tell their stories as they saw them, or they're fictions, right? Because one of the things I always talk about with Lorna's work is how the texts and the image don't line up. There's a disconnect between what you see written and what you see in the object. That also becomes very important for later artists to see that

3 Lowery Sims, "The Mirror the Other: The Politics of Esthetics," *Artforum* (March 1990), https://www.artforum.com/print/199003/the-mirror-the-other-the-politics-of-esthetics-34139.

you don't have to be so didactic, but it is your own truth and fiction at the same time.

With the passing of time, I feel freer to write about those experiences from the 1980s. The alternative space movement also gets narrated with similar exclusions. There's a reason there's a JAM [Just Above Midtown Gallery]. Linda Goode Bryant and her community created JAM because people were locked out of so many things and spaces. You see this same response with Gallery 32 in Los Angeles, founded by Suzanne Jackson, as well as all the work that Samella Lewis did. She got tired of fighting these institutions and put her energy into her own gallery and publishing projects. For me to be able to turn to narrating what was happening on the East Coast has been fun. I'm looking forward to doing more of that.

T.R.A.:

Samella is a great segue into thinking about this final question. The making of this book uses as a point of departure Eileen's first art purchase in 1976 entitled *The Exhorters* by Los Angeles-based artist Ruth Waddy, who was in community and co-conspiring with Samella Lewis to create a greater ecosystem for Black artists. I think it's particularly interesting that Eileen discovers Ruth Waddy in the Baldwin Hills Crenshaw Mall, where the African American Museum was located. Her mother sees an ad in the *Los Angeles Times* about a printmaking workshop, and they decide to go. They see this printmaker making prints, selling her work in the mall, and Eileen decides to buy a print per the encouragement of her mother, Rosalind.

The collection starts here. It starts with this maternal baton-passing of art appreciation. Of caring for another elder, Black artist, woman organizer, and activist. Ruth Waddy was just such a force during her time. So I wanted to end here, while invoking the brilliant Erin Christovale and the 2020 exhibition *Collective Constellation: Selections from the Eileen Harris Norton Collection* at Art + Practice. Kellie, you were engaged along with Bridget Cooks to talk about Waddy's influence on Black art history in California and beyond. I wish to expand on that illuminating dialogue here. Can you talk about the ways in which Waddy showed up in your research in Los Angeles?

K.J.:

Ruth Waddy is amazing as an activist. She comes to LA and then art really becomes a way for her to organize people because it's social. She travels all around the United States

by bus, collecting these prints by Black printmakers. She's also connected to a history of Black curatorial engagement among people like Alain Locke and others who encouraged shows that celebrated the moment of emancipation in the nineteenth century. Mabel Wilson talks about it in her book

Installation view of *Collective Constellation: Selections from the Eileen Harris Norton Collection* at Art + Practice, February 8, 2020–January 2, 2021.

Negro Building. This is a real theme throughout the twentieth century. Waddy is taking that forward. Her activism in the art space is about creating an exhibit presence for Black artists. So it's just fascinating that Eileen encounters Waddy and her work, purchases it, and it becomes a way for her to continue that tradition. And she's young; is she a teenager at that time?

T.R.A.:

Eileen was a young adult.

K.J.:

And, it's not like they were big-time art collectors or something, but her mother said, "Do this." And, to see how that sets somebody on such a longer road is also amazing.

T.R.A.:

Absolutely. Susan, Kris, do you want to add to that at all?

K.K.:

There is a beautiful connection to community engagement that's evident in that story of discovery and the work Eileen is doing with Art + Practice. I see an extraordinary continuity in her care of community, collecting, and philanthropy that extends to the present.

T.R.A.:

Yes, absolutely. Thank you for bringing it back full circle. And I think, too, in just thinking about Leimert Park as a force, the history that's contained there—the Brockman Gallery and Gallery 32, was a couple miles away with Suzanne Jackson leading that charge in the 1960s. Eileen grew up alongside these currents, even if she wasn't within them; this community was ubiquitous. What I've been gathering from Eileen's patronage and collector's practice is that so much sociality exists around the artwork that she acquires. And I think that pretense was influenced by her encounter with Waddy and being able to talk directly to an artist and see the work being created in real time.

L.S.S.:

I met Ruth in the mid-1970s when a group of 250 Black people in the arts, from the East Coast, chartered a plane to go to the National Conference of Artists meeting in Pomona, California. It was my first trip to California. And that was an incredible trip because we met Ruth, we met Samella Lewis. . . . This is when Linda Goode Bryant was formulating the idea of Just Above Midtown Gallery and was making contact with artists like David Hammons, Dan Concholar, and Suzanne Jackson. But it was really important because we know about Samella and Ruth's books, *Black Artists on Art*, volumes one and two (1969, 1971), which is, to me, still an astounding collaboration. And then Samella working with Mary Jane Hewitt on the *International Review of African American Art*. Ruth Waddy speaks to a larger group of Black women who were so key in the sixties and seventies—EJ Montgomery is another agent—who really supported and promoted Black artists.

Belkis Ayón, *Dormida (Sleeping)*, 1995. Collography on paper; 26¾ × 36¾ in. Catalog number 95.02.

Chronology

Sophia Belsheim

Historical Events

1920

The 19th Amendment to the US Constitution is passed, granting women the right to vote. Black women are excluded from these rights.

1940

The National Association for the Advancement of Colored People (NAACP) founds the Legal Defense and Education Fund as the first civil and human rights law firm in the United States, with Thurgood Marshall as its first director-counsel.

Eileen Harris Norton Events

1952

Eileen Harris is born in Los Angeles, in the neighborhood of Watts, to Rosalind Van Meter Harris and Willie Frank Harris. Eileen's mother is described by many people as always helping neighborhood families in need by buying them clothes and food. Rosalind, who works at Thrifty (now Rite-Aid), is also a hospital volunteer for a period of time. Her spirit of generosity and charity greatly informs Eileen's identity and philanthropic work later in life.

Eileen as a baby, 1952.

1954

In *Brown v. Board of Education*, the US Supreme Court rules unanimously that racial segregation in public schools violates the 14th Amendment to the Constitution, which mandates equal protection of the laws to any person within its jurisdiction.

The first incarnation of the J. Paul Getty Museum opens to the public in Getty's ranch house in Pacific Palisades (then Malibu).

Eileen's mother and uncle watch Simon Rodia construct the Watts Towers. Rodia completes the towers in 1954.

Simon Rodia and his Watts Towers in 1953.

1955

Emmett Till is lynched in Mississippi after being falsely accused of offending a white woman in her family's grocery store.

The Vietnam War begins.

Rosa Parks boards the Cleveland Avenue bus in Montgomery, Alabama, and refuses to give up her seat to white passengers. Her arrest inspires the Montgomery bus boycott, a yearlong civil rights protest against segregated seating.

Rosalind Alma Van Meter Harris (left) and Rosa Parks in Eileen's home, 1990s.

From left: Eileen's mother, Rosalind Van Meter Harris; Uncle Hubert Garth Van Meter; Grandfather Robert Van Meter; Uncle Robert Green Van Meter; and Uncle Donald James Van Meter, 1980s.

1960

The Student Nonviolent Coordinating Committee (SNCC) is founded in Raleigh, North Carolina. Soon after, SNCC members ride interstate buses into the segregated South to test the enforcement of the US Supreme Court's ruling that segregated interstate travel was unconstitutional. Future US Congressman John Lewis, a founding member of SNCC, serves as its field secretary.

1963

The 16th Street Baptist Church in Birmingham is bombed and four Black girls are killed.

John Lewis is elected the third chairman of SNCC, serving until 1966.

Dr. Martin Luther King Jr. delivers his "I Have a Dream" speech at the March on Washington for Jobs and Freedom.

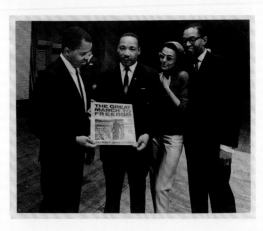

From left: Berry Gordy and Dr. Martin Luther King Jr. hold King's first Motown album next to Lena Horne and Billy Taylor, Atlanta, 1963.

1956

Eileen's parents divorce. She lives with her mother, as well as her uncles and grandfather, who work for the US Postal Service.

Eileen's first day of school in Watts, California, 1958.

1956–76

On the weekends, Eileen visits local museums and institutions around Los Angeles with her mother.

1965

The US Congress passes the Voting Rights Act, which requires states and local jurisdictions with a history of suppressing voting rights based on race to submit changes in their election laws to the US Justice Department for approval.

Malcolm X is killed at the Audubon Ballroom in Harlem, New York City.

The Los Angeles County Museum of Art (LACMA) opens on Wilshire Boulevard.

Restrictions are lifted on immigration from East Asia, welcoming many Korean, Thai, and Filipino people to Los Angeles.

The Watts Rebellion ignites, spurred by police pulling over Marquette Frye, a Black motorist, near the intersection of Avalon Boulevard and 116th Street in the Watts neighborhood of Los Angeles. An argument breaks out between Frye and the police, which escalates into a fight. Six days of civil unrest follow with 14,000 members of the California Army National Guard deployed to suppress the uprising.

A 1965 postcard reads: "The largest art museum to be built in America in the last quarter century . . . consist[ing] of three pavilion-like structures arranged in a central raised plaza and sits like a gleaming white island in a shimmering pool of water." Courtesy of the James H. Osborne Collection, Gerth Archives and Special Collections CSU Dominguez Hills.

1966

Black Panther civil rights leader Stokely Carmichael coins the term "Black Power."

1965

On the evening of August 11, Eileen and her mother, Rosalind, are driving home when an altercation breaks out in Watts. By the time they arrive home, the event has made local news and marks the beginning of the six-day Watts Rebellion.

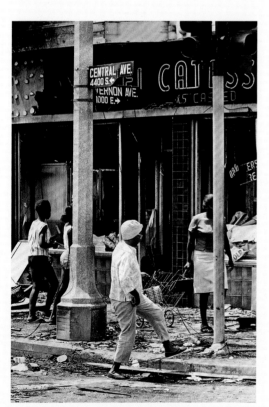

A group of Black women step through rubble and demolished storefronts on Central and Vernon Avenues where businesses were destroyed and looted during the Watts riots in Los Angeles, California, August 1965.

1968

Dr. Martin Luther King Jr. is assassinated in Memphis, Tennessee.

The Fair Housing Act is passed to extend federal protection to civil rights workers.

The Studio Museum in Harlem is founded in New York City.

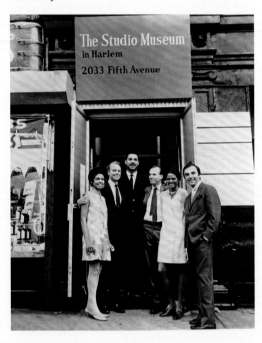

From left: Eleanor Holmes Norton, Carter Burden, Charles E. Inniss, Campbell Wylly, Betty Blayton-Taylor, and Frank Donnelly at the Studio Museum in Harlem on opening night, 1968.

1970

Eileen graduates from Hamilton High School.

Eileen begins her freshman year of college at the University of California, Los Angeles (UCLA).

Eileen and Grandma Aril Bell Thompson in Bakersfield, California, September 1971.

1972

Shirley Chisholm runs for the office of president of the United States but is unsuccessful in her bid.

A poster for presidential candidate Shirley Chisholm, 1972. Collection of the Smithsonian National Museum of African American History and Culture, Gifted with pride from Ellen Brooks.

Eileen and her mother, Rosalind, in Venice, Italy, 1972.

1973

Tom Bradley becomes mayor of Los Angeles, the second Black mayor of a major US city.

Attorney Marian Wright Edelman founds the Children's Defense Fund.

1975

The Vietnam War ends.

1973

For a month in the summer between her junior and senior years of college at UCLA, Eileen travels with her family to North Africa and Europe, where they attend a safari in Kenya and visit European capitals, such as Stockholm, Copenhagen, and Vienna.

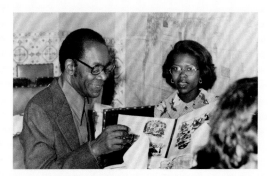

Eileen and Uncle Robert in Portugal, July 7, 1972.

1974

Eileen graduates from UCLA, majoring in French and minoring in Spanish. In her fifth year of school, she receives a certificate in teaching English as a Second Language (ESL).

1975

Eileen begins teaching within the Los Angeles Unified School District (LAUSD). She teaches ESL at West Athens Elementary in South Los Angeles. The school's student body is primarily Black, but war and unrest in Central America lead to a large influx of Latino students, which increases demand for ESL teachers.

Eileen enrolls at the University of Southern California (USC), attending night classes in bilingual education.

1976

Eileen's mother, Rosalind, notices an announcement in an October issue of the *Los Angeles Times* for a series of printmaking workshops in celebration of the *Two Centuries of Black American Art* exhibition at LACMA.

A *Los Angeles Times* newspaper clipping from October 17, 1976. It announces one of Ruth Waddy's workshops, in celebration of David Driskell's unprecedented exhibition *Two Centuries of Black American Art*, which was held at LACMA in 1976.

1976

Eileen's mother, Rosalind, urges her to acquire works by the artist Ruth Waddy during a visit to the Museum of African American Art. There Eileen buys one work directly from the artist at her booth. This work of art represents the start of Eileen's art collection.

Ruth Waddy, *Days of the Week Sampler*, 1973. Reproduction of linocut print; 18 × 24 in.

1977

The California African American Museum (CAAM) is founded. The museum begins operations in 1981 and locates to its permanent home at Exposition Park in 1984.

1977

Eileen graduates from USC with a master's degree in bilingual education and starts teaching ESL, kindergarten through sixth grade, at West Athens Elementary. Many of Eileen's Latino students experience difficulty in learning basic subjects, such as math and English. She identifies that many of her students' parents are illiterate and comes to understand the importance of parental engagement in education.

1979

The Sandinista National Liberation Front overthrows the forty-six-year-long Somoza dictatorship in Nicaragua, leading to a civil war.

Civil war breaks out in El Salvador, led by the Farabundo Martí National Liberation Front.

The Museum of Contemporary Art (MOCA) is founded in downtown Los Angeles.

1981

IBM releases the IBM PC, the company's first mass-market personal computer.

IBM 3270 PC The Smart Desk, vintage 1980s print ad.

1981

Eileen meets Peter Norton via the singles magazine *Intro* and they have their first date.

1982

Peter purchases an IBM personal computer.

Peter establishes Peter Norton Computing, Inc. Eileen leaves her teaching position at LAUSD to help Peter grow his business.

Eileen and Peter start visiting local galleries and artist studios in Venice, California.

1983

Eileen marries Peter at the Albertson Wedding Chapel in Los Angeles.

Peter and Eileen's wedding portrait, 1983.

1983–84

Peter and Eileen hire additional staff, working from their apartment in Venice to support the growing business.

1984

Los Angeles hosts the Summer Olympic Games.

The Santa Monica Museum of Art is founded.

Gina Hemphill, granddaughter of famed Olympian Jesse Owens, carries the torch into the Coliseum for the opening ceremonies of the Summer Olympic Games in Los Angeles, July 28, 1984.

1984

Eileen and Peter acquire their first work of art as husband and wife. The work is by Carla Pagliaro, and Eileen and the artist become good friends. Eileen and Peter focus on collecting works of art by emerging artists that cost less than $10,000.

Eileen and Peter start attending art tours run by Nancy Kattler and visit galleries across Los Angeles, forming and expanding upon relationships with emerging artists and the city's art galleries.

1986

Oprah Winfrey launches her talk show.

1987

Eileen and Peter meet Betye Saar and acquire their first work by the artist.

Eileen and Peter move to Santa Monica from Venice to live on Adelaide Drive.

Diana Norton is born.

Betye Saar at Watts Tower, undated. Saar Family photograph.

1988

Michael Norton is born.

Eileen and Peter start The Peter Norton Family Christmas Project, for which Eileen and Peter commission artists to make original editioned works that they send out to friends, leaders in the arts, and institutions at the holiday season each year. Artists commissioned to create works include May Sun, Kara Walker, Lorna Simpson, and many others.

1989

Eileen and Peter establish The Peter Norton Family Foundation with a mission to support contemporary art, health, education, and human services. The health, human services, and education focus of the foundation targets organizations in Los Angeles that serve women and children. Eileen serves as vice president of the foundation until 2009.

1990

The Hammer Museum opens in the Los Angeles neighborhood of Westwood.

1991

The Internet becomes publicly available.

The Cold War ends.

1992

The 1992 Los Angeles Uprising takes place after policemen are acquitted of beating Rodney King. A total of 64 people die during the riots, with as many as 2,383 reported injured.

1990

Peter Norton Computing, Inc., is sold to Symantec and renamed Peter Norton Computing Group.

Eileen, Peter, Diana, and Michael move to a house on La Mesa Drive in Santa Monica. Here, Eileen and Peter host a number of fundraising events for local charities as well as local, national, and international art institutions. Eileen and Peter welcome many actors and artists of color to these events. Eileen also fondly remembers hosting a party in honor of Rosa Parks.

La Mesa is established as a space to display their extensive art collection.

Eileen joins the Children's Defense Fund, as she is greatly impacted by the work of Marian Wright Edelman, its founder and president emerita. Marian's deep conviction about children's issues, including poverty, education, and health, deeply moves Eileen.

Eileen and Peter acquire a series of works by Carrie Mae Weems. Eileen becomes friends with the artist and acquires many of her photographic, sculptural, and video works over the years.

Eileen and Peter pose for the *New York Times*, October 26, 1997. Pictured behind them: Andrea Zittel, *A to Z 1994 Living Unit Customized for Eileen and Peter Norton*, 1994, and David Hammons, *Bag Lady in Flight*, c. 1975–76, reconstructed 1990.

1991

Eileen and Peter hire Fran Seegull from a local Los Angeles gallery as program officer of The Peter Norton Family Foundation. Fran supports Eileen and Peter with their contemporary art collection.

Eileen creates and founds the Forum on Children's Issues, an annual event committed to analyzing the policies that shape the physical, emotional, and intellectual needs of children. Starting in 1993, the forum hosts several gatherings with children's rights practitioners and thought leaders, including former First Lady Hillary Rodham Clinton, President of the Children's Defense Fund Marian Wright Edelman, and others, to discuss the state of children in the United States.

1992

Eileen and Peter hire Bill Begert as curator of The Eileen Harris Norton and Peter Norton Art Collection.

1995

The Million Man March is held in Washington, DC, to promote African American unity and family values.

1994

Eileen and Peter hire Beverly Walton to assist with The Peter Norton Family Foundation. Beverly later becomes Eileen and Peter's house manager at their home on La Mesa Drive in 2004.

1995

Eileen meets Kara Walker and acquires a watercolor by the artist. Eileen later purchases more of her works, including the large-scale installation *Slavery! Slavery!* (1997).

Eileen acquires Lorraine O'Grady's *Mlle Bourgeoise Noire Costume*, a gown, pair of gloves, tiara, and cape of 180 white gloves that Lorraine wore during her first performance work in 1980-81.

1996

Eileen and Peter hire Susan Cahan as senior curator and director of art programs for the Eileen Harris Norton and Peter Norton Art Collection. Susan plays a role in helping guide Eileen and Peter's acquisitions and curates installations in their Santa Monica home. Kris Kuramitsu starts working for Eileen and Peter's collection as assistant curator.

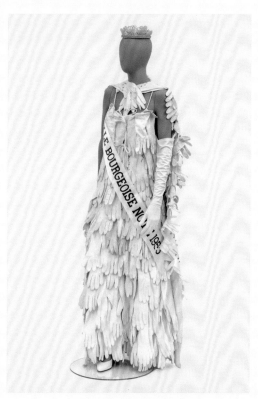

Lorraine O'Grady, *Mlle Bourgeoise Noire Costume*, 1980. Silk, cut glass, metal, and mixed media; dimensions variable.

1997

Eileen travels with the MOCA Curators Council to Havana, Cuba, and meets artist Belkis Ayón. Belkis later travels to Los Angeles and stays at Eileen and Peter's home, along with artist Aimée García. That same year, Eileen travels with the Guggenheim Museum to attend the opening of Guggenheim Bilbao in Bilbao, Spain.

Aimée García, *Aimée como Penélope II*, 1997. Oil on canvas, wire, and Cibachrome, two parts; photograph: 19¼ × 28 in., painting: 26½ × 20 in.

1999

Eileen and Peter hire Tom Solomon, Los Angeles-based independent curator and former contemporary art gallery owner, to lead a deaccession of works from their art collection to hone its focus on artists of color, women artists, and artists from Los Angeles. They distribute about 1,000 works of contemporary art to twenty-nine museums in the United States and England. The gifts are valued at more than three million dollars.

2000

Eileen and Peter separate.

Eileen meets artist Mark Bradford. Mark starts cutting Eileen's hair, and they become close friends.

Mark Bradford and Daniel Joseph Martinez make Eileen's Christmas card using an image capturing Eileen, Diana, and Michael in Mark's studio.

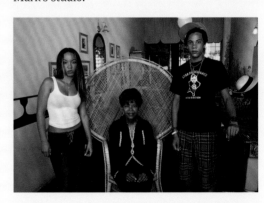

Harris Norton Family Christmas Card with Diana Norton, Eileen Harris Norton, and Michael Norton, 2000. Designed by Mark Bradford and Daniel Joseph Martinez; Los Angeles, California.

2001

The exhibition *Freestyle*, curated by Thelma Golden, is held at the Studio Museum in Harlem, New York.

Spreads of the *Freestyle* exhibition catalog, showing an image of Trenton Doyle Hancock's studio (left) and the title page (right), 2001. Phillip Morris Companies Inc.

2001

Eileen moves to a new home on Adelaide Drive in Santa Monica.

Eileen joins the Hammer Museum's board of directors.

Eileen promotes Kris Kuramitsu as director of art programs at The Eileen Harris Norton Collection.

2003

Eileen joins the Studio Museum in Harlem board of directors.

Eileen purchases a large-scale installation by artist Nzuji De Magalhaes titled *Prenda (Souvenir)* (2002). Originally from Angola, Nzuji studied art in Los Angeles while living in Costa Mesa, California.

2004

Eileen joins the Hammer Museum's board of advisors.

2008

Barack Obama becomes the 44th president of the United States and Michelle Obama becomes the first lady.

2007

Eileen meets Democratic presidential candidate Barack Obama at a political event in Los Angeles.

Eileen and Barack Obama, 44th president of the United States, Los Angeles, California, 2007.

2009

Eileen establishes the Eileen Harris Norton Foundation with a mission to achieve social and environmental justice through supporting organizations dedicated to education, families, and the environment.

2010

Eileen hires artist Sean Shim-Boyle as collection manager to oversee her art collection.

2011

Eileen establishes Leimert Project, an art gallery dedicated to educating schoolchildren about contemporary art, in the South Los Angeles neighborhood of Leimert Park.

Leimert Project, Los Angeles, 2011. Photograph by Kelly Barrie.

2013

Eileen hires Sophia Belsheim as collection manager to oversee her artworks and establish a digital database of her collection.

2018

The Equal Justice Initiative founds The Legacy Museum: From Enslavement to Mass Incarceration and the National Memorial for Peace and Justice in Montgomery, Alabama, led by the attorney and social justice activist Bryan Stevenson. The museum serves as an educational space investigating the history and legacy of racial inequality in the United States, and the memorial is the country's first to be dedicated to its legacy of enslaved Black people and systemic racism toward Black people.

2020

The COVID-19 pandemic starts.

The American Uprising is sparked in support of Black lives following the death of George Floyd in Minneapolis.

Senator Kamala Harris, of California, becomes vice president of the United States.

Artist Amy Sherald paints a portrait in honor of Breonna Taylor, the young woman who lost her life at the hands of police officers in Louisville, Kentucky. Sherald sells the painting and donates one million dollars to the University of Louisville to establish two grant programs in Taylor's name with the intention to inspire equality and social justice for all.

2014

Eileen co-founds Art + Practice with artist Mark Bradford and activist Allan DiCastro in Leimert Park.

Art + Practice founders Eileen Harris Norton, Mark Bradford, and Allan DiCastro, Leimert Park, Los Angeles, July 11, 2018.

2020

Eileen loans artworks to Art + Practice for the exhibition *Collective Constellation: Selections from the Eileen Harris Norton Collection*, curated by Hammer Museum Associate Curator Erin Christovale. The exhibition celebrates select women of color in Eileen's collection.

Amy Sherald participates in an artist talk with Hammer Curator Erin Christovale at Art + Practice, with Eileen in attendance, 2020.

2022

Ketanji Brown Jackson becomes the 116th associate justice of the Supreme Court of the United States.

US House Representative Karen Bass is elected as the first female mayor of Los Angeles.

2022

LACMA hosts *The Obama Portraits*, by Kehinde Wiley and Amy Sherald, from the Smithsonian's National Portrait Gallery. In conjunction with the exhibition's tour, LACMA presents *Black American Portraits*, an exhibition that pays tribute to David Driskell's exhibition *Centuries of Black American Art*, which was presented forty-five years earlier.

Art + Practice announces a five-year collaboration with CAAM as a museum-in-residence program in Leimert Park.

Art + Practice establishes a two-year collaboration with PILAglobal to support displaced children and families worldwide.

Installation view of *Collective Constellation: Selections from the Eileen Harris Norton Collection* at Art + Practice, February 8, 2020–January 2, 2021.

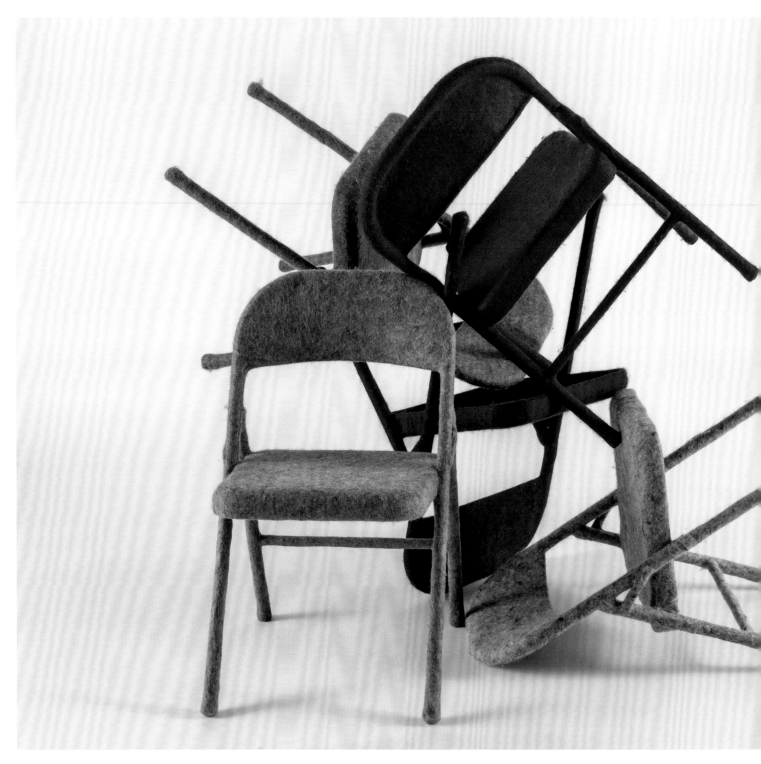

Tanya Aguiñiga, *Felt Chairs*, 2012. Metal folding chairs and felt;
each: 32 × 17 × 17½ in.

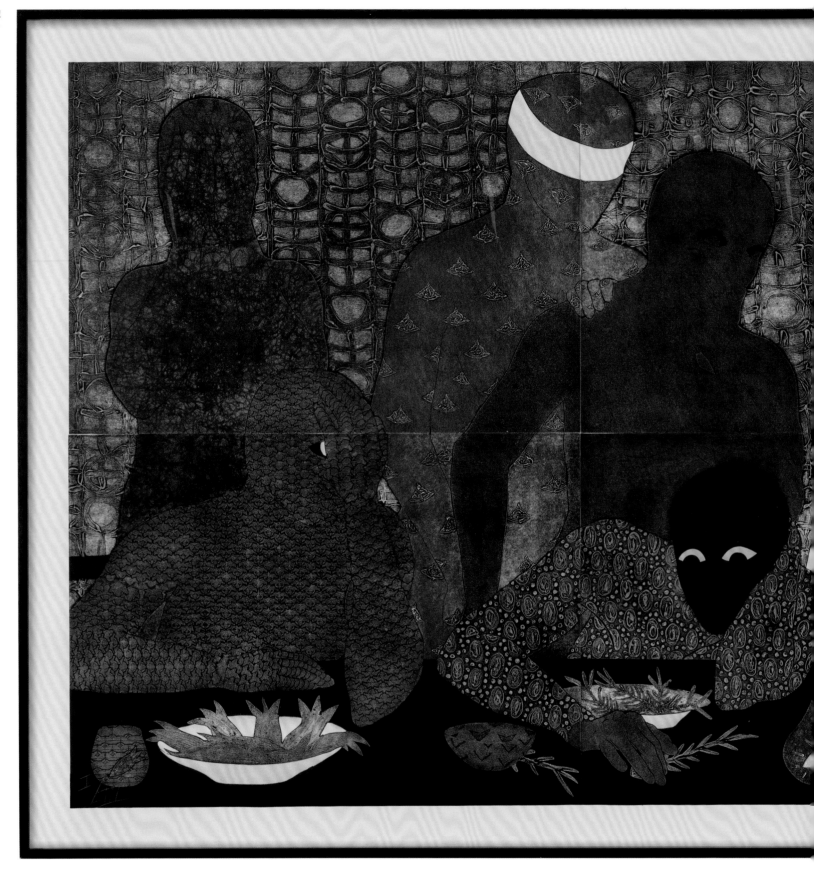

Belkis Ayón, *La Cena*, 1991. Collography on paper;
each panel: 27½ × 39½ in. Catalog number 91.08.

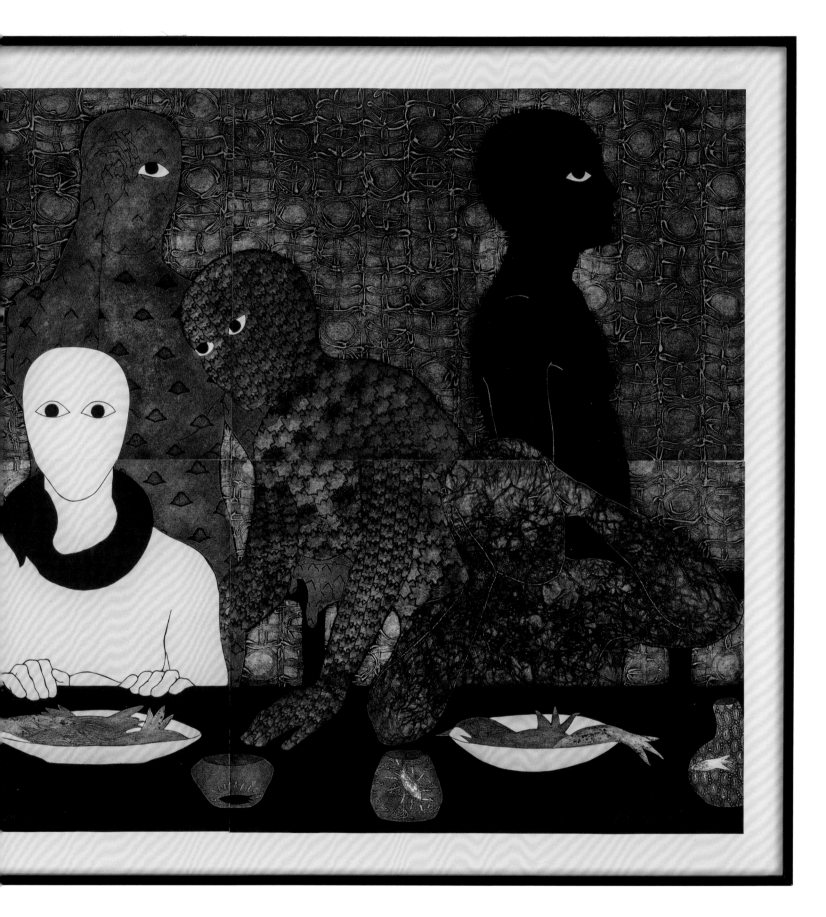

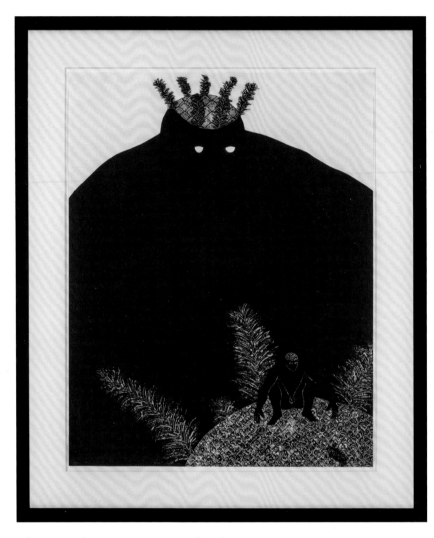

Belkis Ayón, *Mi alma y yo te queremos*, 1993. Collography on paper;
44½ × 37½ in. Catalog number 93.20.

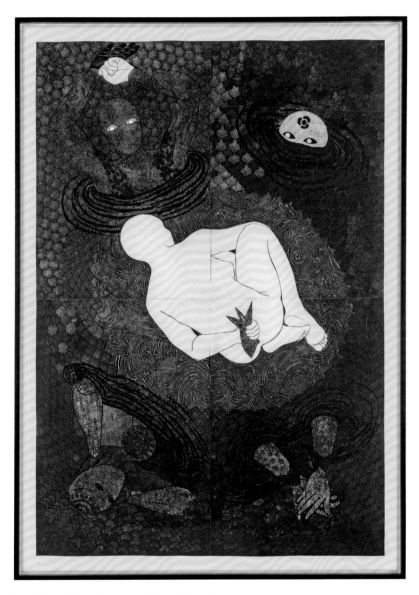

Belkis Ayón, *Sin título (Mujer en posición fetal)*, 1997. Collography on paper;
76 × 54 in. Catalog number 96.06.

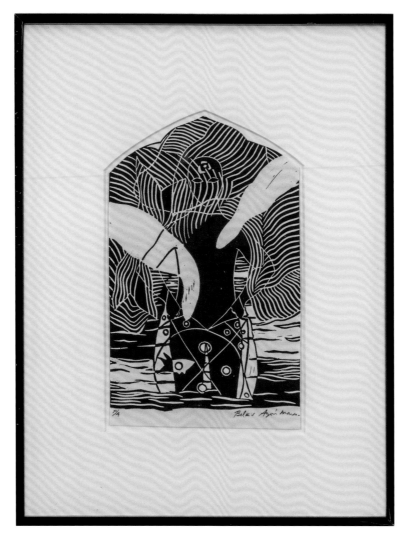

Belkis Ayón, *Sin título*, 1996. Linoleum; 15¾ × 13 in. Catalog number 96.04.

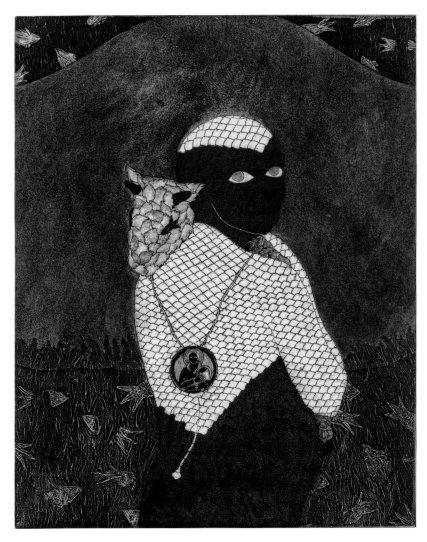

Belkis Ayón, *Sin título (Sikán con chivo)*, 1993. Collography on paper; 35 × 27¾ in.
Catalog number 93.14.

Sadie Barnette, *Untitled (Free Angela)*, 2018. Mixed media; 12 × 14¾ × 3 in.

Sonia Dawn Boyce, *1930s to 1960s*, 2006–7. Hard ground, soft ground,
and spit bite etching on Pexcia Magnani paper; 30 × 20 in.

Avril Coleridge-Taylor

Muriel Smith

Elizabeth Welch

Pearl Prescod

Pauline Henriques

Winifred Atwell

Adelaide Hall

Nadia Cattouse

Shirley Bassey

P.P. Arnold

Cleo Laine

Mabel Mercer

Audrey Hall

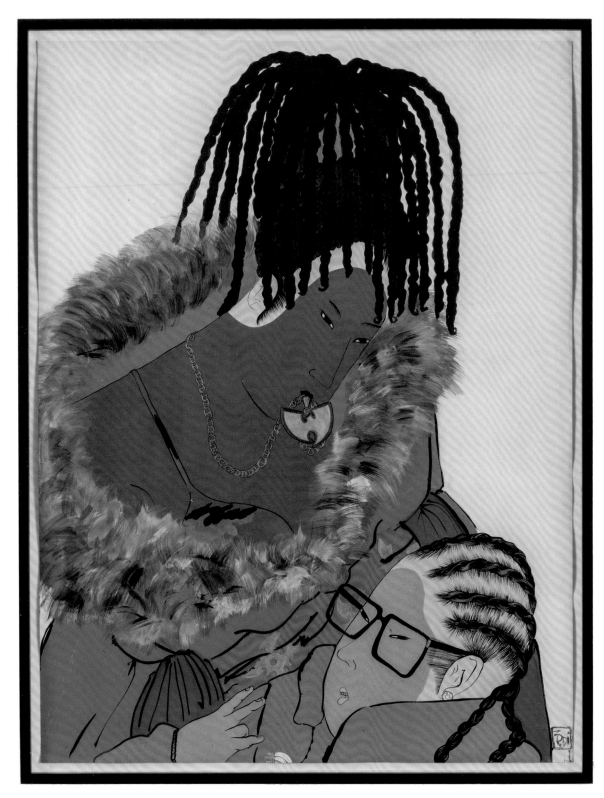

Iona Rozeal Brown, *a3 blackface #22*, 2002. Acrylic on paper; 50 × 38 in.

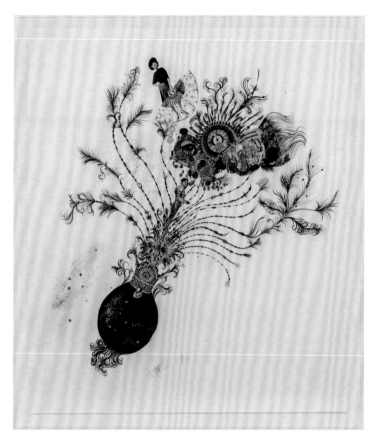

Carolyn Castaño, *Sudden Fanfare*, 2003. Watercolor on paper with mixed media; 45 × 61 in.

Carolyn Castaño, *Venus II*, 2004. Mixed media on paper; 22 × 30 in.

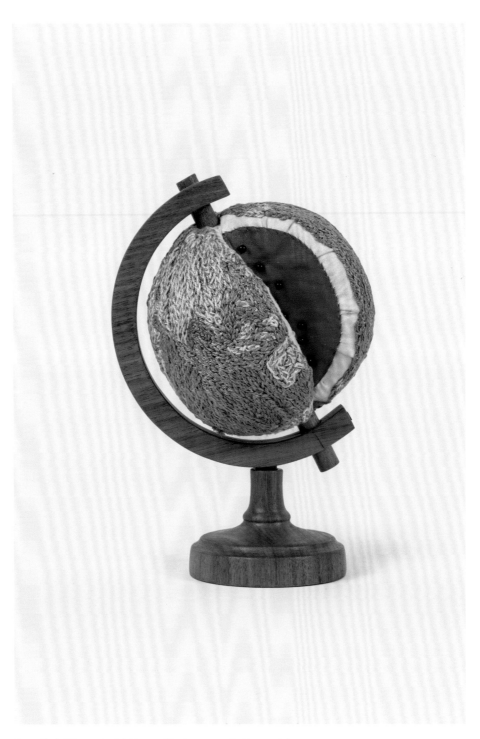

Sonya Clark, *Watermelon World*, 2014. Wood, cotton, embroidery, and pins;
7 × 5 × 5 in.

Nzuji De Magalhaes, *Nzinga Mother*, 2001. Yarn, acrylic paint, and chalk;
48 × 36 in.

Nzuji De Magalhaes, *Nzinga Teacher*, 2006. Yarn, chalk, and acrylic on canvas;
48 × 36 in.

Nzuji De Magalhaes, *Prenda (Souvenir)*, 2002. Mixed media; dimensions variable.

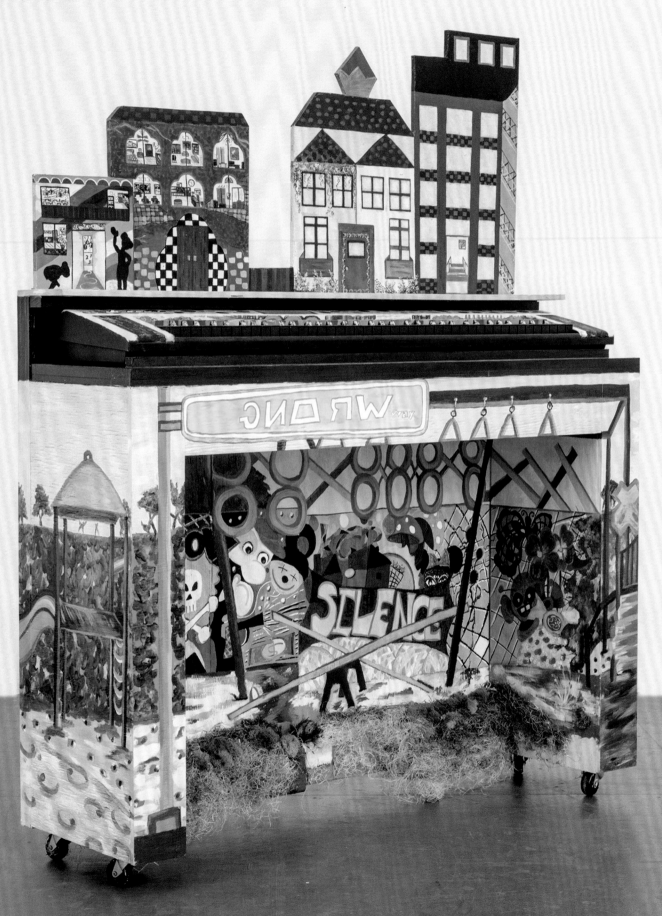

Nzuji De Magalhaes, *Wrong Way*, 2009–12. Acrylic paint, electric piano keyboard, and wood; 51 × 15½ × 57 in.

Karla Diaz, *Balloon Legs*, 2021. Watercolor and ink on paper; 24 × 18 in.

Karla Diaz, *La Cantina*, 2021. Watercolor and ink on paper; 11 × 14 in.

Karla Diaz, *El Circo*, 2021. Watercolor and ink on paper; 11 × 14 in.

Genevieve Gaignard, *Miss Daisy*, 2020. Chromogenic print; 30½ × 21¼ × 1½ in.
Edition 3/3, 2 APs.

Aimée García, *La fuente*, 1997. Oil on canvas, glass, and
blood; 65¾ × 31¼ in.

Aimée García, *Aimée como Penélope I*, 1997. Oil on canvas, human hair, and
Cibachrome, two parts; photograph: 22¾ × 18¼ in., painting: 21½ × 17 in.

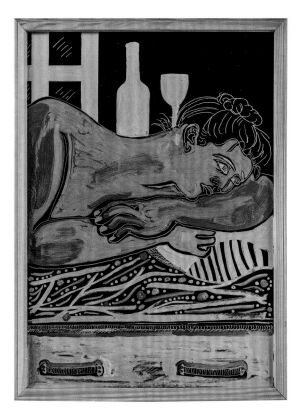

Deborah Grant, *Harlem Flophouse in the Afternoon*, 2005. Enamel on blackboard; 24 × 18 in.

Deborah Grant, *Verdicts*, 2001. Oil on canvas; 38 × 38 × 2½ in.

Deborah Grant, *The Last of the E.B.T. (Electronic Benefit Transfer)*, 2005. Enamel on blackboard; 24 × 18 in.

Deborah Grant, *The Women of Delano Village*, 2005. Enamel on blackboard; 24 × 18 in.

Renée Green, *From Partially Buried in Three Parts (Kent, Ohio)*, 1999.
Photograph on Fuji crystal archive paper; 15¾ × 19¾ in. Edition 1/250.

Renée Green, *Color II*, 1990. Glass, pigment, plexiglass, and wood; 48 × 96 × 4 in.

MONDAY

Pea-green

THURSDAY

Fawn (not as bright as Tuesday)

SATURDAY

White

"When I think at all definitely about the month of January, the name or word appears to me reddish, whereas April is white, May yellow, the vowel 'i' is always black, the letter 'o' white, and 'w' indigo-blue. Only by a determined effort can I think of 'b' as green or blue, for me it has always been and must be black; to imagine August as anything but white seems to me an impossibility, an altering of the inherent nature of things."

Pictured: Sherin Guirguis, *Untitled*, 2009. Watercolor, ink, and silver leaf on
hand-cut paper; 31 × 46 in.

Aiko Hachisuka, *Rolling Sketch*, 2001. Found object, fabric, and metal wire;
61 × 26 × 53 in.

Kira Harris, *Harlem Nights*, 2004. Digital c-print mounted on Sintra; 18 × 12 in.

Mona Hatoum, *Hair Necklace*, 1995. Human hair, wood, and leather; dimensions variable. Edition 3/3.

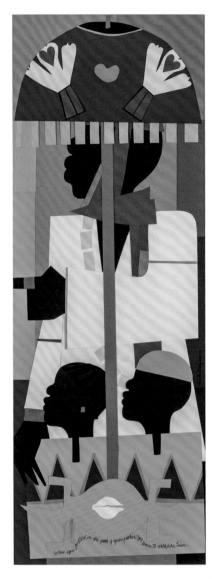

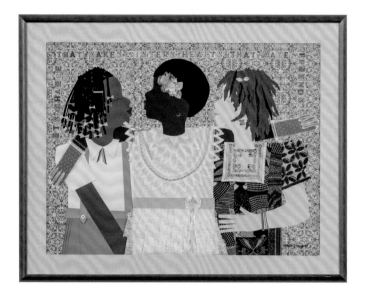

Varnette P. Honeywood, *Hearts Make Friends*, 1986. Collage on printed paper and lace; 38 × 48 × 1¼ in.

Varnette P. Honeywood, *When You Follow in the Path of Your Father, You Learn to Walk Like Him*, 1983. Collage on paper; 40¼ × 15¼ × ¾ in.

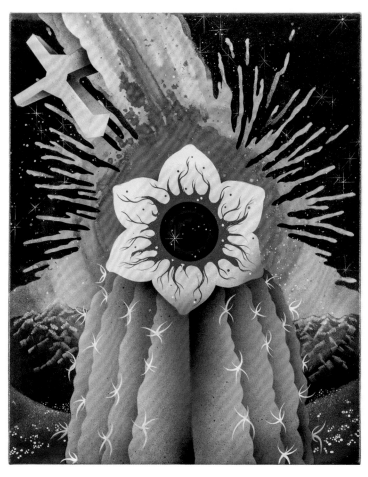

Pearl C. Hsiung, *Woah is We*, 2009. Oil and enamel on canvas; 20 × 16 in.

Pearl C. Hsiung, *Know Me in Team*, 2007. Enamel on canvas; 48 × 36 in.

Chandra McCormick, *Neisha Young*, 1993. Photograph; 15 × 15 × 1 in.
Edition 3/20.

Julie Mehretu, *Rogue Ascension*, 2002. Color lithograph on Somerset Satin
white paper and Denril vellum; 24½ × 32 in. Edition 27/35, 7 APs.

Julie Mehretu, *Entropia (review)*, 2004. 32-color lithograph and screenprint
on Arches 88 paper; 29 × 40 in. image size; 33½ × 44 in. paper size. Edition
of 45.

Ana Mendieta, *Untitled (Cosmetic Facial Variations)*, 1972/1997. Suite of four
color photographs; each: 16 × 20 in. Edition of 10 with 3 AP.

Ana Mendieta, *Untitled (Cosmetic Facial Variations)*, 1972/1997.
Suite of four color photographs; each: 20 × 16 in. Edition of 10 with 3 AP.

Ana Mendieta, *Untitled (Cosmetic Facial Variations)*, 1972/1997.
Color photograph; 25 × 18½ in. Edition of 10 with 3 AP.

Beatriz Milhazes, *Cacoa*, 2004. Collage on paper; 53 × 39½ in.

Beatriz Milhazes, *Ovo de Pascoa*, 2003. Acrylic on canvas; 117¹¹⁄₁₆ × 74⅝ in.

Clockwise:

Adia Millett, *Wonder Bread*, 2003. Yarn and cross-stitch backing; 13¾ × 15¾ in.

Adia Millett, *Vaseline*, 2003. Yarn and cross-stitch backing; 15⅛ × 13⅛ in.

Adia Millett, *Kool-Aid*, 2003. Yarn and cross-stitch backing; 15⅛ × 13⅛ in.

Adia Millett, *Bait Consumption*, 2003. Cross-stitched thread, mesh, and
frames, two parts; each: 12 × 41 in.

Yunhee Min, *Structure in Space/Composite #2*, 2001. Photograph and acrylic
on paper; 30 × 22 in.

Mariko Mori, *Cinderella*, 1994. Sandblasted oval mirror; 63½ × 29½ × ¼ in.

Wangechi Mutu, *A Lilliputian Haunt*, 2003. Ink, collage, and contact paper on Mylar; 60 × 41 in.

Wangechi Mutu, *Howl*, 2006. Archival pigment print with screenprinting; 40 × 28 in. Edition of 40.

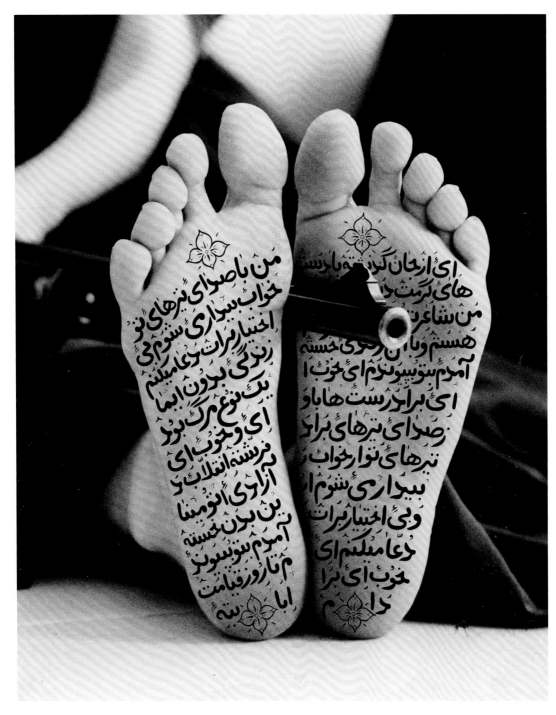

Shirin Neshat, *Allegiance with Wakefulness*, 1994. Black and white RC print and ink.

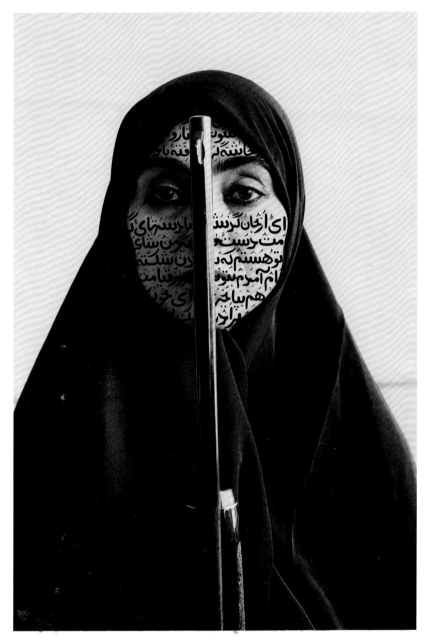

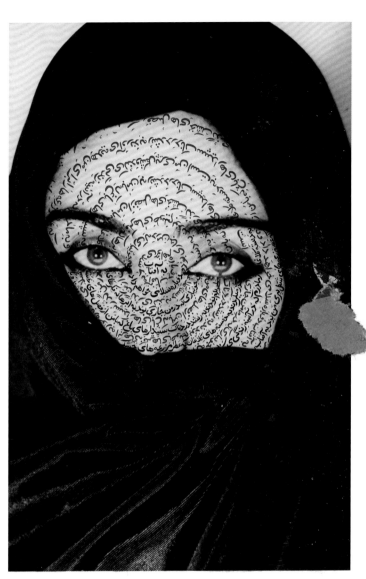

Shirin Neshat, *I Am Its Secret*, 1993. RC print and ink.

Shirin Neshat, *Rebellious Silence*, 1994. RC print and ink.

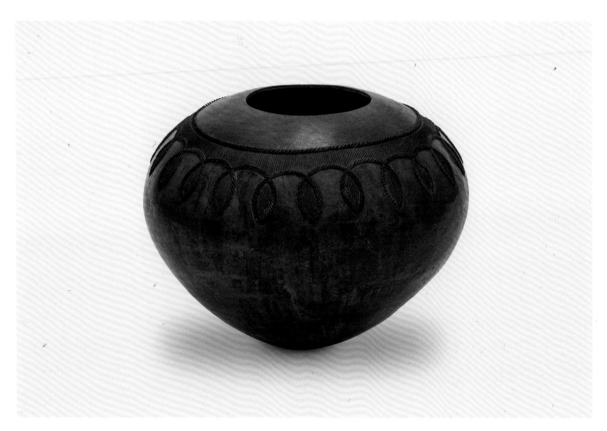

Mncane Nzuza, *Ukhambra #105 (N2)*, date unknown. Ceremonial beer-serving vessel, pit-fired hand-built earthenware, burnished surface; 12 × 16 in.

Toyin Ojih Odutola, *Damn*, 2002. Giclée print; 11⅝ × 11⅝ in.

Lorraine O'Grady, *Dracula the Artist*, 1991. Two black and white
photomontages; each: 32 × 40 in. Edition of 8 and 3 APs.

Lorraine O'Grady, *Ceremonial Occasions 2 (from the Miscegenated Family
Album Series)*, 1980. Cibachrome diptychs; each: 27¾ × 38¾ in. Edition 1/8.

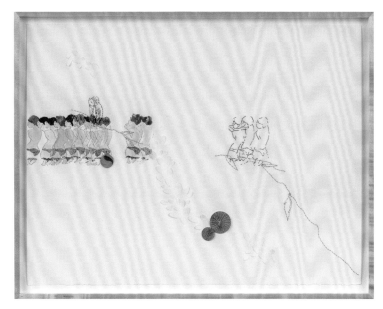

Ruby Osorio, *Reconfiguring*, 2003. Gouache, ink, and thread on paper;
22 × 30 in.

Ruby Osorio, *Chatter*, 2003. Gouache, ink, and thread on paper; 22 × 30 in.

Ruby Osorio, *Path Less Traveled*, 2004. Gouache, ink, and thread on paper;
60 × 22 in.

Marta María Pérez Bravo, *Para ayudar a un hermano (To help a brother)*, 1994. Gelatin silver print; 20 × 16 in. Edition 10/15.

Marta María Pérez Bravo, *No vi con mis propios ojos (I did not see with my own eyes)*, 1991. Gelatin silver print; 25 × 21¼ × 1 in. Edition 8/15.

Marta María Pérez Bravo, *Llamando (Calling)*, 1994. Gelatin silver print; 25 × 21¼ × 1 in. Edition 6/15.

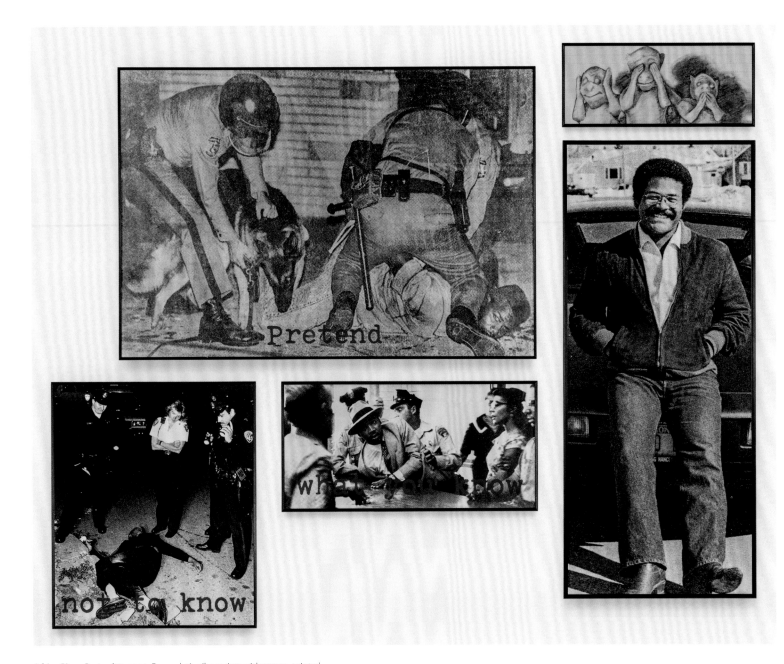

Adrian Piper, *Pretend #3*, 1990. Four gelatin silver prints with screen-printed text and one gelatin silver print mounted on foam core; 44 × 64 in., 12 × 29 in., 67 × 29 in., and 18 × 37 in. Photograph photo credit: Gerald Martineau/The Washington Post.

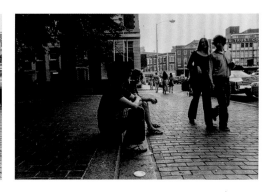

Adrian Piper, *The Mythic Being: Cruising White Women*, 1975. Documentation of the performance. Three gelatin silver prints; each: 8 × 10 in. Documentation photo credit: James Guttmann.

Adrian Piper, *Why Guess #1*, 1989. Two gelatin silver prints mounted on foam core, with screen-printed text on one print; each: 36 × 33½ in. Photograph photo credit: Ebony.

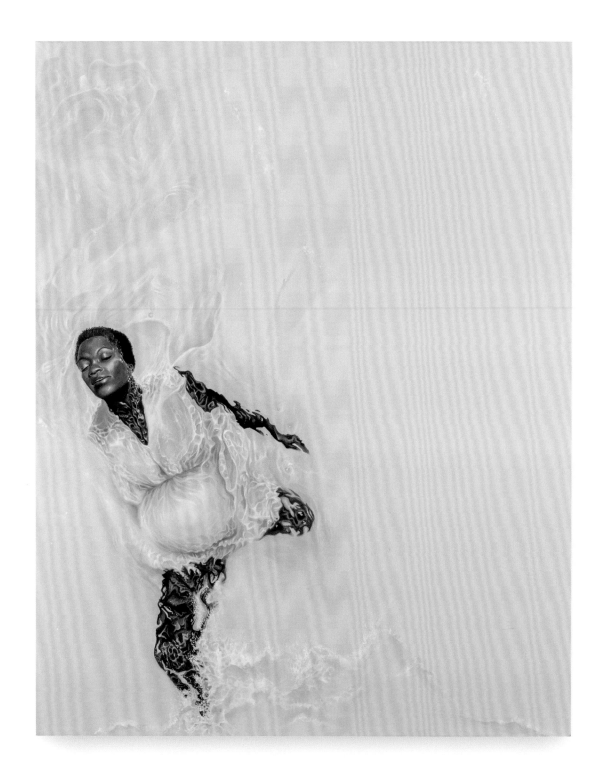

Calida Rawles, *Wade, Ride This Wave of Mine*, 2020. Acrylic on canvas;
60 × 48 in.

Sandy Rodriguez, *Lecherona-Asclepius curassavica from the Codex Rodriguez Mondragon 2*, 2017. Walnut ink, Asclepius curassavica ink, cochineal, watercolor, mayan green, and watercolor pencil on amate paper; 15 × 30 in.

Sandy Rodriguez, *Pann's*, 2015. Watercolor on Arches paper; 22 × 30 in.

Sandy Rodriguez, *Inglewood oil fields no. 2*, 2015. Watercolor on Arches paper; 22 × 30 in.

Alison Saar, *La Rosa Negra*, 1986. Beads, sequins, and fabric; 24½ × 25½ × 3¼ in.

Alison Saar, *Cora d'Oro*, 1985. Gold leaf and ragboard; 18½ × 13 × 2½ in.

Alison Saar, *Bye Bye Blackbird*, 1992. Mixed media with neon, two elements; dimensions variable.

Alison Saar, *Bat Boyz II*, 2001. Wood baseball bats and pitch; dimensions variable.

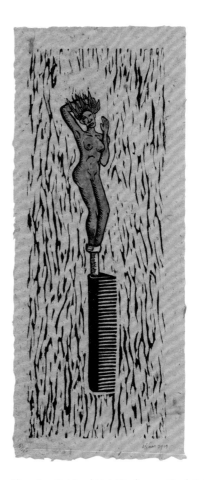

Alison Saar, *Blonde Dreams*, 1997. Wood, tar, gold leaf, and rope; 95½ × 7 × 6 in.

Alison Saar, *Hot Comb Haint Study*, 2019. Hand-tinted linocut print; 17⅞ × 7½ in. Edition 21/25.

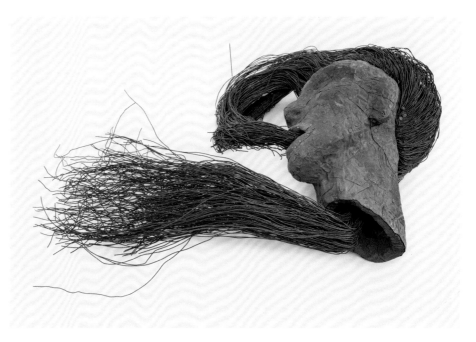

Alison Saar, *Conked*, 1997. Wood, paint, ceiling tin, and wire; dimensions variable.

Alison Saar, *Somnambulist*, 1991. Woodcut on rice paper; 26⅞ × 20¼ in.
Edition 7/30.

Alison Saar, *Untitled*, 2002. Woodcut print; 14¾ × 9¾ in.

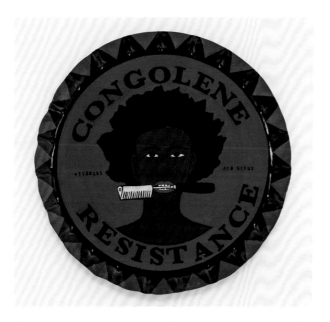

Alison Saar, *Congolene Resistance*, 2020. Enamel on found tin; diameter: 18 in.

Alison Saar, *Umbra*, 2022. Cast iron and enamel ink; 18⅛ × 10 × 1¾ in.

Alison Saar, *Pallor Trick*, 2013. Cast bronze, stone, and silk; 14¼ × 5½ × 6 in.
Edition 2/5.

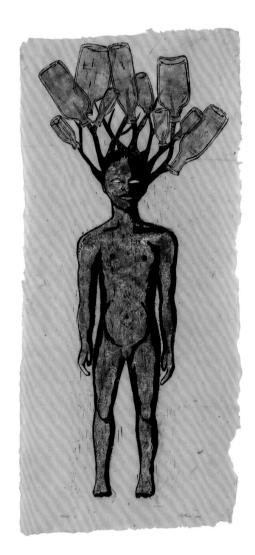

Alison Saar, *Topsy*, 2003. Monoprint (woodcut and collage);
50½ × 22½ in.

Alison Saar, *Spiral Betty*, 2006. Four-color woodblock print with hand-
coloring; 20 × 15 in. Edition of 100.

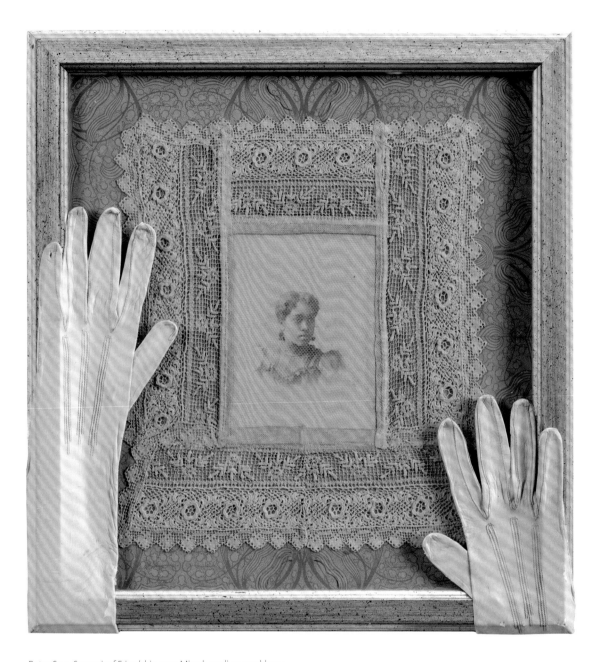

Betye Saar, *Souvenir of Friendship*, 1977. Mixed-media assemblage;
15¾ × 14¾ × 1 in.

Betye Saar, *Sanctuary's Edge*, 1988. Mixed-media assemblage; 13 × 12 × 3½ in.

Betye Saar, *A Handful of Stars*, 2016. Bronze with patina and walnut base; 8⅜ × 3¾ × 5 in. Edition 1/18.

Betye Saar, *The Weight of Buddha (Contemplating Mother Wit and Street Smarts)*, 2014. Mixed-media assemblage; 19½ × 7 × 7 in.

Betye Saar, *We Was Mostly 'Bout Survival*, 2017. Mixed-media assemblage;
37 × 8½ × 2¾ in.

Betye Saar, *Blue Mystic Window w/ Moons & Stars*, 2022. Watercolor and mixed media on paper in found window frame; 17½ × 18¾ × 1 in.

Betye Saar, *Male Doll with Female Head*, 2020. Watercolor on paper; 15¾ × 13⅛ in.

Lezley Saar, *The Universe Vol. 1*, 1993. Mixed media; dimensions variable.

Lezley Saar, *Views of Man*, 1993. Mixed media; dimensions variable.

Lezley Saar, *Birth of Religion*, 1991. Mixed media; dimensions variable.

Lezley Saar, *Rose J. Jones*, 1991. Mixed media; dimensions variable.

Analia Saban, *Pleated Ink, Window with Collapsible Gate*, 2017. Laser-sculpted paper on ink on wood panel; 60 × 40 × 2¹⁄₁₆ in.

Amy Sherald, *When I let go of what I am, I become what I might be
(Self-Imagined atlas)*, 2018. Oil on canvas; 54 × 43 × 2 in.

Top: Lorna Simpson, *Tense*, 1991. Three gelatin silver prints, five engraved plastic plaques; overall: 65 × 124 in., each: 49 × 39 in. Edition 1/3 with 1 AP.

Bottom: Lorna Simpson, *ID*, 1990. Two gelatin silver prints, two engraved plastic plaques; overall: 49 × 84 in., each: 49 × 40¾ × 1⅝ in. Edition 2/4 with 2 APs.

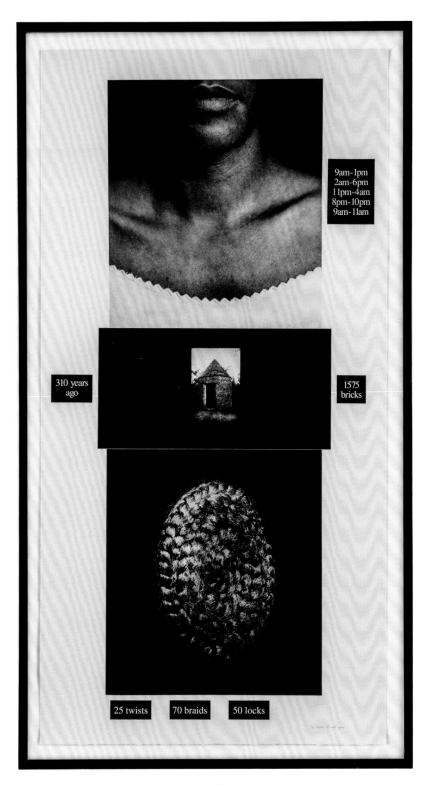

Lorna Simpson, *Counting*, 1991. Photogravure with silkscreen; 78¾ × 43⅛ ×
2 in. Edition 31/60 with 10 APs and 4 PPs.

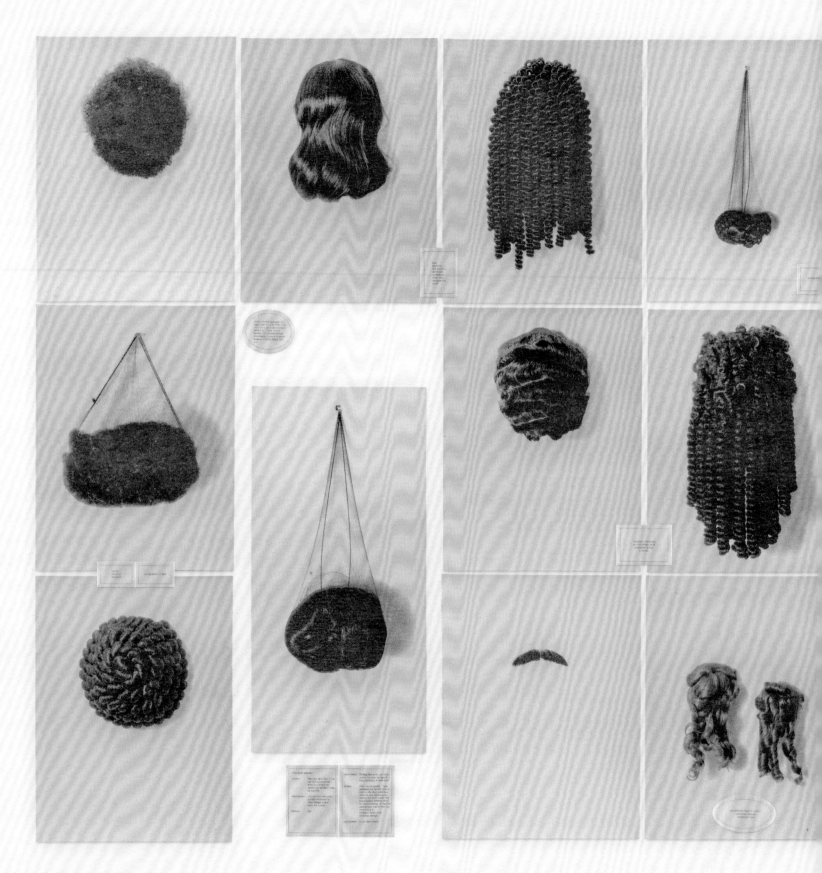

Lorna Simpson, *Wigs (Portfolio)*, 1994. Waterless litho on felt; overall: 72 ×
162 in.; wooden box: 34 × 19 × 6⅜ in. Thirty-eight panels total, including
seventeen with text. Edition 1/15 + 5 APs.

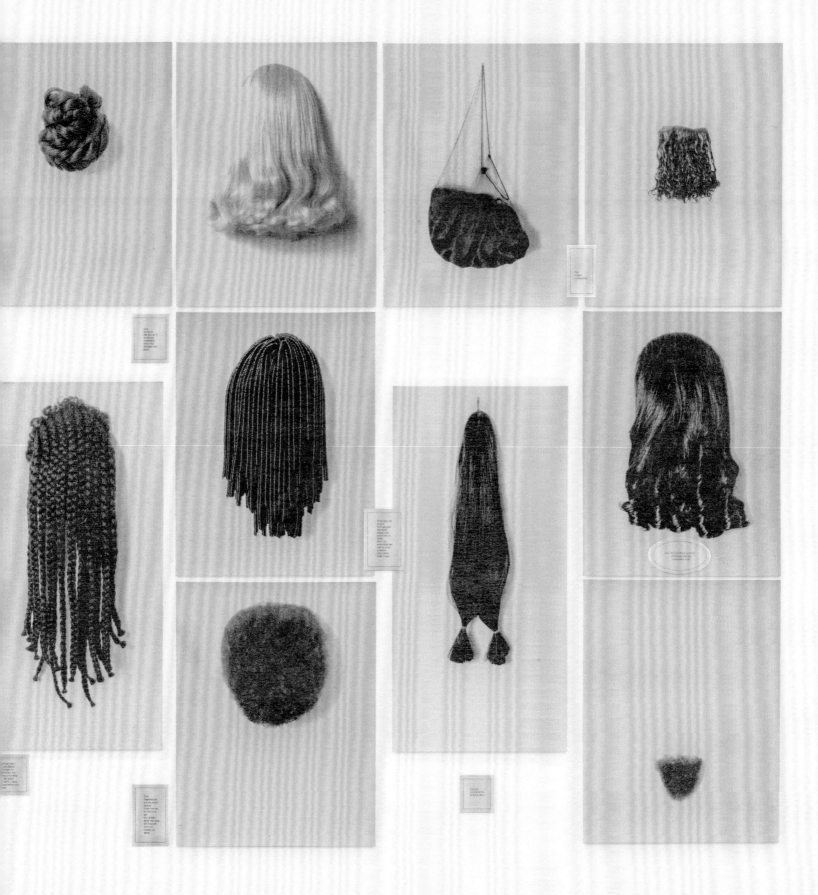

Lorna Simpson, *7 Mouths*, 1993. Seven photo linen panels; 61 × 16 in.
Edition of 3 with 2 APs.

Lorna Simpson, *The Park*, 1995. Serigraph on six felt panels with two felt text panels; 67¼ × 67¼ × ⅛ in. Edition of 3 with 2 APs.

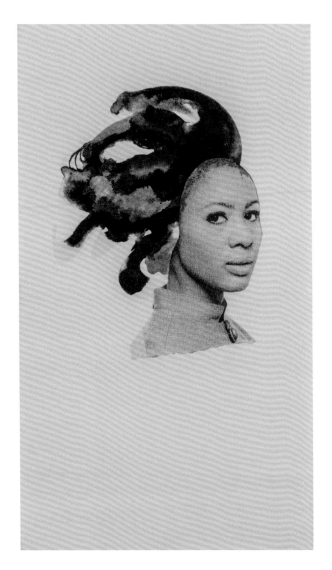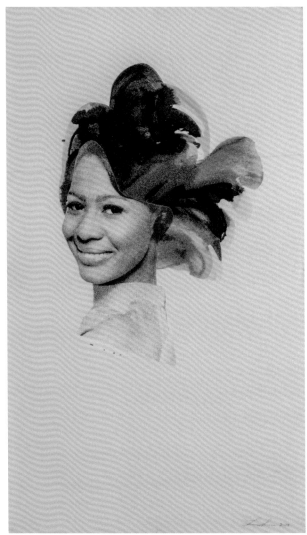

Lorna Simpson, *Double Portrait (Visual Arts Lincoln Center/Vera List Art Project 2013)*, 2013. Serigraph on two felt panels; 34½ × 40 in. Edition 24/27 with 7 APs.

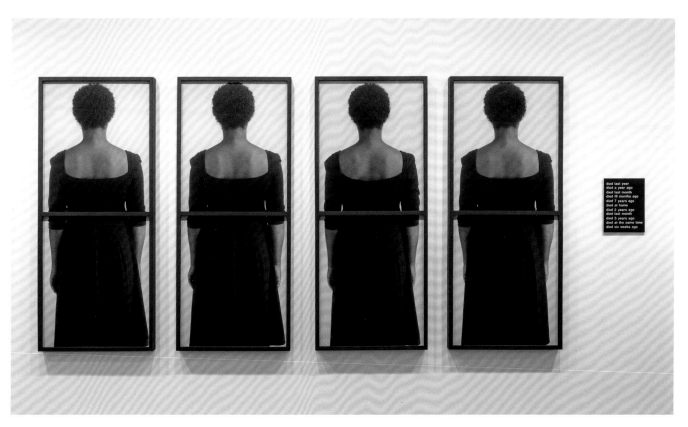

Lorna Simpson, *Time Piece*, 1990. Eight dye diffusion color Polaroids with one engraved plastic plaque; overall: 49¼ × 128½ × 1⅞ in.; each frame: 49¼ × 21⅞ × 1⅞ in.; plaque: 10 × 8 × ½ in. Edition 2/4.

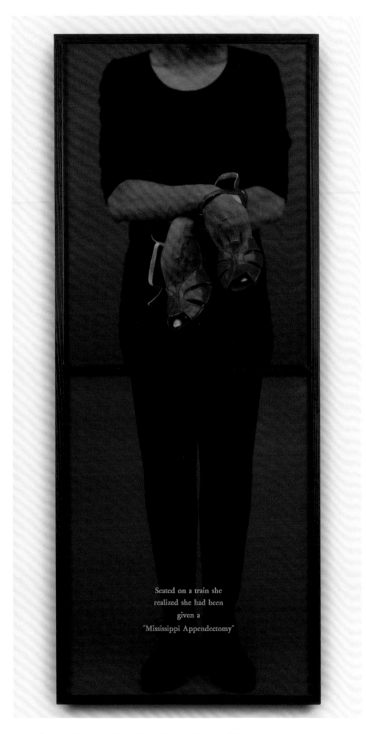

Seated on a train she
realized she had been
given a
"Mississippi Appendectomy"

Lorna Simpson, *Landscape/Body Parts III*, 1992. Two dye diffusion color
Polaroid prints and engraved plexiglass; 49⅜ × 20½ × 2 in. Edition 3/5.

May Sun, *Lest We Forget*, 1990. Screenprint on cotton; 2 × 8 × 7 in. Edition: Peter Norton Family Christmas Project.

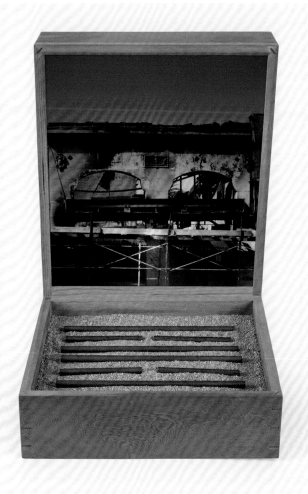

May Sun, *Reconfiguring the Urban Landscape*, 1992. Mixed media; 25 × 20 × 18 in.

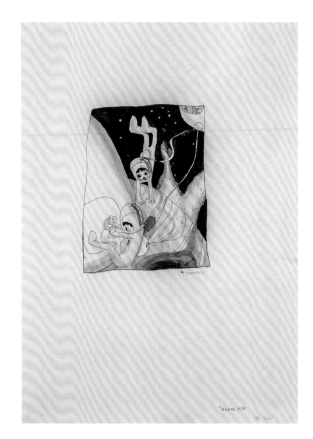

Aya Takano, *Discovery*, 1999. Watercolor and ink on paper; 7 × 10 in.

Aya Takano, *Camp*, 1999. Watercolor and ink on paper; 3½ × 5 in.

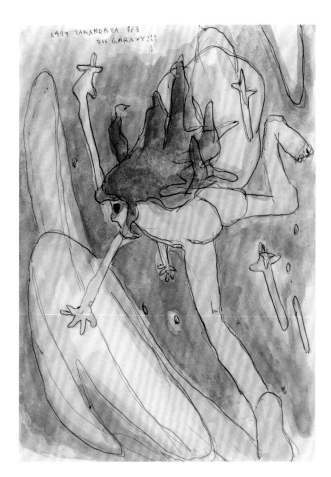

Aya Takano, *Oh Galaxy!*, 1999. Watercolor and ink on paper; 3½ × 5 in.

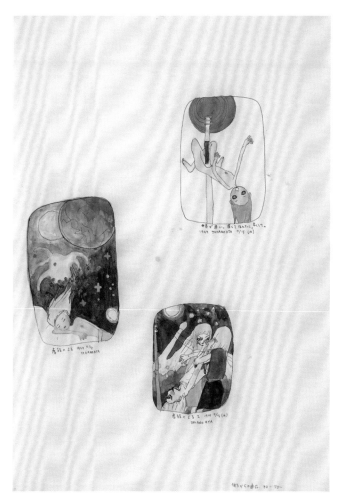

Aya Takano, *Series of the Night 2*, 1999. Watercolor and ink on paper;
10 × 14 in.

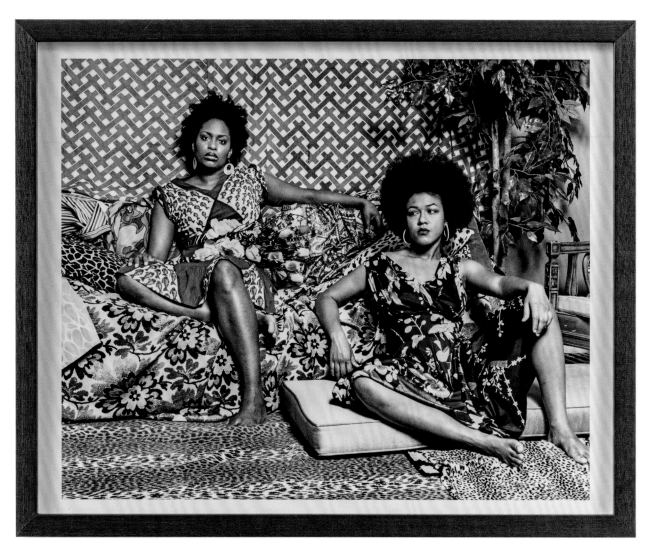

Mickalene Thomas, *A Moment's Pleasure in Black and White*, 2006. Black and white photograph; 17 × 21 in. Edition 3/6.

Mickalene Thomas, *Brawlin' Spitfire Wrestlers*, 2007. Resin, paint, and Swarovski crystals; 14 × 9¾ × 10 in. Edition of 71.

Linda Vallejo, *pink metallic honeycomb man.* Mixed-media sculpture;
35 × 18½ × 5 in.

Kara Walker, *Li'l Patch of Woods*, 1997. Etching with chine collé; 18 × 14 in.
Edition of 35. Publisher: Landfall Press, Inc., Chicago.

Kara Walker, *Untitled*, 1995. Ink, pencil, and gouache on paper, nineteen parts;
framed (9): 15 × 12 in., framed (10): 12 × 15 in.

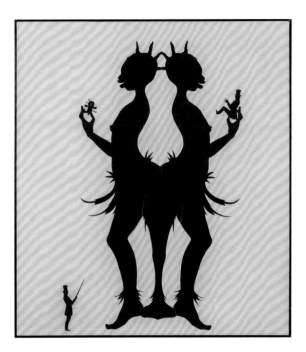

Kara Walker, *You Do*, 1994. Cut paper on canvas; 55 × 49 in.

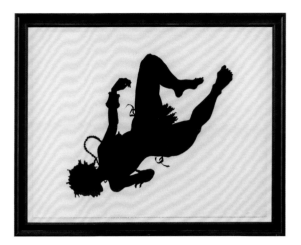

Kara Walker, *African/American*, 1998. Linoleum cut; 46 × 60½ in. Edition 4/40.

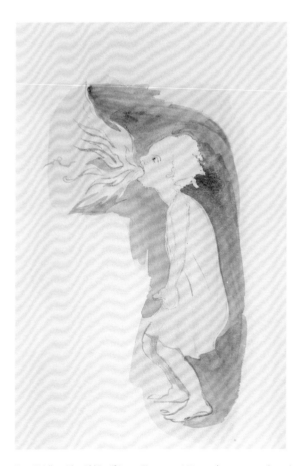

Kara Walker, *The Old Stuff Burns First*, 1995. Watercolor on paper; 8 × 11 in.

Kara Walker, *Slavery! Slavery! Presenting a GRAND and LIFELIKE Panoramic Journey into Picturesque Southern Slavery or "Life at 'Ol' Virginny's Hole' (sketches from Plantation Life)" See the Peculiar Institution as never before! All cut from black paper by the able hand of Kara Elizabeth Walker, an Emancipated Negress and leader in her Cause,* 1997. Cut paper and adhesive on wall; 11 × 85 ft.

Kara Walker, *Cotton*, 1997. Etching with chine collé; 18 × 14 in. Edition of 35.
Publisher: Landfall Press, Inc., Chicago.

Kara Walker, *Queen Bee*, 1998. Gouache and cut paper on paper;
64 × 42 in.

Kara Walker, *Negro History Minute*, 1998. Watercolor and gouache on paper;
52 × 99 in.

Kara Walker, *Untitled (blue constellation)*, 2000. Gouache on paper;
12¼ × 9 in.

Kara Walker, *The Bush, Skinny, Deboning*, 2002, Painted laser-cut steel,
three parts; dimensions variable. Edition 27/100.

Kara Walker, *Restraint*, 2009. Etching with aquatint and sugarlift; 31 × 23⅞ in. Edition of 8.

Kara Walker, *Untitled*, 2005. Conté on paper; 19 × 25 in.

BLACK MAN WITH A WATERMELON

BLACK WOMAN WITH CHICKEN

Carrie Mae Weems, *Black Man with a Watermelon*, 1987. Silver print; 16 × 20 in. Edition of 5.

Carrie Mae Weems, *Black Woman with Chicken*, 1987. Silver print; 16 × 20 in. Edition of 5.

Wrapped as they were in their magic, dripping from honey poured from the calabash, they needed more than love to stave off the hunger nipping at their bud. Neither with certainty remembered suggesting eating from the tree in the garden, but somehow or another the decision had been made. It could have been her; she was a curious rebellious woman for sure. On the other hand, he was a man enraptured with the spices of life. One thing was certain, this was the ending and the beginning of things. Square-toed and flat-footed they danced before the lawd with all their might, but evidently it was too late. Banished from the heavenly garden of earthly delight they landed head first smack in the middle of a tradition that denied them both. Even the lion, sovereign beast of the savanna kingdom, cried for them.

A woman is like an apricot,
eighteen days and she is out of season

Carrie Mae Weems, *Africa Series*, 1993. Two silver prints and two text panels; dimensions variable. Edition of 10.

Against this back drop, ha, and in the eyes of the almighty, ha, he denounced her; claiming for himself alone the tools of power. Shocked by his betrayal, but no fool, she turned to the ruler of darkness, acquiring three keys.

one to the cupboard
one to the bedroom
one to the cradle

She fought him like a champ, but neither won, it was much more complicated than that. With his tools of power and her keys to the kingdom they stood face to face on top of their own mountain with a swing-low valley between them.

A man is like the hands of a clock,
he points in all directions

Carrie Mae Weems, *Sea Island Series (house)*, 1992. Three silver prints and
one text panel; 41½ × 61¼ × 1½ in. Edition 4/10.

Carrie Mae Weems, *Untitled (Weems and Buffalo)*, 2000. Inkjet print on canvas; 62½ × 71 in.

Carrie Mae Weems, *May Flowers*, 2001. Iris print; 14½ × 12½ in.

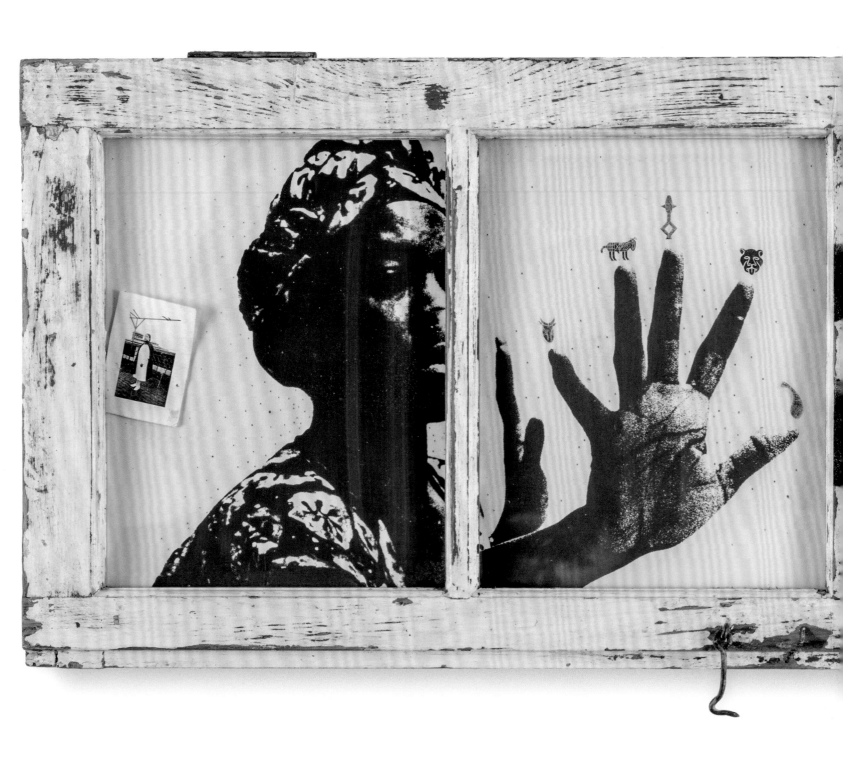

Pat Ward Williams, *Loa*, 1986–1994. Cyanotype on punched paper, film positive, snapshot, and window frame; 17 × 49 × 2½ in.

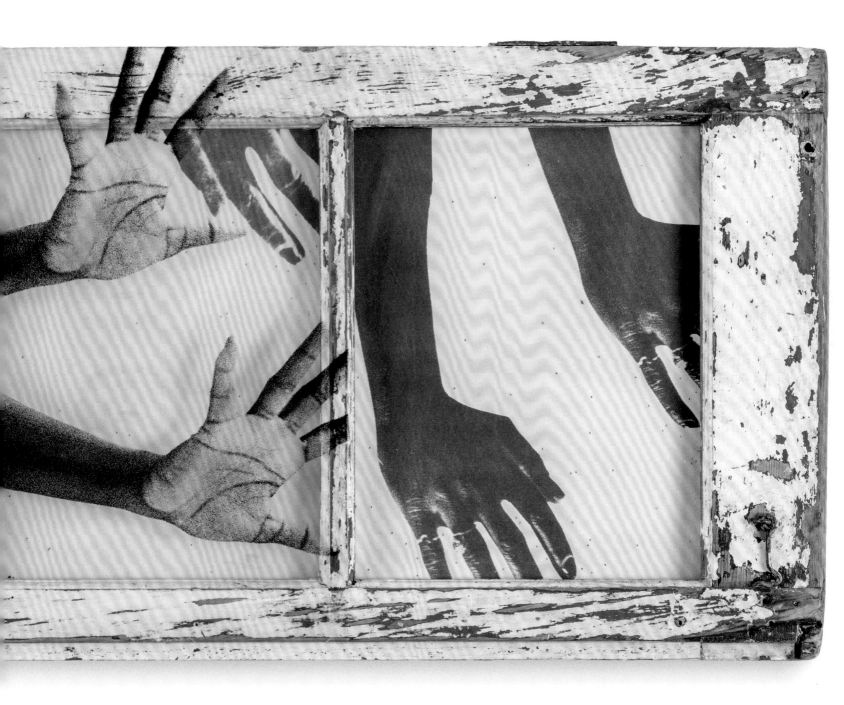

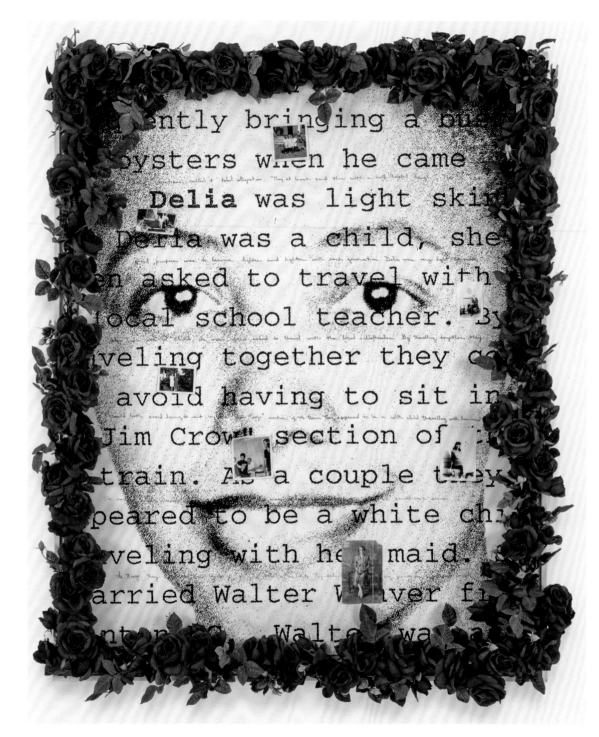

Pat Ward Williams, *Delia*, 1992. Mural print and mixed media; 57 × 46 × 5 in.

Paula Wilson, *The Source (from the Individual Series)*, 2008. Woodblock print, gouache, and collaged oil paintings on paper with wood frame; 31½ × 24 in.

Paula Wilson, *Treat for the Birds*, 2005. Woodblock, oil, and silica flat on paper; 16 × 9½ × 2 in.

Saya Woolfalk, *No Placean Anatomy (Human/Plant/Animal)*, 2008. Digital
print with silkscreen and gouache; 26 × 30 in. Edition 7/35.

Samira Yamin, *(Geometries) Fire IX*, 2017. Hand-cut *Time* magazine;
15¾ × 10⅜ in.

Lynette Yiadom-Boakye, *Carpal Tunneller*, 2013. Oil on canvas; 31½ × 23⅝ in.

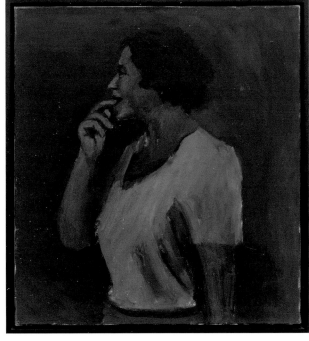

Lynette Yiadom-Boakye, *Every Choice Available*, 2012. Oil on canvas; 31¼ × 29¼ × 2¼ in.

Brenna Youngblood, *The Backbone of Resentment and Reassurance 19*, 2006.
Color photographs, acrylic paint/medium, and spray paint on panel; 48¼ × 48 in.

Brenna Youngblood, *Color Checker*, 2007. Color photographs, acrylic paint/
medium, spray paint, collage on panel with found frame; 15 × 19 in.

Brenna Youngblood, *Currency*, 2006. Card photographs, acrylic paint/
medium, and spray paint; 14 × 11 in.

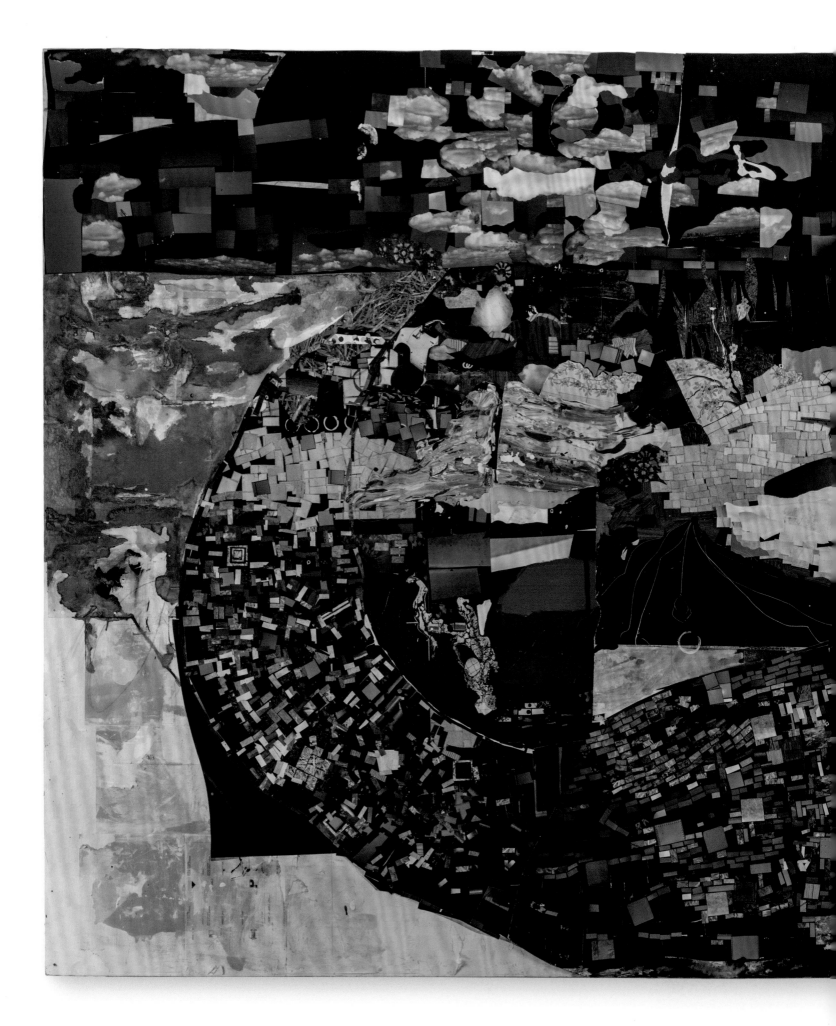

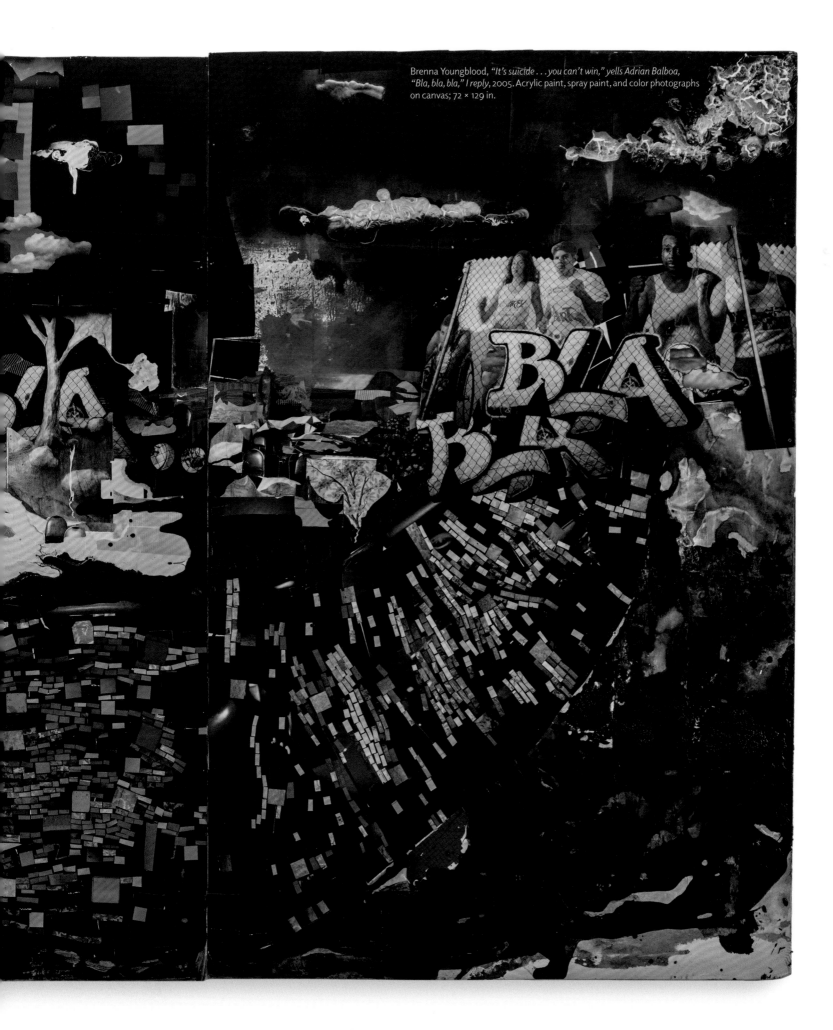

Brenna Youngblood, *"It's suicide . . . you can't win," yells Adrian Balboa, "Bla, bla, bla," I reply*, 2005. Acrylic paint, spray paint, and color photographs on canvas; 72 × 129 in.

Eileen Harris Norton in her home in Santa Monica, 2020.
Pictured: Kara Walker, *Untitled*, 1995.

Acknowledgments

Eileen Harris Norton

In 1976, I met artist Ruth Waddy with my mother at the now Baldwin Hills Crenshaw Mall in South Los Angeles. My mother and I spoke at great length with Mrs. Waddy, learning about her practice and work. Before leaving, my mother encouraged me to purchase an artwork from her. I walked away from my exchange with a linocut print titled *The Exhorters* (1976). This work represents the first artwork in my collection.

This volume would not have been possible without that first moment—an exchange between an artist with whom I developed a connection, and my mother's encouragement to support an artist I valued. Today, I am honored to have amassed a collection of works that expands beyond that first acquisition to include artists who I am grateful to know and have learned from. Those women artists are celebrated in this book, and I share them with you, to dive in and soak up their wisdom, grace, and continued curiosity for life.

I would like to begin by thanking my family, including my mother, Rosalind Van Meter Harris; my father, Willie Frank Harris; grandfather, Robert Van Meter; uncles, Robert Green and Donald; and my children, Diana and Michael Norton. From the early days to today, they have been with me on my journey and have shaped who I am.

I would like to thank my dear friends, Mark Bradford and Allan DiCastro, for their friendship and partnership in working within the art world, as well as within social services, through our work at Art + Practice. I am proud of our collective journey in supporting the needs of transition foster youth and refugees, and the artists of color whom we celebrate through our collaborations with museum institutions.

I would also like to thank those who have had a part in making this volume possible. Thank you to my long-time collection manager, Sophia Belsheim, for helping shepherd this book since the beginning. I thank the contributors Susan Cahan, Chelsea Mikael Frazier, Thelma Golden, Genevieve Hyacinthe, Kellie Jones, Gelare Khoshgozaran, Kris Kuramitsu, Sarah Elizabeth Lewis, Steven Nelson, Legacy Russell, Lorna Simpson, and Lowery Stokes Sims, for your words that shed light on the artists I collect and admire. Thank you to Polymode for realizing our vision in your beautiful design. Thank you to Gina Broze and Susan Larsen for your partnership in navigating the rights and copyedits that make this book sing. And thank you to Marquand Books and Yale University Press for bringing this volume to life for the world to enjoy.

I am grateful to Taylor Renee Aldridge for her tireless work and curatorial vision in realizing this book. Thank you for joining us together in ways that have surprised and moved me to my core.

A special acknowledgment to the artists in this book. Your voice is the foundation of what this volume is based on. You bring forth your vision and light into the world. I honor that.

Index

Contributor Bios

Taylor Renee Aldridge is the Visual Arts Curator at the California African American Museum (CAAM) and co-founder of ARTS.BLACK, an influential journal of art criticism for Black perspectives.

Sophia Belsheim is Collection Manager of the Eileen Harris Norton Collection and Director of Art + Practice, a nonprofit organization founded by Eileen Harris Norton, artist Mark Bradford, and activist Allan DiCastro.

Susan E. Cahan, PhD, is Dean of the Tyler School of Art and Architecture. She served as Senior Curator for the collection of Eileen and Peter Norton and Arts Programs Director for the Peter Norton Family Foundation from 1996 to 2001. Her recent publications include *Mounting Frustration: The Art Museum in the Age of Black Power* (2016) and *Rethinking Art Philanthropy and the Problem of Conflict of Interest* (2004).

Chelsea Mikael Frazier, PhD, is an Assistant Professor of African American Literature and Culture at Cornell University. She is currently at work on an ecocritical investigation of contemporary Black women artists, writers, and activists.

Thelma Golden is the Director and Chief Curator of The Studio Museum in Harlem. She currently serves on the Board of Directors for the Andrew W. Mellon Foundation, Barack Obama Foundation, Crystal Bridges Museum, and Los Angeles County Museum of Art.

Genevieve Hyacinthe, PhD, is Associate Professor of History of Art and Visual Culture and an MFA fine art faculty member at California College of the Arts, San Francisco. She is the author of *Radical Virtuosity: Ana Mendieta and the Black Atlantic* (2019).

Kellie Jones, PhD, is Chair of the Department of African American and African Diaspora Studies and Hans Hofmann Professor of Modern Art at Columbia University. Dr. Jones, a member of the American Philosophical Society and the American Academy of Arts and Sciences, has also received awards for her work from the Hutchins Center for African and African American Research, Harvard University, and Creative Capital | Warhol Foundation. In 2016 she was named a MacArthur Foundation Fellow.

Gelare Khoshgozaran is an undisciplinary artist and writer whose work engages with the legacies of imperial violence manifested in war and militarization, borders, and archives. Khoshgozaran is an Assistant Professor of Art at UCLA School of Art and Architecture, and editor at *MARCH: a journal of art and strategy*.

Kris Kuramitsu is an independent curator and educator in Los Angeles. Previously, she served as Curator for the collections of Eileen and Peter Norton and the Collection of Eileen Harris Norton, and as the Arts Programs Director for the Peter Norton Family Foundation.

Sarah Elizabeth Lewis, PhD, is an art and cultural historian and founder of Vision & Justice. She is the John L. Loeb Associate Professor of the Humanities and Associate Professor of African and African American Studies at Harvard University.

Steven Nelson, PhD, is Dean of the Center for Advanced Study in the Visual Arts at the National Gallery of Art, Washington, DC. Nelson is Professor Emeritus of Art History and African American Studies at the University of California, Los Angeles.

Legacy Russell is the Executive Director and Chief Curator of The Kitchen. Her recent exhibitions include *Samora Pinderhughes: GRIEF* (2022, The Kitchen); *The Condition of Being Addressable* (2022, ICA LA); and *Sadie Barnette: The New Eagle Creek Saloon* (2022, The Kitchen). Her first book is *Glitch Feminism: A Manifesto* (2020). Her second book, *BLACK MEME*, is forthcoming via Verso Books.

Lorna Simpson raises questions about the nature of representation, identity, gender, race, and history in her work. Her art is in the Museum of Modern Art, New York; Museum of Contemporary Art, Chicago; Walker Art Center, Minneapolis; and Whitney Museum of American Art, New York, and other notable collections.

Lowery Stokes Sims, PhD, served on the education and curatorial staff of The Metropolitan Museum of Art (1972-99), as Executive Director and President of The Studio Museum in Harlem (2000-7), and retired as Curator Emerita from the Museum of Art and Design (2007-15). Sims is currently an independent curator and consultant.

Image Credits

All images are courtesy the artist unless otherwise noted. In reproducing the images contained in this publication, every effort has been made to trace the copyright holders of the works published. The publisher apologizes for any omissions that may have inadvertently been made.

Artworks Pictured

Tanya Aguiñiga, b. Tijuana, Mexico
Felt Chairs (p. 65, pp. 148-49)
© Tanya Aguiñiga, Courtesy of Volume Gallery and the Artist

Belkis Ayón, b. Havana, Cuba
Dormida (Sleeping) (p. 129); *La Cena* (pp. 150-51); *Mi aima y yo te queremos* (p. 152); *Sin título (Mujer en posición fetal)* (p. 153); *Sin título* (p. 154); *Sin título (Sikán con chivo)* (p. 155)
All artworks © Belkis Ayón Estate, Havana, Cuba

Sadie Barnette, b. Oakland, CA
Untitled (Free Angela) (p. 156)
© Sadie Barnette, Courtesy of the artist and Charlie James Gallery, Los Angeles

Sonia Dawn Boyce, b. London, United Kingdom
1930s to 1960s (p. 157)
© 2023 Artists Rights Society (ARS), New York / DACS, London

Iona Rozeal Brown, b. Washington, DC
a3 blackface #22 (p. 158)
© Iona Rozeal Brown

Carolyn Castaño, b. Los Angeles, CA
Sudden Fanfare (p. 159); *Venus II* (p. 159)
All artworks © Courtesy of Walter Maciel Gallery and the Artist

Sonya Clark, b. Washington, DC
Watermelon World (p. 160)
© Sonya Clark

Nzuji De Magalhaes, b. Angola
Nzinga Mother (p. 161); *Nzinga Teacher* (p. 161); *Prenda (Souvenir)* (pp. 162-63); *Wrong Way* (p. 164)
All artworks © Nzuji De Magalhaes

Xiomara De Oliver, b. Grand Forks, Canada
Parlor B-Girl #33 (p. 74); *Parlor B-Girl #35* (p. 74); *Parlor B-Girl #37* (p. 74); *Allegory of Some Bombshell Girls—only in flamingo grass* (p. 75)
All artworks © Xiomara De Oliver, courtesy of Galerie Anne de Villepoix

Karla Diaz, b. Los Angeles, CA
La Cantina (p. 165); *Balloon Legs* (p. 165); *El Circo* (p. 165)
All artworks © Karla Diaz and Luis De Jesus Los Angeles

Genevieve Gaignard, b. Orange, MA
Miss Daisy (p. 166)
© Genevieve Gaignard, Courtesy of the artist and Vielmetter Los Angeles

Aimée García, b. Matanzas, Cuba
Aimée como Penélope II (p. 142); *La fuente* (p. 167); *Aimée como Penélope I* (p. 168)
All artworks © Aimée García

Deborah Grant, b. Toronto, Canada
Verdicts (p. 169); *Harlem Flophouse In The Afternoon* (p. 169); *The Last of the E.B.T. (Electronic Benefit Transfer)* (p. 170); *The Women of Delano Village* (p. 170)
All artworks © Deborah Grant

Renée Green, b. Cleveland, OH
Mise-en-scène II: Commemorative Toile (p. 19); *From Partially Buried in Three Parts (Kent, Ohio)* (p. 171); *Color II* (pp. 172-73)
All artworks © Renée Green, Courtesy of the artist and Free Agent Media

Sherin Guirguis, b. Luxor, Egypt
Untitled (p. 174)
© Sherin Guirguis, Courtesy of the artist

Aiko Hachisuka, b. Nagoya, Japan
Rolling Sketch (p. 175)
© Aiko Hachisuka

Kira Harris, b. Los Angeles, CA
Harlem Nights (p. 176)
© Kira Harris

Mona Hatoum, b. Beirut, Lebanon
Measures of Distance (p. 87); *Doormat* (p. 89); *Untitled (Latin grater)* (p. 122); *Grater Divide* (Courtesy White Cube) (p. 123); *Hair Necklace* (p. 177)
All artworks © Mona Hatoum. Courtesy the artist

Varnette P. Honeywood, b. Los Angeles, CA
Hearts Make Friends (p. 178); *When You Follow in the Path of Your Father, You Learn to Walk Like Him* (p. 178)
All artworks © Varnette P. Honeywood, 1986, Permission by the © Varnette P. Honeywood Estate

Pearl C. Hsiung, b. Taichung, Taiwan
Woah Is We (p. 179); *Know Me In Team* (p. 179)
All artworks © Pearl C. Hsiung

Emily Kame Kngwarreye, b. Utopia, Sandover, Australia
Wild Yam and Emu Food (p. 60)
© Emily Kame Kngwarreye / Copyright Agency. Licensed by Artists Rights Society (ARS), New York, 2023

Yayoi Kusama, b. Matsumoto, Nagano, Japan
Film stills from *Kusama's Self-Obliteration* (p. 68)
© YAYOI KUSAMA

Samella Lewis, b. New Orleans, LA
Couple (p. 108)
© 2023 Samella Lewis / Licensed by VAGA at Artists Rights Society (ARS), New York

Maya Lin, b. Athens, OH
Phases of the Moon (p. 92); *Silver River Mississippi* (p. 95)
All artworks © Maya Lin Studio, courtesy Pace Gallery

Liza Lou, b. New York, NY
Kitchen (p. 25)
Courtesy the artist and the Whitney Museum of American Art

Chandra McCormick, New Orleans, LA
Ascension (p. 59); *Neisha Young* (p. 180)
All artworks © Chandra McCormick

Julie Mehretu, b. Addis Ababa, Ethiopia
Landscape Allegories (pp. 104-5); *Rogue Ascension* (p. 181); *Entropia (review)* (p. 182)
All artworks © Julie Mehretu

Ana Mendieta, b. Havana, Cuba
Untitled (Cosmetic Facial Variations) (wig) (p. 183); *Untitled (Facial Cosmetic Variations) (stocking)* (p. 183); *Untitled (Cosmetic Facial Variations) (shampoo)* (p. 183)
All artworks © 2023 The Estate of Ana Mendieta Collection, LLC. Courtesy Galerie Lelong & Co. / Licensed by Artists Rights Society (ARS), New York, Photos courtesy Galerie Lelong & Co.

Beatriz Milhazes, b. Rio de Janeiro, Brazil
Cacoa (p. 184); *Ovo de Pascoa* (p. 184)
All artworks © Beatriz Milhazes Studio. Photo: Sid Hoeltzell, Courtesy the artist

Adia Millett, b. Los Angeles, CA
Kool-Aid (p. 185); *Vaseline* (p. 185); *Wonder Bread* (p. 185); *Bait Consumption* (p. 186)
All artworks © Adia Millett

Yunhee Min, b. Seoul, Korea
Structure in Space/Composite #2 (p. 187)
© Yunhee Min

Mariko Mori, b. Tokyo, Japan
Subway (p. 109); *Star Doll* (p. 110); *Cinderella* (p. 188)
All artworks © 2023 Mariko Mori, Member Artists Rights Society (ARS), New York

Wangechi Mutu, b. Nairobi, Kenya
Untitled (p. 100); *Untitled* (p. 101); *Untitled* (pp. 102-3); *Howl* (p. 189); *A Lilliputian Haunt* (p. 189)
All artworks © Wangechi Mutu, Courtesy of the artist and Gladstone Gallery

Senga Nengudi, b. Chicago, IL
R.S.V.P. (p. 20)
© Senga Nengudi

Shirin Neshat, b. Qazin, Iran
Rapture Series (pp. 50-51)
© Shirin Neshat, Courtesy of the artist, Gladstone Gallery, & Noirmontartproduction, Paris
Allegiance with Wakefulness (p. 190); *I Am Its Secret* (p. 191); *Rebellious Silence* (p. 191)
© Shirin Neshat, Courtesy of the artist and Gladstone Gallery

Mncane Nzuza, b. South Africa
Ukhambra #105 (N2) (p. 192)
© Mncane Nzuza

Toyin Ojih Odutola, b. Ige, Nigeria
Damn (p. 193)
© Toyin Ojih Odutola, Courtesy of the artist, Jack Shainman Gallery, New York and Corvi-Mora, London

Lorraine O'Grady, b. Boston, MA
Sisters I-IV (Miscegenated Family Album Series) (p. 10, Cover Flap); *Mlle Bourgeoise Noire Goes to the New Museum* (p. 34); *Mlle Bourgeoise Noire Costume* (p. 141); *Dracula the Artist* (p. 194); *Ceremonial Occasions 2 (from the Miscegenated Family Album Series)* (p. 195)
All artworks © 2023 Lorraine O'Grady / Artists Rights Society (ARS), New York

Ruby Osorio, b. Los Angeles, CA
Path Less Traveled (p. 196); *Chatter* (p. 196); *Reconfiguring* (p. 196)
All artworks © Ruby Osorio

Marta María Pérez Bravo, b. Havana, Cuba
Para ayudar a un hermano (To help a brother) (p. 197); *Llamando (Calling)* (p. 197); *No vi con mis propios ojos (I did not see with my own eyes)* (p. 197)
All artworks © Marta María Pérez Bravo

Adrian Piper, b. New York, NY
Food For the Spirit, #6 of 14 (p. 66); *Food For the Spirit, #12 of 14* (p. 66); Video still from *Funk Lessons* (p. 78); *Food For the Spirit, #1 of 14* (pp. 78-79); *Self-Portrait Exaggerating My Negroid Features* (p. 121); *Pretend #3* (p. 198); *The Mythic Being: Cruising White Women* (p. 199); *Why Guess #1* (p. 199)
All artworks © Adrian Piper Research Archive Foundation Berlin

Calida Rawles, b. Wilmington, DE
Wade, Ride This Wave of Mine (p. 200)
© Calida Rawles, Courtesy of the artist and Various Small Fires, Los Angeles/Seoul

Faith Ringgold, b. New York, NY
Wanted: Douglass, Tubman, and Truth (pp. 62-63)
© 2023 Faith Ringgold / Artists Rights Society (ARS), New York, Courtesy ACA Galleries, New York

Sandy Rodriguez, b. National City, CA
Lecherona-Asclepius curassavica from the Codex Rodriguez Mondragon 2 (p. 201); *Inglewood oil fields no. 2* (p. 202); *Pann's* (p. 202)
All artworks © Sandy Rodriguez

Alison Saar, b. Los Angeles, CA
Cora d'Oro (p. 203); *La Rosa Negra* (p. 203); *Bye Bye Blackbird* (p. 204); *Bat Boyz II* (p. 204); *Blonde Dreams* (p. 205); *Conked* (p. 205); *Hot Comb Haint Study* (p. 205); *Somnambulist* (p. 206); *Untitled* (p. 206); *Congolene Resistance* (p. 207); *Pallor Trick* (p. 207); *Umbra* (Courtesy of Flying Saucer Press) (p. 207); *Spiral Betty* (p. 208); *Topsy* (p. 208)
All artworks © Alison Saar. Courtesy of L.A. Louver, Venice, CA

Betye Saar, b. Los Angeles, CA
Last Dance (p. 15); *Souvenir of Friendship* (p. 209, Back Cover); *Sanctuary's Edge* (p. 210); *A Handful of Stars* (p. 211); *The Weight of Buddha (Contemplating Mother Wit and Street Smarts)* (p. 211); *We Was Mostly 'Bout Survival* (p. 212); *Blue Mystic Window w/ Moons & Stars* (p. 213); *Male Doll with Female Head* (p. 213)
© Betye Saar, Courtesy of the artist and Roberts Projects, Los Angeles, California

Lezley Saar, b. Los Angeles, CA
The Universe Vol. 1 (p. 214); *Views of Man* (p. 214); *Birth of Religion* (p. 215); *Rose J. Jones* (p. 215)
All artworks © Lezley Saar and Walter Maciel Gallery, Los Angeles

Analia Saban, b. Buenos Aires, Argentina
Pleated Ink, Window with Collapsible Gate (p. 216)
© Analia Saban, Courtesy of the Artist, Tanya Bonakdar Gallery, Sprüth Magers, Galerie Praz-Delavallade

Doris Salcedo, b. Bogotá, Colombia
Atrabiliarios (p. 80)
© Doris Salcedo, Photo by Patrizia Tocci © White Cube

Amy Sherald, b. Columbus, GA
When I let go of what I am, I become what I might be (Self-Imagined atlas) (p. 217)
© Amy Sherald, Courtesy the artist and Hauser & Wirth, Photo by Joseph Hyde

Lorna Simpson, b. Brooklyn, NY
III (Three Wishbones in a Wood Box) (p. 24); *Untitled (Curator trip to Johannesburg Biennial, 1997)* (pp. 28-29); *You're Fine* (pp. 38-39); *Double Portrait* (pp. 65, 224); *ID* (p. 218); *Tense* (p. 218); *Counting* (p. 219); *Wigs* (pp. 220-21); *7 Mouths* (p. 222); *The Park* (p. 223); *Time Piece* (p. 225); *Landscape/Body Parts III* (p. 226)
All artworks © Lorna Simpson, Courtesy the artist and Hauser & Wirth

Kianja Strobert, b. New York, NY
Hurtle (p. 33); *Marathon (II)* (p. 33); *Big Blue* (p. 33)
All artworks © Kianja Strobert

May Sun, b. Shanghai, China
Reconfiguring the Urban Landscape (p. 227); *Lest We Forget* (p. 227)
All artworks © May Sun

Aya Takano, b. Saitama, Japan
Camp (p. 228); *Discovery* (p. 228); *Oh Galaxy!* (p. 229); *Series of the Night 2* (p. 229)
All artworks © 1999 Aya Takano/Kaikai Kiki Co., Ltd. All Rights Reserved.

Alma Thomas, b. Columbus, GA
Azaleas in Spring (p. 70); *Untitled* (p. 73); *Air View of Spring Nursery* (p. 76); *Untitled (Study for Resurrection)* (p. 77)
All artworks © 2023 Estate of Alma Thomas (Courtesy of the Hart Family) / Artists Rights Society (ARS), New York

Mickalene Thomas, b. Camden, NJ
A Moment's Pleasure in Black and White (p. 230); *Brawlin' Spitfire Wrestlers* (p. 231)
All artworks © 2023 Mickalene Thomas / Artists Rights Society (ARS), New York

Fatimah Tuggar, b. Kaduna, Nigeria
Working Woman (p. 22); *Twig Whisk* (p. 125)
All artworks © Fatimah Tuggar & BintaZarah Studios

Linda Vallejo, b. Los Angeles, CA
pink metallic honeycomb man (p. 232)
© Linda Vallejo

Ruth Waddy, b. Lincoln, NE
The Children (p. 43); *Self-Portrait* (p. 44); *Untitled #1*, Series B (Photo courtesy of Museum of Nebraska Art, Kearney, Nebraska) (p. 44); *The Exhorters* (p. 47); *Emergency Call* (p. 48); *The Fence* (Photo courtesy of Treadway Gallery, Cincinnati, OH) (p. 48); *What Would You Do* (Image Courtesy of John Moran Auctioneers Inc., www.johnmoran.com) (p. 48); *Our Children* (Photo courtesy of Museum of Nebraska Art, Kearney, Nebraska) (p. 49); *Days of the Week Sampler* (p. 136)
All artworks © Ruth Waddy

Kara Walker, b. Stockton, CA
Freedom, a Fable: A Curious Interpretation of the Wit of a Negress in Troubled Times (p. 106); *The Means to an End … A Shadow Drama in Five Acts* (pp. 114-15); *Li'l Patch of Woods* (p. 233); *Untitled* (pp. 234, 260); *African/American* (p. 235); *The Old Stuff Burns First* (p. 235); *You Do* (p. 235); *Slavery! Slavery!* (pp. 236-37); *Cotton* (p. 238); *Negro History Minute* (p. 239); *Queen Bee* (p. 238); *Untitled (blue constellation)* (p. 240); *The Bush, Skinny, Deboning* (p. 241); *Restraint* (p. 242); *Untitled* (p. 242)
All artworks © Kara Walker, courtesy of Sikkema Jenkins & Co. and Sprüth Magers

Carrie Mae Weems, b. Portland, OR
Framed by Modernism (Seduced By One Another, Yet Bound by Certain Social Conventions; You Framed The Likes of Me & I Framed You, But We Were Both Framed By Modernism; & Even Though We Knew Better, We Continued That Time Honored Tradition of The Artist & His Model) (pp. 36-37); *When and Where I Enter, The British Museum* (p. 64); *Black Man With a Watermelon* (p. 243); *Black Woman With Chicken* (p. 243); *Africa Series* (pp. 244-45); *Sea Islands Series (house)* (p. 246); *May Flowers* (p. 247); *Untitled (Weems and Buffalo)* (p. 247)
All artworks © Carrie Mae Weems, Courtesy of the artist and Jack Shainman Gallery, New York

Pat Ward Williams, b. Philadelphia, PA
Loa (pp. 248-49, Front Cover); *Delia* (p. 250)
All artworks © Pat Ward Williams

Paula Wilson, b. Chicago, IL
Remodeled (p. 113); *The Source (from the Individual Series)* (p. 251); *Treat for the Birds* (p. 251)
All artworks © Paula Wilson and Emerson Dorsch Gallery

Saya Woolfalk, b. Gifu, Japan
No Placean Anatomy (Human/Plant/Animal) (p. 252)
© Saya Woolfalk, Courtesy Leslie Tonkonow Artworks + Projects, New York

Samira Yamin, b. Evanston, IL
January 11, 2010 IV (pp. 83, 91); *October 1, 2001—IV* (p. 84); *Geometries XXI* (pp. 90, 91); *(Geometries) Fire IX* (pp. 91, 253)

All artworks © Samira Yamin and PATRON
Lynette Yiadom-Boakye, b. London, United Kingdom
Every Choice Available (p. 254, Interior Flap); *Carpal Tunneller* (p. 254)
All artworks © Lynette Yiadom-Boakye, Courtesy of the artist, Jack Shainman Gallery, New York and Corvi-Mora, London

Brenna Youngblood, b. Riverside, CA
The Backbone of Resentment and Reassurance 19 (p. 255); *Color Checker* (p. 256); *Currency* (p. 257); *"It's suicide … you can't win," yells Adrian Balboa, "Bla, bla, bla," I reply* (pp. 258-59)
All artworks © Brenna Youngblood, Courtesy of the artist and Roberts Projects, Los Angeles, California

Photography Captions
Sojourner Truth, "I Sell the Shadow to Support the Substance," Photo: www.metmuseum.org (p. 30); Ruth Waddy with some of her artwork and her dog Cliquot. Los Angeles Times Photographic Archive. Department of Special Collections, Charles E. Young Research Library, UCLA (CC BY 4.0) (p. 40); Installation view of *Black Male.* Digital image © Whitney Museum of American Art / Licensed by Scala/ Art Resource, NY (p. 52); Installation view of *Collective Constellation: Selections from the Eileen Harris Norton Collection* at Art + Practice. February 8, 2020-January 2, 2021. Courtesy Art + Practice (pp. 128, 147); From left, Berry Gordy and Martin Luther King Jr. hold King's first Motown album. Uncredited photo (p. 132); A group of Black women step through rubble and demolished storefronts on Central and Vernon Avenues where businesses were destroyed and looted during the Watts riots in Los Angeles, California, August 1965. Hulton Archive/Getty Images (p. 133); A postcard from 1965 that read: "The largest art museum to be built in . . . ," Photo: Courtesy of the James H. Osborne Collection, Gerth Archives and Special Collections CSU Dominguez Hills (p. 133); (L-R) Eleanor Holmes Norton, Carter Burden, Charles E. Inniss . . . Photo: Courtesy of The Studio Museum in Harlem (p. 134); A poster for presidential candidate Shirley Chisholm from 1972. Photo: Courtesy of the Smithsonian National Museum of African American History and Culture (top right: p. 134); IBM 3270 PC The Smart Desk, vintage 1980s print ad. © IBM (p. 137); Gina Hemphill, granddaughter of famed Olympian Jesse Owens. © Los Angeles Herald Examiner Collection (p. 138); Betye Saar, Betye Saar at Watts Tower. Unknown date. Saar Family photograph. © Betye Saar, Courtesy of the artist and Roberts Projects, Los Angeles, California (p. 139); Eileen Harris Norton and Peter Norton pose for a portrait with *The New York Times.* Courtesy the Eileen Harris Norton Collection (p. 140); 2001 Ad in The New Yorker, The Studio Museum in Harlem—*Freestyle.* Photo: The Studio Museum in Harlem (p. 143); Freestyle exhibition catalog title page. Photo: The Studio Museum in Harlem (p. 143); Art + Practice founders Eileen Harris Norton, Mark Bradford and Allan DiCastro, Leimert Park, Los Angeles, July 11, 2018. Courtesy of Art + Practice. (p. 146, left)

Photography Credits
Kelly Barrie: p. 145; Sophia Belsheim: p. 146 (right); Bettmann / Getty Images: p. 131 (middle); Mark Bradford and Daniel Joseph Martinez: p. 142; Geoffrey Clements: p. 52; Courtesy of The Columbus Museum: p. 76; Iain Dickens: p. 123; Courtesy of Hemphill Artworks: p. 77; Joseph Hyde: p. 217; Anne Knudsen: p. 138; Jill Krementz: p. 134 (left); John Malmin: p. 40; Plauto: p. 191 (right); Cynthia Preston: p. 190, p. 191 (left); Damien Turner and Rob Dyck: p. 146 (left); James Wang (p. 225); Robert Wedemeyer: p. 213 (left); Charles White: pp. 36-37, p. 43, p. 44, p. 66, pp. 78-79 (right), p. 108, p. 122, p. 128, p. 136, p. 141, p. 147, p. 154, p. 156, p. 159 (left), pp. 164-65, p. 169 (right), pp. 172-73, p. 178 (right), p. 182, p. 184 (left), p. 189 (right), p. 193, p. 203, p. 209, p. 218 (top), p. 235 (top right), p. 240, p. 254, p. 256, Back Cover; Joshua White: p. 10, p. 15, pp. 19-20, p. 22, p. 24, pp. 28-29, pp. 33-34, pp. 38-39, p. 47, p. 48 (left), pp. 50-51, pp. 59-60, pp. 62-65, p. 70, pp. 73-75, pp. 83-84, pp. 89-92, p. 95, pp. 100-106, pp. 108-10, pp. 113-15, p. 121, p. 125, p. 129, p. 142 (left), pp. 148-53, p. 155, pp. 157-58, p. 159 (right), pp. 160-63, pp. 166-68, p. 169 (left), pp. 170-71, pp. 174-77, p. 178 (left), pp. 179-81, p. 183, p. 184 (right), pp. 185-88, p. 189 (left), p. 192, pp. 194-98; p. 199 (bottom), pp. 200-202; pp. 204-6, p. 207 (left, middle), p. 208, p. 210, p. 211 (left), p. 212, pp. 214-16, p. 218 (bottom), pp. 219-22, p. 224, pp. 227-34, p. 235 (left, bottom right), pp. 236-39, pp. 241-53, p. 225, pp. 257-60, Inside Flap, Front Cover

Library of Congress Control Number: 2023944219
ISBN 978-0-300-27229-1

Published by the Eileen Harris Norton Collection

Distributed by Yale University Press
302 Temple Street
P.O. Box 209040
New Haven, CT 06520-9040
yalebooks.com/art

Produced by Marquand Books, Seattle
marquandbooks.com

Edited by Taylor Renee Aldridge
Copyedited by Susan Higman Larsen
Designed by Polymode, Los Angeles/Raleigh: Brian Johnson, Silas Munro, and Randa Hadi
Typeset in Odile and Elido
Proofread by Ivy Long
Collection Management by Sophia Belsheim
Photo research by Gina Broze, Smart Rights
Color management by I/O Color, Seattle
Printed and bound in Italy by Graphicom